WESTMAR COLLEGE LIBRARY

W9-ARG-619

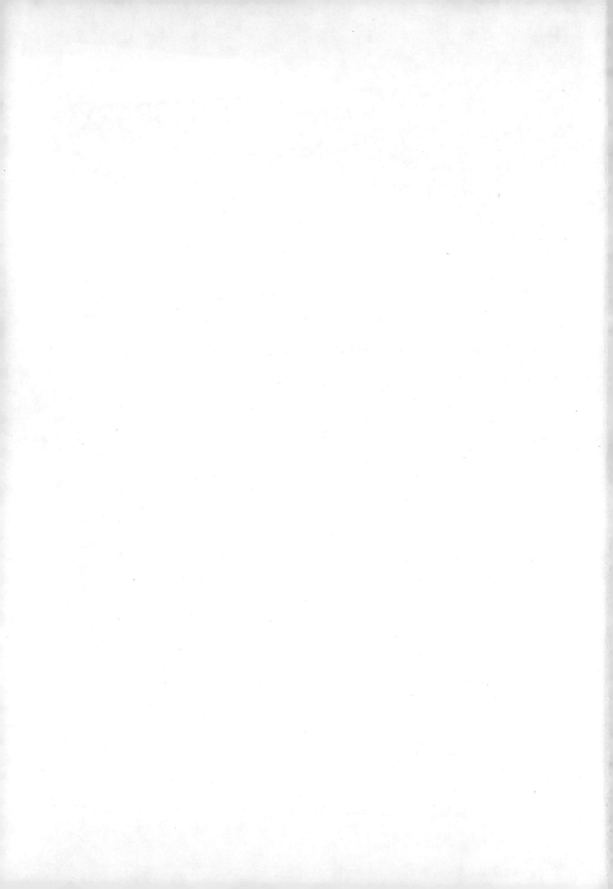

VELÁZQUEZ

VELÁZQUEZ

The Art of Painting

MADLYN MILLNER KAHR

ICON EDITIONS

HARPER & ROW, PUBLISHERS

NEW YORK, HAGERSTOWN, SAN FRANCISCO, LONDON

ND
813
.V4
K24
1976

VELÁZQUEZ: THE ART OF PAINTING. Copyright © 1976 by Madlyn Millner Kahr. All rights reserved. Printed in the United States of America. No part of this book may be used or reproduced in any manner whatsoever without written permission except in the case of brief quotations embodied in critical articles and reviews: For information address Harper & Row, Publishers, Inc., 10 East 53rd Street, New York, N.Y. 10022. Published simultaneously in Canada by Fitzhenry & Whiteside Limited, Toronto.

FIRST EDITION

Designed by C. Linda Dingler

Library of Congress Cataloging in Publication Data

Kahr, Madlyn Millner.
 Velázquez: the art of painting.

 (Icon editions)
 Bibliography: p.
 Includes index.
 1. Velázquez, Diego Rodríguez de Silva y, 1599–1660.
ND813.V4K24 1976 759.6 [B] 75–39563
ISBN 0–06–433575–5

76 77 78 79 10 9 8 7 6 5 4 3 2 1

93747

Dedicated to the memory of
Sidney Kahr

Contents

Acknowledgments

It gives me pleasure to record here my gratitude to those who facilitated my research on Velázquez by making available to me technical studies and other information: in Madrid, at the Museo del Prado, Prof. Xavier de Salas and Rocío Arnáez; in London, at the National Gallery, Allan Braham, and, at the Wallace Collection, Terence Hodgkinson; in New York, at the Hispanic Society of America, Dr. Priscilla E. Muller. I should also like to mention my appreciation for the libraries, photographic archives, and print collections without which my work would have been impossible, particularly the Frick Art Reference Library, the library of the Institute of Fine Arts of New York University, the New York Public Library, and the library of the Metropolitan Museum of Art, in New York; the Courtauld Institute and the Warburg Institute, in London; and the Rijksprentenkabinet and library of the Rijksmuseum, in Amsterdam. For various kinds of help, my thanks go to Prof. Julius S. Held, Prof. Howard Hibbard, Dr. Andrew S. Kahr, and—most of all—Dr. Sidney Kahr.

Introduction

The rejection suffered by the innovative painters of the late nineteenth century has perpetuated until today the idea that it is the normal fate of venturesome forms of art to be ignored or scornfully dismissed. But in fact the legend of the artist at odds with society is directly contradicted by masses of evidence provided by the history of Western art. Art has usually, if not always, served the purposes of dominant forces in the culture that gave rise to it. And society has generally given its most capable artists appropriate rewards in terms of the values of the times.

The career of the Spanish seventeenth-century painter Diego Velázquez is an exemplary case of the artist of striking originality who appears to have been supremely adapted to his environment. Yet the social and economic possibilities open to him were limited by the bounds set by his particular cultural setting. How the social situation affected his art and how he reacted to his place in society are considerations central to this study of his life and work.

Velázquez was a success long before the Metropolitan Museum purchased his portrait of *Juan de Pareja* (Fig. 52) at the record price of $5,544,000 in 1971. Recognition of his gifts came early, and professional and social satisfactions graced his career from beginning to end. His works, highly appreciated during his lifetime, were later a source of inspiration to Spanish artists from Goya to Picasso and up to the present day. French artists, too, have been deeply impressed by them, beginning in the 1820s. In 1865 Manet called Velázquez "the painter of painters." Sargent, among American artists, showed his debt to Velázquez. Not only painters, but the general public have admired and enjoyed his pictures, generation after generation. No less than in the past, people today delight in their enduring freshness.

Though much loved, the paintings of Velázquez have commonly been misunderstood since they came to wide notice after many of them were removed from their long seclusion in the Spanish royal palaces and

placed in the National Museum in Madrid in 1819. They were shaped by a culture very foreign to the modern mind. We cannot hope to comprehend them without sympathetic attention to the conditions of life and the patterns of belief that entered into their creation. Even Velázquez, who was recognized during his lifetime as an authentic genius, an artist of the top rank, and who early in his career became the favorite Court painter and close associate of his King, was not immune to either the restrictions or the ideals that governed Spanish society in his day. In keeping with contemporary standards, he brought all his skills to bear on efforts to improve his status.

To explain how Velázquez's social determinants had evolved, this book starts with a chapter that provides a brief survey of the historical background that formed his world. Particular attention is given to the religious, social, and economic forces that contributed to the culture of Spain and specifically to that of Seville as Velázquez was growing up and entering upon his career there early in the seventeenth century.

The section on the life and work of the artist that follows includes discussion and reproductions of most of the works in acceptable condition that in my opinion are wholly by Velázquez's hand, including all of his major paintings. The paintings are reproduced and discussed chronologically, so far as possible. Velázquez rarely signed or dated his work, and there is reliable contemporary documentation regarding only a few of the paintings.

A large section of the book is devoted to a study of the painting known as *Las Meninas*, or *The Maids of Honor* (Fig. 62), and its place in the history of art. This masterpiece, long recognized as the culmination of Velázquez's career as a painter, presents a most intriguing problem of interpretation, for which a solution is here proposed. As the investigation of this picture provides insight into the artist's aspirations and his relations with his social milieu, it also sharpens our perceptions concerning the culture in which Velázquez lived and its impact on his art. The light thus shed on the personality of the artist is especially valuable because we have so little information about Velázquez's thoughts and feelings. Only two personal letters written by him are known. The early biographies give but scanty references to his private life, and they are colored, besides, by the values of their authors and the stereotypes of their times. To speak for him directly, there are at most a drawing or two and his paintings—of which about one hundred still exist that are entirely by his hand and are in good enough condition to provide trustworthy evidence of his style.

I.

Cultural and Social Patterns
That Shaped Velázquez's Career

Spanish pride is legendary. It grew from roots deep in history. The ideal of the noble, excellent, superior person is expressed in the word *hidalgo*, a contraction of a phrase meaning "son of a *somebody*." To be an *hidalgo* required long and untainted lineage, free not only from the admixture of foreign blood but also from the stain of working for a living. Those who could not qualify for this exalted class were traditionally relegated to a permanently inferior position in life. History gives some clues as to how this extreme emphasis on social status came about.

The geography of Spain fated its people to a lonely development. The Iberian Peninsula is cut off from Europe on the north by the Pyrenees and is isolated by the sea on the other three sides. This has fostered an independent course of history, with a tendency to lag behind the rest of Western Europe in various significant ways. The location of the Peninsula made it, at the same time, a natural link between North Africa and Western Europe and, later, between the New World across the Atlantic and the old civilizations around the Mediterranean. As a crossroads of the world, Hispania was repeatedly invaded. The Phoenicians and later the Greeks established trading posts on its shores. Celts came from the north. The Romans colonized, seeding a Hispano-Roman culture of considerable importance to the Roman Empire as well as to the future of Spain. Spanish Roman writers for a time dominated Latin literature, into which the Stoicism of Seneca the Younger and the satire of Martial introduced new and—some say—essentially Spanish flavors.

As the Roman bonds dissolved, the Visigoths, Christians from Northern Europe, invaded and achieved control of most of the Penin-

sula. Then, in the eighth century, Arabic-speaking Muslims made the first of a series of invasions that eventually succeeded in pushing the Christians back to a small holding on the northern frontier. The Muslim nation prospered and established a way of life that, among other accomplishments, kept alive classical knowledge and culture that were lost to the Europe of the Dark Ages. The Muslim-Spanish culture that ensued, which was notable for its literary and scientific attainments, made lasting contributions to European artistic and intellectual life. In the twelfth century, however, the Arabs of Iberia, divided and quarreling among themselves, were conquered by new invaders from North Africa, Berbers of Moroccan origin, who came to be known as Moors. They too were Muslims, but their different, less advanced culture introduced new grounds for strife.

The Christians who had been pushed into the north became in turn the aggressive invaders. Little by little, starting—according to tradition —in 718, they regained territory. Alliances of Christians and Muslims against the co-religionists of either party were not uncommon in the continuing conflict. Finally, with the fall of Granada in 1492, Christians were once again in power over the entire Peninsula. But for more than a century after this time, life in Spain was marked by Muslim values which, in contradistinction to Christian principles, viewed life on earth as worth living and appreciated sensuous experience.

The Peninsula had long been divided into three kingdoms: Aragón, Castile, and Portugal. In 1469, with the marriage of Isabella of Castile to Ferdinand, heir to the throne of Aragón, these two kingdoms, in effect, merged, though officially each ruler was sovereign in his own country and a consort in that of his spouse. Isabella, a person of strong character who became Queen at the age of twenty-three, was successful in controlling the Cortes of Castile and putting down the feudal lords who jeopardized the central authority. Among the forces she had to contend with were the three military orders, which had all been founded in the late twelfth century. The Orders of Calatrava and Alcántara were originally devoted to the reconquest, while the Order of Santiago served to safeguard the pilgrim route to Compostela. They remained centers of immense wealth, power, and prestige, capable of raising and supporting their own armies. Isabella gained control over this potential threat to her ascendancy by persuading the Pope, from whom they received their authority and who nominated their Grand Masters, to vest the administration of the Orders in Ferdinand. These avenues of money and patronage were thereafter at the service of the Spanish crown.

Richly endowed by the various ethnic strains that contributed to the formation of their people, the Spanish monarchs disowned this diversity. Their country has never fully recovered from the obsession with racial purity and doctrinal uniformity that has given an ugly and often irrational tone to Spanish policy. In the service of this obsession, Ferdinand and Isabella established a uniquely effective system of persecution. At their request, in 1478 Pope Sixtus IV founded the Spanish Inquisition, "the Holy Office." This was distinct from the medieval Papal Inquisition. It functioned in virtual independence from Rome, and its purposes were political no less than religious. It served to unify the nation in support of the crown. Repugnant as its activities may be to those who cherish freedom of thought and speech, it must be granted that the Holy Office was, for its time, not unusually brutal or unjust. It was unusually efficient. The Inquisition had agents in all parts of the land; through public trials and executions they made its power known to all the people. Thus it exerted tremendous pressure for conformity. The crown was surprisingly independent of the Pope. Not only was the Holy Office at the service of the sovereigns, but ecclesiastical appointments were also under their control. This ensured the rulers the cooperation of the clergy in their task of centralizing authority over their fractious lands.

Two triumphs with far-reaching consequences took place in 1492: the completion of the reconquest and Columbus's giant step onto land in the Western Hemisphere. The Spanish, doubly convinced that God was on their side, enthusiastically pursued what they saw as their divine mission to spread the faith. In that same year the edict requiring Jews to be baptized or be expelled was promulgated and enforced. In 1494 Pope Alexander VI conferred the title of "Catholic Monarchs" on Ferdinand and Isabella, and they took their place in history as *los Reyes Católicos*. Perhaps this appellation further intensified their zeal for a purely Catholic country. In 1501, in violation of the liberal peace treaty granted them at the conquest of Granada, the Moors in Castile were faced with the same alternatives that had been forced on the Jews nine years earlier: baptism or expulsion. Under these conditions, many Jews and Moors became nominal Christians. These *Marranos* and *Moriscos* became the prime targets of the Inquisition. Whether they were genuine converts or not, individuals of these ethnic strains were mistrusted and persecuted unto the fourth generation. Religious orthodoxy came to be identified with ethnic purity.

When Isabella died, in 1504, the elder of her surviving daughters was declared Queen of Castile, though she was mentally incompetent.

Known as *Juana la Loca* (Joan or Joanna the Mad), she was married to Philip "the Fair" of Burgundy, who became regent of Castile; he aroused great antipathy because of his foreign, Flemish ways. When Philip suddenly died two years later, Ferdinand returned from Aragón to Castile to act as regent for his daughter, and shortly before his death in 1516, he named Joanna's eldest son, Charles of Ghent, heir to his own throne of Aragón. The sixteen-year-old Charles must already have been a forceful individual; he demanded to be proclaimed King of Castile as well. Thus as King Charles I he became the first to rule over a united country comprising Castile and Aragón, a country in which, ironically enough, he had never set foot and whose language he could not speak.

When Charles arrived in Spain in 1517 from his native Flanders he was accompanied by Flemish nobles and officials. This foreign intrusion was not welcomed, and it was only through bribery and reassuring oaths on his part that he was able to prevail on the Cortes of Castile, of Aragón, and of Catalonia (which was attached to the crown of Aragón) in turn to swear formal oaths of fealty to him. Upon the death of his grandfather, the Emperor Maximilian, two years later, Charles again successfully resorted to bribery to win the imperial crown over his rivals, Francis I of France and Henry VIII of England. Thus early in his reign, by buying imperial power, he saddled Spain with heavy debts and with powerful enemies who never ceased to oppose him as long as they lived. French and English fears of the concentration of power in his hands and suspicions of his ambition for complete domination were well founded. Both France and England had reason to feel threatened. As Emperor Charles V of the Holy Roman Empire, he controlled Germany, the Low Countries, Spain, Roussillon, the Franche Comté, half of Italy, and the Indies. The Italian holdings were part of his Spanish inheritance; Sardinia and Sicily (as well as the Balearic Islands off the Mediterranean coast of Spain) were old possessions of the crown of Aragón, and Ferdinand had added the kingdom of Naples in the course of his extensive military adventures.

The superiority of the Spanish infantry had been established by the beginning of the sixteenth century, during the Italian campaigns of Ferdinand. The new organization and tactics devised at that time by "The Great Captain," Gonzalo Fernández de Córdoba, gave the Spanish troops advantages in both offense and defense through the deployment of varied weaponry, including long pikes, in a square battle formation. The Spanish also had the benefit of military leadership whose

quality was enhanced by the fact that no other profession was acceptable for a Spanish gentleman. Capable and energetic nobles turned to the army as the only theater of action open to them. For a century and a half no foe ever defeated the Spanish in a pitched battle. This enabled Charles to undertake with confidence a wide-ranging series of military initiatives. In 1521 he led a successful campaign to take Milan, then held by the French, in order to secure a land route between his widespread possessions. Four years later his troops were victorious over a French army at Pavia, near Milan, and took captive Francis I himself, who for a year thereafter was Charles's prisoner in Madrid. Against the Turks, the Emperor's forces fought engagements as far afield as Tunis and the banks of the Danube.

In Germany Charles had to face the problem of political as well as religious rebellion stimulated by the Reformation. He hoped that the Church, through a general council, would accept reforms that would avert the threatened break in Christian unity. Only after peace had been concluded with France, in December 1545, was the council assembled in Trent. It was dominated by Spanish churchmen. Though Trent was on German territory, its proximity to Italy caused the Lutherans such mistrust that they refused to participate. A Holy War against the heretics was proclaimed by the Pope and prosecuted by the Emperor. His victory at Mühlberg in 1547—immortalized by Titian's *Equestrian Portrait of Charles V*—was the high point of his campaign against the Protestants. Five years later, at Innsbruck, this victory was negated when a surprise attack put the Emperor's forces to flight.

Whether successful or not, military activities are costly in both men and money. Charles repeatedly found it necessary to borrow from the foreign, mainly German and Italian, banking houses to which he was already deep in debt—and even so his soldiers often went unpaid. Interest was still being paid on debts contracted by Ferdinand, and as the indebtedness increased, so did the interest rates. Inflation added to the burdens of the Spanish people. Still, history has credited Charles V with great deeds. He gave his people an exhilarating new sense of destiny. Turning inner rebelliousness into hostilities against foreign foes, he welded them into a nation with pride in its nationality. They could congratulate themselves on being the dominant European power, the foremost defenders of the faith, and the conquerors of the rich, mysterious lands across the Atlantic. But poverty came to them hand-in-hand with pride.

Perhaps Charles's guilt about his responsibility for economic disas-

ter played a part in his melancholy decision to dismember his vast empire. He abdicated the Netherlands in 1555 and Spain with its Italian holdings in 1556, in favor of his son Philip. In 1558 he turned over the imperial crown to his brother Ferdinand. Having been absent from Spain for more than half of his forty-year reign, he returned there to live in retirement in the Monastery of Yuste, in Extremadura, where he died a few months after completing his abdication. It may be that his gift to Spain of the Netherlands and Milan, both more properly parts of the Empire, was an effort to make amends for bringing Spain to the verge of bankruptcy.

His son, King Philip II, was also a strong ruler who had a very long reign, from 1556 to 1598. His temperament was quite different from his father's, however, and he tried to achieve through diplomacy much the same goals as Charles V had fought for on the field of battle. Indeed one battle, that of San Quentin in 1557, was enough for Philip, and he never afterward left the Peninsula. Two years later he made peace with France, after which he never again personally waged a foreign war. His domestic enterprises were effective in shoring up the unity and pride of the nation. In 1561 he established the first national capital in Madrid, an insignificant city that happened to be at the geographical center of Spain. The old Alcázar in Madrid, in which Francis I had been held prisoner, became the Royal Palace. According to legend, it was in fulfillment of a vow he had made at the Battle of San Quentin that in 1563 Philip began construction some thirty miles northwest of Madrid of *El Real Monasterio de San Lorenzo de El Escorial*. This vast project provided a focus for national pride and effort and for religious zeal. It was, in a way, Philip's equivalent to his father's feats of arms. During the more than twenty-one years that it was under construction, Philip spent most of his time at the site, in the foothills of the Guadarrama mountains.

El Escorial was to provide a worthy final resting place for Philip's parents, himself, and the Spanish sovereigns who would come after them, along with a well-endowed community of monks who would never cease to sing masses for the eternal salvation of their souls, and a church in which they might do this. In addition, it was to fill the need for a retreat in which Philip might find refuge from the worldly concerns that claimed this attention in Madrid, so that he could concentrate on his religious devotions. That these other-worldly aims called forth so insistently material an instrument for their achievement as El Escorial is itself a Spanish Baroque paradox. The first plans were

drawn by Juan Bautista de Toledo, who had studied in Italy and worked on St. Peter's under Michelangelo. When Toledo died, in 1567, Juan de Herrera, who had been associated with him in the work, took over supervision until the completion of the building on September 13, 1584. The King himself, it is said, was responsible for the austerity of its style. He decreed that the architecture should reflect the renunciation of everything in this world, including all the joys of the senses. The shape of the complex is itself symbolic. The plan is in the form of a gridiron, the instrument of martyrdom of Saint Lawrence, the early martyr, much venerated in Spain, to whom the project was dedicated.

El Escorial promptly became known as the "Eighth Wonder of the World," both for its unprecedented size and for its wealth of religious relics. It embodies temporal and religious power on an immense scale. In the course of time it housed a collection of works of art that in themselves would have been a world-famous attraction. It would be hard to conceive of a more grandiose monument to the power of Spain under the House of Austria and to Spain's commitment to religion.

"Let them eat pride" would have been the appropriate motto for the monarch who devoted vast sums to the construction of El Escorial while his people faced misery and even starvation. Spanish agriculture had declined, partly because it had been sacrificed to the interests of the powerful sheep-owning league, partly because of the lack of labor after the expulsion of the Moors and the departure of many energetic young people for the Spanish settlements overseas, and for various other reasons including the presumption that useful work was degrading. Inflation was out of control. Interest on the royal debts ate up the annual national income. Along with the other resources of the ruling house, the income from the Military Orders had long been mortgaged to foreign bankers. The extreme emphasis on being a gentleman, which precluded activity in industry or trade, was another factor that persistently arrested the economic development of Spain. Even confiscatory taxation could not meet the need for funds to retain solvency. Beggary was the fate of the poor, corruption and venality that of the upper classes.

It is not easy to reconcile the dismal economic realities of late-sixteenth-century Spain with the traditional notion that Spain's "Golden Age" was golden in more than a metaphorical sense. The great adventure of discovery and conquest in the Western Hemisphere was a source of wealth and trade, as well as a tremendous stimulus to imagination and pride. When Balboa sighted the Pacific in 1513, this had instigated fur-

ther exploration and exploitation of what was now recognized as a New World. Spanish *conquistadores* under Cortés conquered Mexico from a base on Cuba between 1519 and 1522. The conquest of Peru from a base on Panama by Pizarro followed between 1531 and 1534. In the name of the Church, the Aztecs and the Inca were plundered, before being extirpated. In 1565 Spain occupied the Philippine Islands. Treasure did indeed pour in from the new possessions. But it was not sufficient to keep up with the ever-increasing interest on debts and the drain of new expenditures. Competition and inflation damaged Spanish trade. The currency was debased. The importation of gold and silver was not enough to save the economy.

Philip II nevertheless had his successes as well as his failures. He gained a major triumph over the Turks in 1571, when his half-brother, Don Juan of Austria, led naval forces to a great victory in the Battle of Lepanto. Through a combination of political and military maneuvers Philip managed to annex Portugal in 1580, unifying the Peninsula for the first time in almost a thousand years. But his guarantee of Portuguese autonomy in domestic affairs, which was a condition of the annexation, prevented incorporation of Portugal in an integrated nation, and only sixty years later the Portuguese regained their independence. The revolt in the Netherlands was an unremitting burden, demanding expensive military action. Queen Elizabeth's treaty with the Dutch rebels in 1585, coupled with English piracy in the New World and persecution of Catholics in England, exacerbated already strained relations with England and led to the Spanish determination to overthrow Elizabeth. The destruction of the "Invincible Armada" that was sent out for this purpose in 1588 damaged the pride of Spain perhaps even more than its finances. By 1596 the realm was again bankrupt. The aging King divested himself of the Southern Netherlands, generally called Flanders, that part of the Low Countries over which he had succeeded in retaining control. He gave it as an independent state to his daughter, Isabella Clara Eugenia, and her husband-to-be, the Archduke Albert, with the proviso that it would revert to the Spanish crown if they should die without issue, as indeed proved to be the case. His heir to Spain and its Italian and American possessions was his twenty-year-old son, who reigned as Philip III.

Philip III was the first of three weak kings with whom the Hapsburg dynasty of Spain petered out. As if in recognition of their incapacity, all three of them turned over the real power to favorite ministers. From the beginning of the reign of Philip III in 1598, for

twenty years the Duke of Lerma ruled in his name, always with an eye to the aggrandizement of himself and his relatives and friends. In impoverished Spain money was attracted as if by magnetism to this select group. Taxes, extortion, the sale of offices and patents of nobility, and corruption in general exceeded even the outrageous scale they had previously reached. As nobles were exempted from taxes, those best able to pay were removed from the tax rolls in increasing numbers. The gap between rich and poor became ever greater. But the miseries of the Spanish people did not deflect their rulers from the mission they had taken upon themselves. The endless struggle with the Ottoman Empire, and with the Barbary pirates who allied themselves with it, fed the flames of the burning desire to spread and defend the faith. The heat also turned inward, to keep religious fanaticism at home boiling.

This was the Spain into which Diego Velázquez was born as the sixteenth century neared its close. The economy was ruinous. The pressures for religious orthodoxy and social conformity were intense. Yet not only did the Spanish Empire continue to play the role of a great political and military power, but it was also the leader of European culture. Intellectual life had made great progress under Ferdinand and Isabella. Eight new universities were founded in the late fifteenth and early sixteenth centuries, and the expansion continued through the sixteenth century. Printing flourished. A fair degree of freedom of expression was permitted in published works. Scholarly centers and libraries thus provided the basis for the development of an extraordinarily high level of culture. Also contributing to this development was the fact that travel and study in Renaissance Italy had been accessible for generations. Under Philip II Spain was a leader of the world in literature, art, and science. Still greater advances were made in the period after the destruction of the Armada. At that time it was Spain in which the outstanding work was being done in astronomy, tropical medicine and ophthalmology, metallurgy and mining, navigation, and theology. A similar claim could be made for the fields of economics and political theory. In literature, too, Spain was leading the way in the novel and drama, as well as the writings of the mystics. Spain also made unparalleled contributions to religious life; the founder and many of the leaders of the Jesuit Order, which provided militant agents of the Counter-Reformation all over the world, were Spanish, and the Order gave expression to a typically Spanish spirit.

Velázquez's native city, Seville, was a center of mercantile activity and of culture. By royal decree, all American trade was limited to the

port of Seville from 1503 to 1717. Science as well as business was fostered by the *Casa de Contratación de las Indias* (House of Commerce with the Indies), which combined the practical functions of a ministry of commerce, a school of navigation, and a court of law regarding trade and shipping to the New World. Exotic goods and individuals arrived, contributing to the colorful life of the city. Wine, oil, citrus fruits, and the splendid textiles manufactured locally were exported. Workshops of potters and glassblowers multiplied, to provide containers for export wares and domestic use, as well as dishes and glassware for the table in fascinating variety. Colonies of foreign traders formed a picturesque quarter in the Triana, reached by crossing the famous bridge of boats across the Guadalquivir River. Gambling houses and inns welcomed the transient population. All kinds of property, including paintings and slaves, were sold at auction in the streets. What a feast for the eyes the city provided for a boy who was to be a painter! For such a boy it was of some importance, too, that there was a thriving trade in paintings in Seville. Large commissions for pictures came from the colonies, and many other paintings were sent to be sold on the open market. Painters also were employed to decorate banners for ships, to make wall paintings in houses, and to paint in lifelike colors the statues destined to embellish churches near and far, as well as to paint altarpieces.

Though there was abundant work for painters in Seville, the social and economic possibilities open to them were limited by the hierarchical organization of the society in which they lived. They were subject to a traditional system of training and regulation through the guild, exactly as shoemakers or other handworkers were. From the time of the Renaissance, artists and their sympathizers had been striving to break the links that from medieval times had bound them to the status of craftsmen and tradesmen. Both the reverence for individuality and originality that marks our approach to the arts today and the fluidity of our social structure make it hard for us to appreciate what was at stake in that struggle. Painters everywhere lived under the restrictions of low status and the monetary disadvantages that followed from it. For those in Spain, however, the difficulties were reinforced by the extreme rigidity of the social order. Rights of precedence were jealously guarded on every level. Striving for status flowed naturally from the exaggerated Spanish ideal of pride. Social status had practical aspects as well. The nobility had great fiscal advantages over the lesser orders. Practitioners of what were recognized as liberal arts were exempt from the crushing sales tax that painters, whose work was clas-

sified as "vile and mechanical," were required to pay. Spain's chronic economic troubles afflicted everyone, but surely those at the bottom of the ladder suffered most.

Even prosperous, commercially oriented Seville, possibly the richest city in Spain, was subject to the tides that swept over the nation. In foreign affairs there was improvement. To Lerma's credit, it must be noted that he ratified the peace with France that had been worked out before the death of Philip II. After the death of Queen Elizabeth, in 1603, Lerma also succeeded in bringing an end to the hostilities with England, and he even established friendly relations with her successor, the peace-loving James I. Peace with the neighbors had finally been achieved after generations of warfare, and now hostility found its target at home. The *Moriscos* were hated because they were hard-working and prudent; they were willing to undertake the despised manual labor that was beneath the dignity of any self-respecting Spaniard. They were also feared because some of them collaborated—or were suspected of collaborating—with the Barbary pirates who raided Spanish coasts and with other enemies of Catholic Spain. They were expelled from Valencia in 1609 and from Castile, Andalusia, Aragón, and Murcia during the next few years. The expressed animosity and violence that accompanied their expulsion must have made it clear to everyone how dangerous it was to be different. The cult of pure blood perhaps gained strength in proportion to the decline of other grounds for pride. Getting along in this society required submission to authority, conformity to the prevailing religious and social values, and a fortunate genealogy—or at least the possibility of claiming to have these three virtues.

In addition to artistic genius, Velázquez had the psychological equipment that made it possible to function superbly under these conditions.

II.

The Artist's Life and Work

1. The Seville Years—and the Rise of Naturalism

On June 6, 1599, the firstborn son of Juan Rodríguez de Silva and Jerónima Velázquez, both natives of Seville, was baptized in that city,[1] probably soon after his birth. His father's parents had moved to Andalusia from their native Portugal (which was under the Spanish crown from 1580 to 1640). In the course of time Diego was joined by three brothers, a sister, and then two more brothers, none of whom left their mark on the world.

At the customary age of about twelve, Diego was apprenticed to Seville's leading teacher of painting, Francisco Pacheco.[2] Pacheco was a person of considerable importance in the community. As inspector for the Holy Office from 1616 on, he was a pillar of conservatism, and his authority over artists, particularly where religious imagery was concerned, was unquestioned. He was at home in intellectual and literary circles. As a painter, however, he was grossly inferior to his gifted pupil. In 1649, five years after Pacheco's death, his book on the art of

1. The baptismal certificate and all of the other known existing documents relating to Velázquez have been published in chronological order in *Varia velazqueña,* along with bibliographic information. Therefore there will be no further notes regarding the documents.
2. Because Velázquez stated in his application for admission to the guild in 1617 that he had been taught by "qualified teachers" in Seville, there has been considerable discussion about who his teacher before Pacheco might have been. The eighteenth-century biographer Palomino wrote (p. 892) that Velázquez studied first with Francisco de Herrera the Elder, who, he said, was a pupil of Pacheco and died in 1656. Since no documentary, iconographic, or stylistic link between Velázquez and Herrera is known, Palomino's remark may have been merely conjectural, and some scholars have rejected the connection. The contract apprenticing Velázquez to Pacheco was written on September 17, 1611, but specified that the usual six-year period agreed to had started on December 1, 1610. As Pacheco had been away from Seville for some time before he signed the contract, it is not unlikely that Velázquez had entered his studio during his absence and had been taught there by assistants in the studio. The possibility that Herrera was one of them is not excluded.

painting, *Arte de la Pintura*, was published. It included considerable information on individual artists. After working on it for more than thirty years, he had finished the manuscript in 1638, and his book remains one of our primary sources of information about Velázquez's career up to that date. They remained in close contact for the remainder of Pacheco's life, for, on April 23, 1618, Velázquez married his teacher's daughter, Juana. He had then been a member of the Guild of Saint Luke, that is, a qualified independent master, for a year, since March 14, 1617. (He was inscribed in the guild as Diego Velásquez de Silba, but in his signature on this document, the last name appears as "Silva." He continued thereafter to use his mother's name, though later in life he sometimes signed himself Diego de Silva Velásquez. At times he spelled his name "Velázquez," which is now the generally accepted spelling.) Two daughters born within three years after his marriage were Velázquez's only children; the younger one died in childhood.

Pacheco reports that Velázquez made many drawings from life during his apprenticeship.[3] Presumably, such drawings served as the basis for the figures in the *bodegones* of which the young artist made a specialty (Figs. 1, 2, 4, 5, 6, 7, and 12). These were pictures of ordinary folk engaged in everyday activities involving food and drink. This type of subject matter, as well as the style that characterizes his works of this period, shows that he had assimilated the new trend in painting that had made its mark in Rome shortly before the turn of the century. Representations of small groups of people in humble circumstances, with figures modeled in strong relief, unified by the fall of sharp light, brought close to the picture plane, firmly linked by compositional diagonals—these features of Velázquez's early paintings show that the style we loosely speak of as Caravaggist was known in Seville by the second decade of the seventeenth century. While adhering to this already widely disseminated modern style, Velázquez's paintings of the Seville years at the same time displayed distinctive characteristics that belonged to him alone. In color they were distinguished by a harmony of greenish ochre and brown earth tones. Forms were strongly modeled, so that the depictions of figures and things seem palpable. And, most impressively, his pictures were graced by an air of quiet reserve that was fundamental to his artistic personality.

Precisely how the iconographic and stylistic features associated with the Caravaggist painters of the early seventeenth century came to

3. Pacheco, Vol. II, p. 146.

shape Velázquez's early paintings has never been fully understood. It is virtually certain that he had not seen a painting by Caravaggio himself at this time. Caravaggesque works by Italian artists that might have been available to him, such as the paintings made by Orazio Borgianni while he was in Spain from about 1598 to 1602 and again in 1604 and 1605, had nothing in common with Velázquez's *bodegones* in subject matter and little resemblance in style. Jusepe Ribera, who was born in Spain but spent most of his working life in Naples, has been suggested as a source. But, so far as is known, no painting by him was brought to Seville before 1620, a few years after Velázquez had begun to work in this style.[4] Groups of two or three figures in half or three-quarter length, arranged in compositions similar to Velázquez's, were numerous among the works of northern followers of the Caravaggist trend; but no specific example can be pointed to that was in Seville at this time. Nor has any such composition been found that unquestionably is reflected in a particular painting by Velázquez. Efforts have been made to relate the style to Sevillian precursors,[5] also unconvincingly. Surely nothing of this sort was to be learned from Pacheco or from Herrera.[6] If Velázquez's tenebrism owed something to the works of Juan de las Roelas, this would hardly begin to explain the style of his early paintings.

In composition, content, and treatment, Velázquez's works of his Seville period belong to a trend in painting that was widespread in the early seventeenth century and continued to expand as the century went on. Some aspects of it may well have been known to him through prints. This movement drew its vital force from the close observation of nature. It represented a sharp turn away from the artificiality of the Mannerist style. Mannerism dominated painting until the last decade of the sixteenth century and continued well into the seventeenth century, when it showed particular strength outside Italy. By Velázquez's time Mannerist painting had become dry, derivative, and outmoded—and that of Seville extremely so.

Caravaggio was the most celebrated exponent of the new naturalism, which spread rapidly from Rome to other art centers. Some of the features that became attached to the name of Caravaggio had in fact been developed in the works of North Italian artists that he undoubtedly was familiar with before he came to Rome, where he had established

4. Justi, Vol. I, p. 121.
5. Trapier, pp. 17 ff.
6. On Herrera, see John S. Thatcher, *Art Bulletin*, 19, 1937, pp. 325–380.

himself by 1592. Interest in chiaroscuro and dramatic light effects
marked the works of Savoldo and other Lombard painters and of the
Bassani in Venice, while compositions grouping two or three half-
length figures close to the picture plane were a Venetian specialty.
These features became hallmarks of the Caravaggist style. Another of
its characteristics, the depiction of physical types taken from the ranks
of ordinary people and not idealized, had its origins in sixteenth-cen-
tury Netherlandish paintings. The Dutch and Flemish forerunners even
exaggerated the commonness of the individuals and activities they
recorded. Their intentions were generally moralizing and satirical.
Lucas van Leyden's woodcut tavern scene of 1519, representing *The
Prodigal Son with Harlots*, set the pattern for many similar scenes that
followed. Such painters as Jan Sanders van Hemessen and Marinus van
Reymerswaele filled what seems to have been a large demand for pic-
tures of ugly men engaged in degrading acts. The grotesqueness of
the figures contributed to the moral point being made—and also to the
fun. Their compositional schemes were reflected in many seventeenth-
century paintings, particularly by Dutch Caravaggists.

The still-life elements that had been secondary in the earlier six-
teenth-century genre pictures later took the foreground, and figural
scenes, usually religious in content, were relegated to small areas of
the background. The best-known examples of this type of Mannerist
inversion are by Pieter Aertsen and his nephew and pupil Joachim
Beuckelaer. In their compositions kitchens or markets overflow with
food that fills the foreground and surrounds, in some cases, life-size
people engaged in the everyday activities appropriate to such a setting.
In the background a miniature biblical scene was inserted. The religious
subjects favored for this purpose were ones that could reasonably be
associated with the kitchen or tavern setting; the Supper at Emmaus,
Christ in the House of Martha and Mary, the Rich Man and the Poor
Lazarus, and scenes from the parable of the Prodigal Son were pre-
ferred. Occasionally these painters omitted the small scriptural scene
and the overt religious meaning it provided for the painting. Their
kitchens and butchers' stalls were presented simply in their own right,
but the implied criticism of concern for worldly pleasures remained.
It was Flemish paintings such as these that inspired the butcher shop
and humble dining scenes that were being painted by Bartolomeo
Passerotti, Vincenzo Campi, and other Italian artists by 1580.[7] A little

7. Charles Sterling, *Still Life Painting*, New York, 1959, p. 42.

later, Passerotti's pupil Annibale Carracci took up such subjects at the
start of his career.[8] The figures in the Italian versions tended to be
coarse to the point of burlesque—a development in keeping with the
northern tradition and rather surprising in Italy. Interest in such subject
matter was in itself subversive of Italian art theory of the period, which
stressed that the highest form of painting was that which dealt with
noble subjects. Yet the painting of ordinary objects and people became
widely popular late in the sixteenth century, and painters in Seville
were among those who took it up.

The strong appeal of naturalism, the desire to work directly from
the model, certainly played a part in this devotion to subjects found
in daily life. Both of the great innovators who made Rome the center
for the renewal of painting at the turn of the seventeenth century
helped to promote the scrutiny of nature as the basis of the art. But
Annibale Carracci in maturity committed himself to the reform of
painting through going back to nature but *correcting what he observed*
in the light of the ideal forms of his great predecessors, especially
Raphael and the classical art of antiquity, while Caravaggio believed
that *nature alone* was sufficient. Even in his religious subjects, Cara-
vaggio depicted ordinary people, without a shred of idealization, in the
guise of sacred figures, and for this he was criticized in some quarters.
Velázquez in his early paintings trod the path that Caravaggio had
very recently cleared, but he explored further, in a direction of his
own. If indeed he had not seen original works by Caravaggio, this may
have helped Velázquez to retain his own individuality from the start.

The earliest surviving work that on the basis of style can firmly
be attributed to Velázquez, *The Meal* (Fig. 1), shows stronger affinities
to Caravaggio than were to appear in any of his other paintings.
Three figures are grouped around a table that is placed centrally in the
foreground, parallel to the picture plane. A knife handle projects over
the near edge of the table, so that its shadow falls on the vertical sur-
face of the tablecloth, perpendicular to the line of the knife
itself. A basket of fruit similarly extending over the near edge of the
table is a striking feature of Caravaggio's *Supper at Emmaus* (London,
National Gallery). By appearing to make an intrusion into the space on
our side of the picture plane, this device causes us to feel that we are
in extremely close proximity to the picture contents. It also stresses the
three-dimensionality of the things represented. The strongly outlined

8. Donald Posner, *Annibale Carracci,* London and New York, 1971, Vol. I,
p. 9 ff.

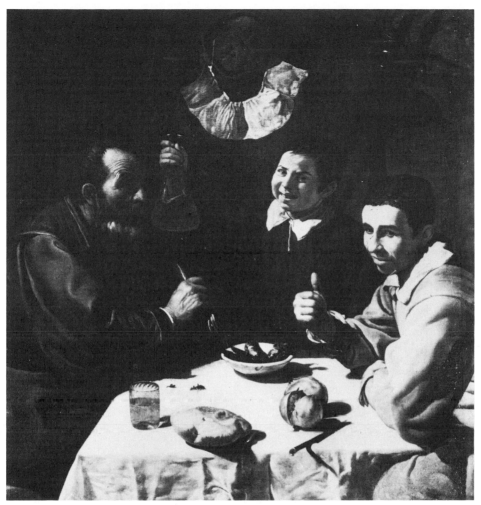

Fig. 1. Velázquez, *The Meal*

contours and intense, well-defined shadows of the objects on the table also contribute to the sense of the solidity of the forms. The space occupied is shallow, as was usual with Caravaggio, and the glances and gestures that the two younger participants direct toward us in Velázquez's scene call to mind such early paintings by Caravaggio as *Bacchus* (Florence, Uffizi) and *The Musicians* (New York, Metropolitan Museum), in which figures directly address the observer. The boy's mischievous smile resembles the expression of Caravaggio's *Cupid Victorious* (Berlin, Dahlem Museum).

The careful organization of a limited number of elements on

the table also reflects Caravaggio's practice. The bread, the glass of wine, the bowl of mussels, the pomegranates (the nearer one of which is split, revealing its luscious seeds, as in Caravaggio's *Bacchus*), and the knife, together form a lozenge-shaped pattern on the brightly lighted table top. The texture, color, and form of each one, and even of the individual mussels, is observed with meticulous care. This is one of the Caravaggesque features that was to remain with the young Velázquez. He generally arranged still-life items with a minimum of overlap, so that each individual object received attention as a complete entity. The strong light from a source high on the left, the deeply shadowed area from which the parts struck by the light emerge, and the depiction of ordinary people in an informal situation are virtually definitive features of Caravaggist painting.

The hat and collar hanging on the wall behind the group, at the upper center, serve to complete the triangular composition formed by the three figures. This, together with the downward-pointed triangle —comprised, on the left, by the right arm of the older man, his wine glass, and the loaf of bread and its shadow, and, on the right, by the left arm of the man in the ochre jerkin and the knife on the table— makes a unified lozenge-shaped composition that fills almost the entire surface of the picture. The individual elements are further organized into parallel relationships, balanced oppositions, and rhythmic patterns. Obviously everything in the picture was carefully thought out and planned. The color scheme is limited mainly to brown, yellowish, and greenish earth tones that were to remain Velázquez's preferred palette for genre paintings during his years in Seville.

The expressions and gestures of the two younger characters in the scene suggest that a specific event is illustrated. The young boy in the center (whose face has been distorted by repaint) lifts the carafe of wine and shows it to us with a roguish grin, while his companion on the right smiles at us slyly as he points to the boy. The old man on the left seems to be unaware of this conspiratorial interplay between his companions and their audience. As his face is turned away from the light, his eyes are in shadow, but it can be seen that he is not looking at what is going on before him; his pupils seem to be turned upward. It seems that he is blind. Only he is eating, and only he has a glass of wine, on the table at his right. Is it possible that a blind old man has sat down to his humble meal, at which he has been joined by a pair of tricksters who do not hesitate to ridicule him as they rob him of his wine? The general tone of the situation, as well as the specific char-

acters and actions, is reminiscent of the picaresque novels that in Veláz-quez's time were vastly popular in Spain. Bitter comments on the brutalizing and demoralizing effects of poverty are hidden behind the amusing adventures and pleasure in successful trickery that provide the obvious appeal of such stories of life on the road.

It has been suggested that in general Velázquez's *bodegones* share some features with this mode of fiction,[9] although no specific parallel between one of his paintings and a literary text has been found. The *pícaro*, the young rogue who wanders and gets on in the world as best he can, the usual protagonist of these novels, might well be repre-sented by Velázquez's boy. The scene calls to mind the earliest picaresque novel, *Lazarillo de Tormes*, which was published in 1554 in three editions, one in Antwerp and the others in the Spanish cities of Burgos and Alcalá de Henares. Young Lázaro's first master, the stingy and brutal blind man from whom he learned his first lessons on how to survive the hardships of life on the road, could well be repre-sented by Velázquez's old man. The painting includes major accessories of tricks the boy played on him, one of which involved a turnip, while in another a jug of wine was the point of contention. The objects on the table also have symbolic meanings. The bread and wine may refer to the Eucharist. The pomegranate is also rich in Christian associa-tions, representing chastity, the Church, and various references to har-monious group life. The knife is a phallic symbol (as is the root vegetable the old man is lifting to his mouth), and mussels also have sexual connotations. Altogether these things suggest the contrast be-tween the spiritual and the animal aspects of human nature.

The Meal, which is the only one of several paintings of groups of three persons around a table that have been attributed to Velázquez that I believe to be by him, is, of all his works, the one that seems in both mood and content to be closest to Caravaggio's paintings and also to picaresque literature. Behind both Caravaggio's paintings and the novels lies a profound concern for the poor and dispossessed.

Probably not long after painting *The Meal,* during his first year or so as an independent master, in 1618, Velázquez dated his *Kitchen Scene with Christ in the House of Martha and Mary* (Fig. 2). Again he limited the main action to a shallow strip in the foreground, in the Caravaggesque way. Placing the two figures at the same depth in space made it impossible for him, at this stage in his development, to coordi-

9. Justi, Vol. I, p. 127; Trapier, p. 63; and Gaya Nuño, 1960.

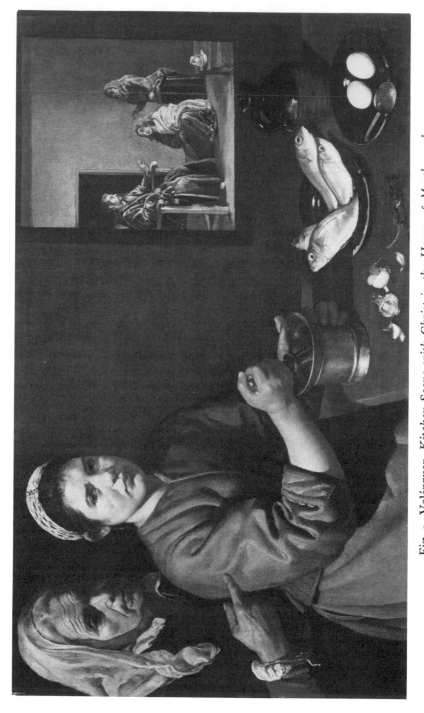

Fig. 2. Velázquez, *Kitchen Scene with Christ in the House of Martha and Mary*

nate their poses satisfactorily. Even more problematic is the relation of the small religious scene to the foreground composition. Various attempts have been made to explain this. Some have thought that Christ in the House of Martha and Mary is to be understood as a painting hanging on the wall. Others regard it as a mirror image.[10] More plausible, I believe, is the interpretation of the little scene as an event taking place in an adjoining room, seen through an aperture in the wall.[11] Though the perspective is faulty, there is no doubt that what borders the little scene is an opening in the thick wall, which cannot have been intended to represent the frame of a mirror or a picture. A 1964 cleaning that removed some misleading repaint has made this quite clear.

It seems likely that Velázquez's unusual, asymmetrical *Kitchen Scene* in horizontal format was inspired by a composition invented by a sixteenth-century Netherlandish painter,[12] and it may be that this source accounts for the lack of clarity that has made this *bodegón* the subject of argument, for the Netherlandish Mannerist compositions often failed to relate the background religious scene in a rational way to the space depicted in the foreground. In some cases they included a group of people much smaller in scale seen through an opening in a wall but on an inexplicably higher level than normal perspective would

10. Trapier (p. 72) saw it as a painting on the wall. López-Rey (1963, pp. 32 f.) argued that it was a mirror. Bartolomé Mestre Fiol ("El 'Espejo referencial' en la pintura de Velázquez: Jesús en casa de Marta y María," *Revista Traza y Baza*, 2, 1973, pp. 15–36) made the ingenious but implausible suggestion that two mirrors across corners of the room were responsible for the mirror image of Christ and the two sisters, reflecting figures of models who were actually in the same room as the two women in the foreground.

11. Beruete, p. 12; Maclaren, p. 122; and Braham, 1965, pp. 362–365. This interpretation may be supported by the similar arrangement of a secondary scene in *The Servant* (Blessington, Ireland, Sir Alfred Beit Collection), which Velázquez presumably painted a year or two later. In this case the small scene (which has been cut at the left) shows Christ with the Pilgrims at Emmaus in a room adjoining that seen in the foreground; both the opening in the wall and the scene it frames are treated quite differently here, however. The main scene of the Beit painting, without the religious insert, appears in the Chicago Art Institute's picture likewise known as *The Servant*. The condition of the Chicago painting makes it extremely difficult to judge.

12. A. L. Mayer long ago related this composition to an engraving by Jacob Matham after Pieter Aertsen, depicting a kitchen replete with fish, with the Supper at Emmaus represented in a small alcove adjoining the back wall. The stagelike alcove is elevated and brightly lighted, and curtains that could close it off have been drawn open. ("Velázquez und die niederländischen Küchenstücke," *Kunstchronik und Kunstmarkt*, N.F., 30, 1918/19, i, pp. 236 f.) The engraving is reproduced in *Varia velazqueña*, Pl. 143a. This seems to have been Matham's own design, apparently a *pastiche* of works by Aertsen (see Bergström, p. 94, n. 9). The drawing by Matham is reproduced by J. Bruyn (*Oud Holland*, 66, 1951, p. 46).

Fig. 3. Jacob Matham, *Kitchen Scene with the Rich Man and Poor Lazarus*, engraving after a painting by Pieter Aertsen

permit, as in Velázquez's *Kitchen Scene.* An engraving by Jacob Matham based on a painting by Pieter Aertsen (Fig. 3) incorporates the background religious scene, The Rich Man and the Poor Lazarus, by placing it in an adjoining room or alcove opening off the foreground room, and it shows other significant similarities with Velázquez's composition. In particular, the motif of the maid in the foreground who looks over her shoulder sullenly at the lascivious peasant who has laid his hand on her right shoulder has much in common with Velázquez's two foreground figures. The plate of fish and the jug in the painting may also reflect the similar details in the print.

If Velázquez indeed had such a print in mind, he greatly simplified the layout and replaced the superabundance in the Flemish kitchen with a still life of relative austerity. Here again, he had some difficulty with the perspective, but the grouping of objects on the table is nevertheless very impressive. Each constituent is accorded full respect. The metallic sheen of the mortar, the contrast of glazed and unglazed earthenware in the jug, the silver fish and white eggs shining against gleaming dark plates, the complex forms of garlic and red pepper—each was studied from life by an observer who clearly delighted in their individual qualities. The reverential reconstitution of the volume and texture of each separate fruit and vegetable in still-life paintings by the Toledan artist

Juan Sánchez Cotán seems to have set a standard for the young Veláz-quez. In contrast, the crudeness with which the little religious scene is painted makes it hard to associate it with the same hand that produced the closely observed foreground elements of the *Kitchen Scene*. Yet the care with which the small scene was integrated into the composition indicates that Velázquez thought of it as an element of the whole, not as an independent statement. The fish on the table in the foreground underline the figure of Christ, whose symbol they are. The little jug on the table in the background plays a part in a diagonal movement, along with the foreground jug, the fish, and the garlic. Christ's lifted hand is echoed by the hand of the old woman, and the diagonal line of the girl's forearm finds a continuation in the receding line of Christ's knees, the arms of his chair, and the heads of his companions. This kind of interweaving was not to be found in the compositions of Aertsen and Beuckelaer.

Christ's visit to the house of Martha (Luke 10, 38–42) is a homily on faith and redemption. Martha, who offered Christ hospitality at her house in Bethany, became the patron saint of cooks and housewives and of those who offer food and shelter to the needy. The sisters Martha and Mary represent the active and the contemplative Christian life, both valued forms of religious devotion.[13] The old woman and the young girl in the foreground of Velázquez's composition cannot represent Mary and Martha. It may be, however, that the old woman stands for spiritual values in contrast with the worldly concerns of the young woman, and thus the foreground scene would parallel the parable's lesson on the efficacy of faith (a point that was stressed by the Jesuits as well as by reformist movements). The foodstuffs on the table suggest the observance of Lent and other times of abstinence.

The old woman and some of the utensils in the *Kitchen Scene* ap-

13. On the meaning of the legend of Saint Martha, see Anna Jameson, *Sacred and Legendary Art*, London, 1890, pp. 381 ff. (First ed., 1848.) On the contrast between the spiritual values represented in the background scene and the material concerns in the foreground in paintings by Aertsen and his circle see B. J. A. Renckens, "Een ikonografische aanvulling op 'Christus bij Martha en Maria' van Pieter Aertsen," *Kunsthistorische Mededelingen van het Rijksbureau voor Kunsthistorische Documentatie*, 4, 1949, pp. 30–32; G. Marlier, *Erasme et la peinture flamand de son temps*, Brussels, 1954, p. 307; P. K. F. Moxey, "Erasmus and the Iconography of Pieter Aertsen's 'Christ in the House of Martha and Mary' in the Boymans-van Beuningen Museum," *Journal of the Warburg and Courtauld Institutes*, 34, 1971, pp. 335–336; J. A. Emmens, "'Eins aber ist nötig'—Zu Inhalt und Bedeutung von Markt—und Küchenstücken des 16. Jahrhunderts," in *Album Amicorum J. G. van Gelder*, The Hague, 1973, pp. 93–101; and C. Brown, "Meaning and Contrast in a Picture from the Circle of Pieter Aertsen," *Burlington Magazine*, 116, 1974, p. 210.

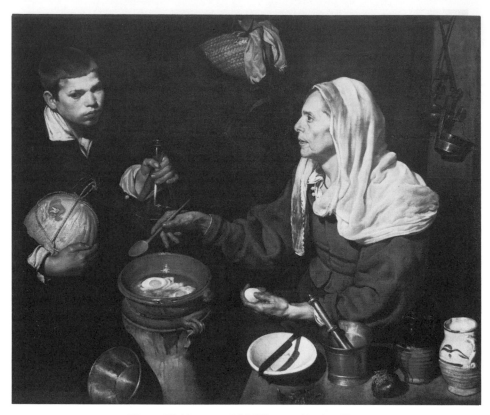

Fig. 4. Velázquez, *Old Woman Frying Eggs*

pear again in a second *bodegón* dated 1618, *Old Woman Frying Eggs* (Fig. 4). This picture shows a considerable advance in the young painter's mastery of his art. The composition is better organized, and the problems with perspective are less disturbing. This picture too had northern antecedents. The subject of the woman cooking is related to traditional representations of the Sense of Taste in series symbolizing the five senses that had long been popular in the Netherlands.[14]

While they clearly represent the ordinary people of Seville, some of the physical types Velázquez selected display an extraordinary dignity of bearing and grace of gesture, like *The Old Woman Frying Eggs*. Even more imposing is *The Waterseller of Seville* of approximately a year later (Fig. 5), to whom the epithet "nature's nobleman" might well apply. The mood established is such that the handing over of the glass

14. Soehner, p. 237. Soehner noted resemblances to Aertsen's painting of *Pancake Bakers* in Rotterdam, Boymans-van Beuningen Museum.

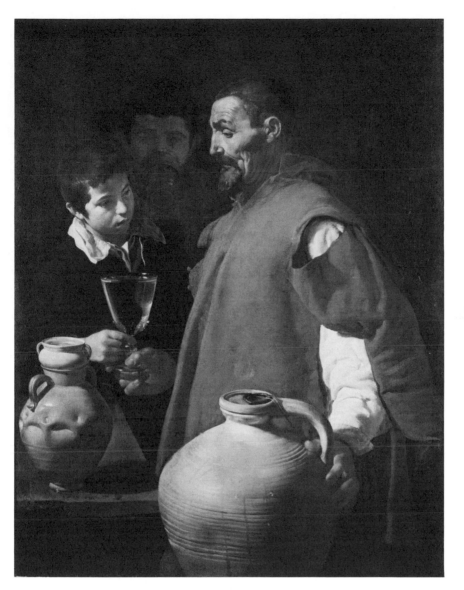

Fig. 5. Velázquez, *The Waterseller of Seville*

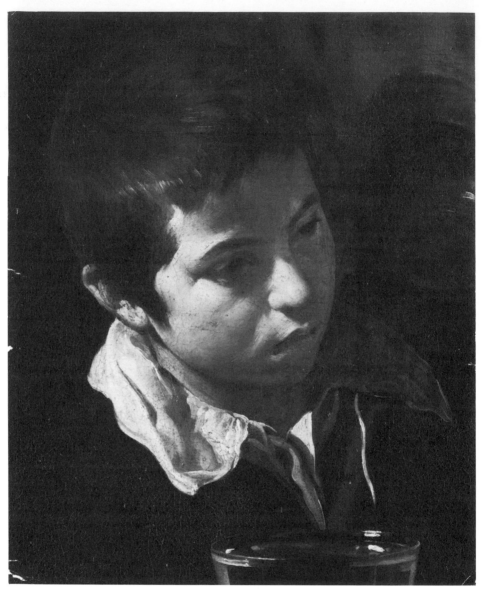

Fig. 6. Velázquez, *The Waterseller of Seville*, detail

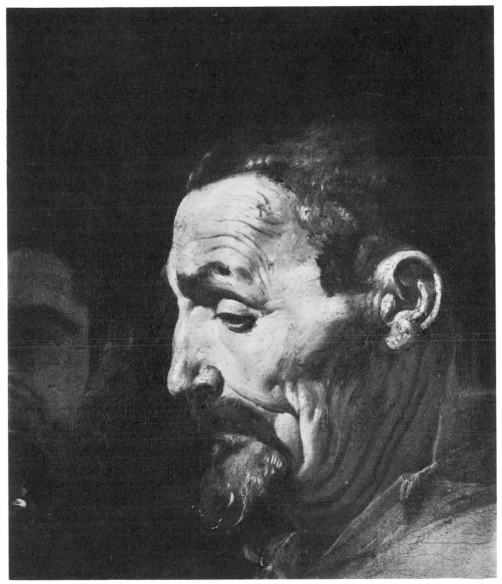
Fig. 7. Velázquez, *The Waterseller of Seville*, detail

of water has a sacramental quality. The water vendors were human oases in hot, dry Seville. They sprinkled water to keep the dust down, besides providing refreshment for the thirsty. For this reason the glass of crystal clear water (with a fig in it, for freshness)[15] has an emotional context of its own. So have the drops of water so carefully depicted as they roll down the side of the jug. They give play, besides, to the artist's interest in the optical distinctness of different materials. The dripping water glistens against the mat finish of the jug, whose striations and irregularities of surface and color contribute to its tactile quality. Pottery, metal, glass, woolen cloth, skin with the marks of age or the smoothness of youth, drops of water—each is characterized with meticulous care. Not only the textures, but the volumes of the objects effectively deny the flat surface of the canvas. The jug in the foreground appears to intrude on the space in which *we* exist. The man seen drinking behind and between the boy and the waterseller is, on the contrary, but a vague, flat form, almost lost in the shadows.

The Waterseller of Seville is the earliest of Velázquez's works of which we know almost the complete history of ownership. It belonged to a fellow Sevillian, Don Juan Fonseca y Figueroa, who died in Madrid on January 15, 1627. Shortly after his death, Velázquez appraised his collection of paintings, among which he listed this picture. Don Gaspar de Bracamonte bought it, after which it went to the brother of King Philip IV, the Cardinal Infante Fernando. It was included in the inventory of the Royal Palace of the Buen Retiro in 1701, and Antonio Palomino noted its location there in his book published in 1724. It was one of the 165 or more paintings taken by Joseph Bonaparte in his flight and captured from him in 1813 at the Battle of Vittoria by British forces under the Duke of Wellington. When the Duke learned that the pictures had been stolen from the Spanish royal collection, he offered to return them, but in 1816 Ferdinand VII of Spain permitted him to keep them as a gift. In this way *The Waterseller* came into the possession of the Wellington Museum, at Apsley House, which was presented to the British nation in 1947.[16]

Similar stylistic features and physical types appear in a religious subject, *The Adoration of the Magi* (Fig. 8), dated 1619, whose kings hardly differ in facial features from the humble people in the *bodegones*. Children who could have posed for the swaddled Christ Child can be met on the streets of Seville today. The Madonna's hands,

15. López-Rey, 1963, p. 163.
16. C. M. Kauffmann, *Paintings at Apsley House*, London, 1965 (unpaged).

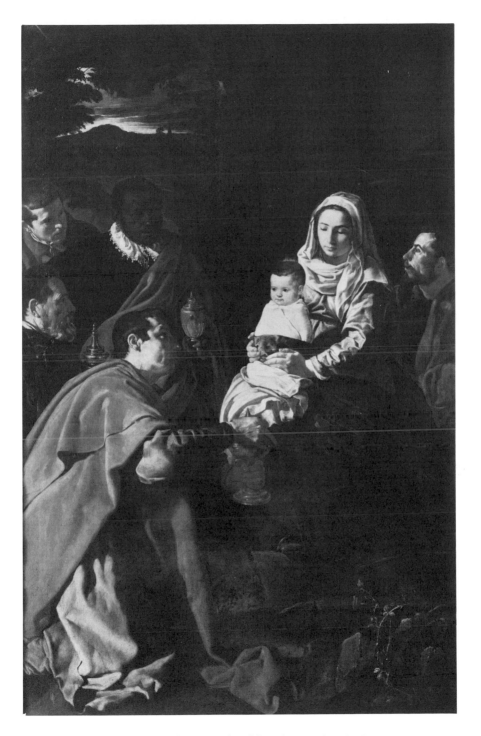

Fig. 8. Velázquez, *The Adoration of the Magi*

like those of the kneeling King in the foreground, seem to have known manual labor. Only the radiance around the head of the Child and the narrow halo above the Madonna remove these very human figures from the ordinary realm of humanity. But there are also other lighting devices that serve to set them apart. The lesser characters in the scene appear against the light, while the extraordinary nature of the Virgin and Child is expressed by the full illumination that makes them glow against the very dark ground to which they are contrasted. The light appears to be not merely unnatural, but supernatural. Yet even this effect is in accord with a naturalistic rationale: Pacheco wrote, in his discussion of the iconography of the Adoration of the Magi: "The star is low and casting lights upon the Child." [17] Minute figures are seen silhouetted against the unearthly light on the distant horizon; we recognize them as the shepherds to whom the angel brought the news of the birth of the Saviour. Also certainly meaningful in this context is the carefully depicted rose bush with long, sharp thorns that is in the right foreground. It foreshadows the Crown of Thorns that evokes the Passion of Christ. The rose is also a symbol of the Madonna. The grave humility of the visitors, the charming effect of human warmth that emanates from the Holy Family, the symbolic elements of setting, light, and foliage—all combine to make this painting a vehicle for the devout sensibility of its creator.

At the same time, in its main features Velázquez's *Adoration of the Magi* adhered faithfully to the official prescription for this subject. Pacheco probably gave Velázquez the instructions he later published in his *Arte de la Pintura*,[18] where he cited Scripture and other authorities to justify various details. The Three Kings, Pacheco says, came upon the Child in the arms of his Mother (not, as in the case of the shepherds, in the manger), a place of great majesty and glory, because God could not place his Son on a better throne. Throwing themselves on the ground, they adored him, kissing the feet of the Child and the hands of the Mother, and, taking out their treasures, they offered him gold, incense, and myrrh. The first and oldest of the Kings, with white hair and beard, was called Melchior; he offered gold, acknowledging the Child as King. The second, a ruddy (or blond), almost beardless young man, offered him incense, avowing him as God. The third, a dark-skinned man of middle age, offered him myrrh, recog-

17. Pacheco, Vol. II, p. 254.
18. Pacheco, Vol. II, pp. 250 ff.

nizing him as mortal man. There are scholars who believe that the glorious Saint Joseph is not to be found in this scene (to show that the Magi did not think he was the natural father of the Christ Child), but, with all due respect for such serious considerations, says Pacheco, we do not disapprove of the presence of Saint Joseph on this occasion. So, he goes on, the picture will be thus: the Most Holy Virgin, seated in the mouth of the cave, very happy and beautiful, is dressed in a girdled rose-colored gown and blue mantle. (Though the Gospel according to Saint Matthew states: *"Et intrantes domum,* it was indeed not a house but a cave in which this mystery took place.") Saint Joseph stands beside her, gazing with admiration. The Christ Child, most beautiful and smiling, is in the arms of his Mother, and, contrary to the common representation, is wrapped in swaddling clothes and blankets, for the weather is cold.[19]

The Three Kings, Pacheco continues, all prostrated on the ground or on their knees, are in grand court dress, the first one kissing the foot of the Child, which has been uncovered from the swaddling clothes. No one is standing, including the servants who are around. The Old King, who is first, has uncovered his head and placed his headdress with his crown, together with his gift, on the ground. The others hold their gifts in their hands, and their headdresses and crowns are on their heads. In the darkness within the cave appear the two animals. The star is low and casting lights upon the Child.

In Velázquez's painting all three of the Kings are bare-headed; all three of them hold their gifts, and no headdresses or crowns are in evidence. The white-bearded Old King has dark hair; he is not kissing the Child's foot, and, indeed, he seems to take second place in the order of obeisances, behind the Young King, who kneels in the foreground. Joseph too appears to be kneeling. The ox and the ass are not to be seen. Architectural elements suggest that the shadowy setting is not a natural cave. Otherwise Velázquez conformed to Pacheco's description. Since Pacheco wrote this long after the picture was painted, it is possible that the differences reflect a change in his conception rather than deviations on the part of Velázquez, who may have followed Pacheco's oral instructions. The composition of the large figures filling the foreground follows an old Spanish tradition based on altar sculpture groups, in which the isocephalic arrangement is combined with a diagonal formed by the kneeling King and the Madonna, who

19. Pacheco, Vol., II, p. 244.

is seated on an elevation.[20] The group of figures appears more crowded than the painter intended it to be, as the canvas has been cut down on both sides and possibly on top and bottom as well.[21] With all its conformity to tradition, Velázquez's *Adoration of the Magi* bears the unmistakable stamp of its time and its particular author. The portrait-like images of the Kings, the Holy Family identified with ordinary humankind, and the carefully observed weight and texture of the forms—all give evidence of the young artist's exploration of the method of naturalism. His use of lighting effects for both unification and expressive purposes, though arbitrary rather than natural, is in accord with modern practice of the time, as developed by Caravaggio and his followers.

Besides his brilliant manipulation of light, Velázquez employed another means to indicate the splendor of the subject: a new richness of color. As compared with the limited gamut in his *bodegones,* the colors in the *Adoration of the Magi* have both greater intensity and variety of hues and more dramatic contrasts of values. The white of the Virgin's shawl and the Child's swaddling cloth are set off by her dress of subtle rose-pink and her dark blue-green cloak and the yellow blanket. The African King standing beside them is a strikingly handsome figure, with his black jacket, white collar, and ruby red cloak and earring. The green robe and golden brown cloak of the foremost King are more elegant versions of the earth colors in the *bodegones,* and the unconventionally youthful Joseph wears a cloak of a harmonizing warm light brown. The lavish quantities of the fabrics indicated and their impressive weight were Velázquez's only other concessions to luxury in a subject which in the hands of other artists usually called for an extravagant display of gold, jewels, and brocades. Even the vessels the Kings offer are relatively modest.

Thus Velázquez brought the Christian miracle down to earth, in the true spirit of the Incarnation as he understood it. Both religious and artistic convictions are expressed in this conception. The supernatural and symbolic elements are brought into accord with the adherence to naturalism that was his guiding principle. Instead of being remote and untouchable, the figures are close to the pious observer, and they are characterized in such a way that he can feel kinship with them.

20. Soehner, p. 235.
21. Trapier (p. 43, Fig. 21) reproduced a lithograph by Cayetano Palmaroli published in 1832, which may show the original composition. As López-Rey (1963, p. 124) pointed out, however, this may represent a reconstruction.

Comparison of the faces in the *Adoration of the Magi* with a portrait painted at about the same time shows that Velázquez's approach to characters in a religious subject did not differ substantially from his cutomary close observation of nature. The *Man Wearing a Ruff* (Fig. 9) could well be the same model who posed for Joseph;[22] in both cases he has been studied with the most objective scrutiny. The portrait provided the opportunity for the depiction of the delicate play of light on the crisp arabesques of the ruff.

Also at this early period in his career, around 1618, Velázquez carried out a commission for a pair of single-figure religious paintings, *The Immaculate Conception* (Fig. 10) and *Saint John Writing the Apocalypse* (Fig. 11). They were apparently made for the Convent of the Shod Carmelites in Madrid, where pictures of their description are known to have been in 1800. The two compositions are neither symmetrical nor well matched to each other in scale, but the paintings are almost precisely the same size, and their subject matter confirms that they are companion pieces. The Virgin of the Immaculate Conception had long been identified with the Woman of the Apocalypse, "clothed with the sun, and the moon under her feet, and upon her head a crown of twelve stars" (Revelation 12, 1). It is the vision of this woman, with the Satanic dragon that confronted her, that Saint John beholds in the sky in Velázquez's painting of *Saint John on the Island of Patmos,* writing the Apocalypse. His painting of the *Inmaculada* likewise shows the Virgin in this guise.[23]

The Immaculate Conception of Mary was not an article of faith at this time; in fact, that Mary was free of sin from her conception was not defined as dogma until 1854. In the early seventeenth century it continued to be the subject of a dispute that had started in the Middle Ages. The idea that Mary was the sole human being exempt from Original Sin is supported neither by Scripture nor by the writings of the Church Fathers. Saint Bernard was the first to make the claim that she had been born free of sin, having been sanctified while in her mother's womb.[24] This conviction found wide support, conforming as it did with

22. Allende-Salazar (p. 273, note on Fig. 12) suggested that this might be a portrait of Pacheco, but there is no basis for this supposition.
23. Pacheco (Vol. II, pp. 209 f.) stipulated that the *Inmaculada* should be portrayed as she appeared in the vision of Saint John the Evangelist.
24. Yrjö Hirn, *The Sacred Shrine*, Boston, 1957, pp. 218 ff. and p. 512, n. 10. (First ed., 1909.) See also A. M. Lépicier, *L'Immaculée Conception dans l'Art et l'Iconographie*, Spa, 1956, especially pp. 128 ff.

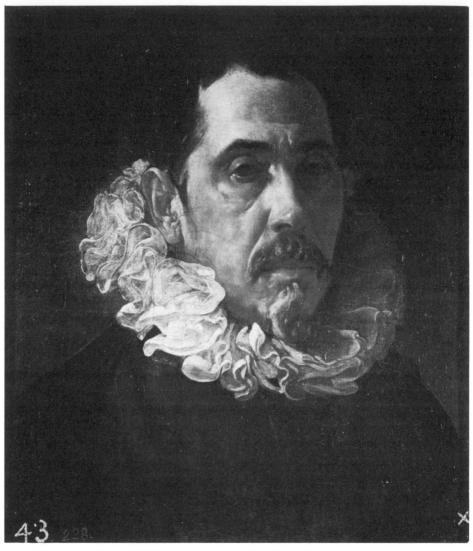

Fig. 9. Velázquez, *Portrait of a Man Wearing a Ruff*

the essence of the cult of Mary, the belief in her unique purity and virtue. Bernard specifically opposed the notion that she had been purified before conception, on the grounds that she did not yet exist before she was conceived. Conception itself, he pointed out, was by its nature sinful. Therefore her purification would have had to take place *in utero*. Thomas Aquinas and other theologians adopted this view.

An opposition party formed, however, in favor of the proposition that Original Sin was not transmitted physically from parents to offspring, but resided in the soul. Thus God could have exempted Mary in advance, making her immaculate at the moment of her animation, that is, the instant when the soul joined the fetus. Duns Scotus played a prominent part in fostering this view. The humble worshipers of the Madonna hardly needed this confirmation of their own conviction. Theologians, however, hotly debated the issue. The Dominicans upheld the position of their own Thomas Aquinas, while the Franciscans supported the argument of their Duns Scotus. Tracts were written, adding fuel to the fire. A fourteenth-century Dominican, Franciscus de Retza, for instance, invoked the most improbable parallels in support of the view that Mary was not conceived without sin, but was sanctified *in utero*. His polemic became available for wide circulation when it was published with woodcut illustrations in 1471, under the title *Defensorium inviolatae virginitatis Marie*, and in numerous other editions before the end of the fifteenth century. Beginning in the late fifteenth century, paintings and sculptures also played a part in the propaganda.[25] During the Counter-Reformation the Immaculate Conception was aggressively promoted, to controvert Luther's strong stand against it.

Spain had a long tradition of devotion to the Immaculate Conception, and violent feelings could be aroused by the arguments about it. On the day of the Feast of Mary's Birth, September 8, 1613, a Dominican monk in Seville spoke in favor of the opinion of his Order on this subject.[26] The populace was roused to anger, eagerly promoted by the clergy. Days of protest followed, with a procession, manifestations in the various churches, and, finally, a delegation sent to the King to persuade him to petition the Pope for definition of the dogma of the Immaculate Conception of the Blessed Virgin Mary. A decree of Paul

25. See, for instance, Montgomery Carmichael, *Francia's Masterpiece*, New York, 1909.
26. Justi, Vol. I, p. 142. López-Rey (1968, p. 31, n. 2) refers to treatises on this subject published in Seville in 1615 and 1616.

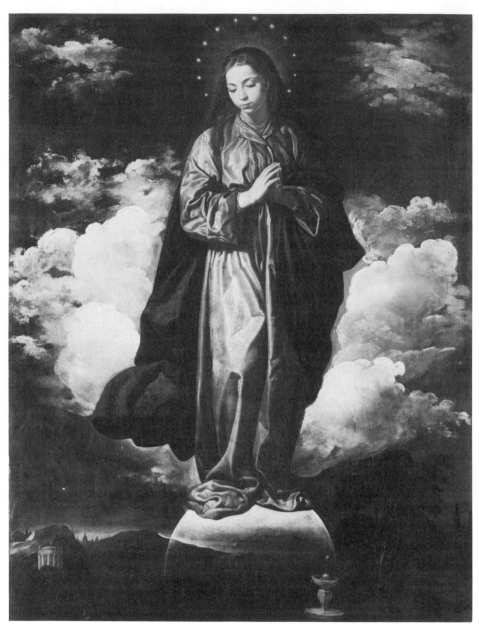

Fig. 10. Velázquez, *The Immaculate Conception*

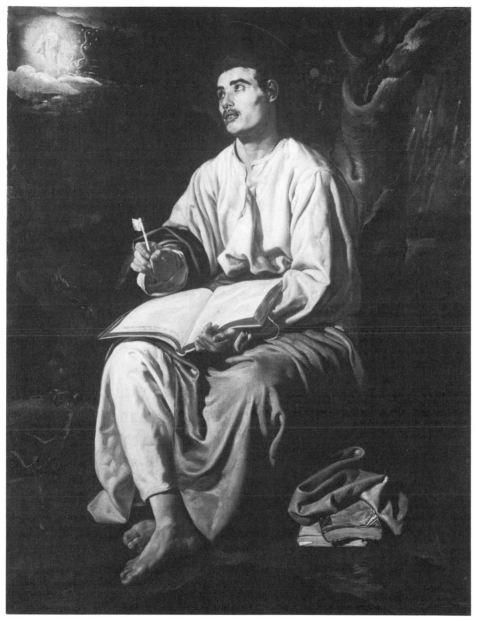

Fig. 11. Velázquez, *Saint John the Evangelist on the Island of Patmos*

V promulgated in 1617 did not grant the request, but gave limited support to the movement, forbidding public denial that the Virgin Mary was conceived free of Original Sin. The news of this decree aroused great enthusiasm in Seville.[27]

In this climate warmed by learned polemics and fervid zeal, the Immaculate Conception was a popular subject for art, and it demanded traditional treatment. Besides its New Testament associations, to the Revelation of Saint John, the image of the Immaculate Conception had long been related to the Old Testament. The verse from the Song of Solomon (4, 7), "Tota pulchra es, amica mea, et macula non est in te," was from medieval times interpreted as a prefiguration of the Immaculate Conception of Mary. The metaphors of the Song of Songs and other Old Testament sources became part of the Litanies of the Virgin of Loreto, which in their present form date from 1576, and these songs of praise were frequently connected with the Immaculate Conception in art and literature. A woodcut in a Book of Hours published by Thielmann Kerver in Paris in 1511 shows the Virgin surrounded by the symbols of her attributes, with inscribed scrolls quoting the Old Testament phrases associated with each one. El Greco was among Velázquez's Spanish forerunners whose interpretation of the Immaculate Conception included some of these symbols scattered in a landscape below the figure of the Virgin. A similar composition that may have been Velázquez's immediate model was painted toward the end of the sixteenth century by Giuseppe Cesari, known as Cavaliere d'Arpino.[28] Such a predecessor might have suggested features of the pose of Velázquez's *Inmaculada* as well as the symbolic details he placed in his beautiful nocturnal landscape. In the right foreground is "a fountain sealed," a token of virginity. At the lower left is a temple, which symbolizes God's dwelling place, a metaphor for the Virgin's body. The ship sailing on the sea is associated with Mary as *Stella Maris*, Star of the Sea. Among the trees, the palm and the cedar also are invoked in praise of her.

The monumental and dignified figure of the *Inmaculada* that

27. Anna Jameson, *Legends of the Madonna*, London, 1909, p. 45. Pacheco wrote a pamphlet on the controversy, which was published in 1620, and painted three pictures of the *Inmaculada*, two dated 1621 and one dated 1624; see Priscilla Muller, *Francisco Pacheco, his Development as a Painter*, Master's Thesis, New York University, Sept., 1959, pp. 35 ff. In 1622 Gregory XV prohibited in private acts as well any denial of the Immaculate Conception of Mary.
28. Madrid, Academia de Bellas Artes de San Fernando.

Velázquez created harks back to statues by the famous Seville school of woodcarvers, among whom Juan Martínez Montañés was the acknowledged master.[29] (Some sixteen years later Velázquez was to paint a portrait of this distinguished sculptor [Fig. 43].) Velázquez might easily have had direct contact with him and with his sculpture at this early period, as Pacheco frequently served as his polychromer. Velázquez's interpretation is unique in that he does not idealize; his young model looks like a girl of the people. She is shown descending to earth, with her downcast eyes looking toward her destination; this is one of the definitive features of the traditional Immaculate Conception pose, though it is not always adhered to. This pose implies the modesty and humility that, along with purity, are essential traits of the Virgin Mary, characteristics that are endlessly praised in her cult.

Velázquez's *Saint John on Patmos*, like his Virgin of the Immaculate Conception, reflects an iconographic type well known in the form of polychromed wood sculptures made in Seville. He sits under a tree, gazing upward with rapt attention, with his pen lifted above the open book that rests on his knees. The eagle, which is the attribute of Saint John the Evangelist, stands at his side, with head turned toward the book. The very large, light surface of the open pages places unusual emphasis on the book, in which Saint John is recording his Revelation. His importance as author of the Gospel is alluded to by the presence of books on the ground at his feet. Unlike the sculptured models that it resembles, the painting includes an image of the vision that the saint is experiencing; this had been a usual feature of prints and paintings that closely resemble Velázquez's composition.[30] Such a combination of the immaterial with an earthly event was common in Baroque painting, but it is rare from the hand of Velázquez.[31] His scene in the

29. A long series of such polychromed wood figures had been created in Seville, among them one by Jerónimo Hernández *c.* 1570, one by Gaspar Nuñez Delgado in 1587, and, during the first third of the seventeenth century, several by Martínez Montañés.

30. Justi (Vol. I, p. 144) proposed an engraving by Johan Sadeler after a painting by Maerten de Vos as Velázquez's model. An altarpiece wing painted by Pieter Aertsen in 1546 (Antwerp, Musée Royal des Beaux-Arts) and a small painting by Pieter Lastman dated 1613 (Rotterdam, Boymans-van Beuningen Museum) present very similar iconography. The Lastman painting in particular is so close to Velázquez's in numerous details as well as in overall composition that the existence of a common prototype must be assumed.

31. Earth and Heaven meet in the painting *The Virgin Bestowing the Chasuble on St. Ildefonso* (Seville, Archbishop's Palace) that has been attributed to Velázquez since the eighteenth century; but this picture is in such poor condition that it cannot be properly judged. Its composition has nothing in common with any of his known works, and its quality seems doubtful.

heavens is small and insubstantial, hinting at an inner experience, in contrast with the solid impression of the figure of Saint John.

In physical type Saint John is unmistakably an ordinary man. The model who posed for him also appears in Velázquez's *bodegones*. Compared with the firm solidity of the figure, the outdoor setting is unconvincing, doubtless because the artist was at his best in painting directly from life in his studio. Very noticeable on this canvas are areas of free and apparently meaningless brushstrokes at the upper right and lower left. Similar random streaks of paint are also to be seen in a number of other paintings by Velázquez. He apparently was in the habit of cleaning paint off his brush by stroking it in this way onto the as yet unpainted parts of the picture, so that the stripes show through in the background that was thinly painted after the completion of the figure. By this practice Velázquez called attention to the process of painting. Whether he consciously aimed at this effect or not, he thereby established a contrast between art and the physical world in which it takes its peculiar place. The distance thus implied between the observer and the depiction is an essential element of the aesthetic response, in which art is perceived as a reality of a different kind.

In his reliance on the close observation of persons and objects, Velázquez would seem to have turned his back on the painting style of his teacher, Pacheco, and his generation of Seville painters. Yet even in this apparently daring deviation from the accepted mode, he may not have been stepping out of line at all. For, as we have noted, there was an international movement in this direction at the time. The other three outstanding Spanish painters of Velázquez's generation—all born within ten years—Ribera, Zurbarán, and Alonso Cano, were also taking part in it. Even Pacheco, at least at that later date when he set down his thoughts in writing, recommended adherence to nature. After praising Caravaggio and Ribera for the lifelikeness of their pictures, he went on to say: "My son-in-law, who is taking the same path, also distinguishes himself from other painters, by keeping nature always before him." [32] By the time Pacheco wrote this, it is true, his son-in-law's merits had already been highly honored in Madrid, which might have induced Pacheco to take a more favorable view of Velázquez's inelegant early paintings. He even wrote specifically in favor of *bodegones*. The way in which he did this indicates that he intended

32. Pacheco, Vol. II, p. 13.

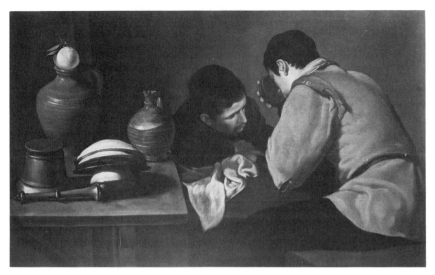

Fig. 12. Velázquez, *Two Young Men at a Humble Table*

to take issue with the detractors of such pictures, among whom the best known is Vincencio Carducho.

Well then, should *bodegones* not be esteemed? Indeed they should, if they are painted as my son-in-law paints them, for in this field he has risen beyond all others, and they are worthy of the greatest respect. With these beginnings and with portraits he reached the true imitation of nature and inspired many with his powerful example. . . . When the spirit, drawing, and coloring of the figures makes them appear alive, and when they are equal to the other objects from nature that are together with them in these pictures, they bring the highest honor to the artist.[32a]

Two Young Men at a Humble Table (Fig. 12), which Velázquez painted in about 1622, exemplifies particularly well Pacheco's point about the equal importance of figures and still-life elements in *bodegones*. Approximately equal space is devoted to the two men on the right side and the still life on the left, with the two halves separated by a compositional diagonal extending from the upper left corner to the lower right. This is countered by another diagonal, from upper right to lower left. The poses of the men imply an equilibrium of forces, so that the figures appear to be as fixed in their places as the objects on the table. The mortar and pestle and small jug seen in earlier *bodegones* are here joined by a group of bowls and a pottery water

32a. Pacheco, Vol. II, p. 137.

jug with an orange in its mouth. The brilliant orange with its glossy green leaves is the coloristic high point of the picture. The orange is like a banner of the city of Seville, for the citrus fruit of southern Spain was a chief article of trade in the port city. Though this painting is not in the best of condition—abrasion and restoration have altered the faces of the men and other areas it provides precious evidence of the compositional power and emotional impact that Velázquez achieved in his *bodegones*. If this is an imitation of nature, as Pacheco would have it, it is an artfully arranged and artistically calculated nature. It conveys a mood of intense introspection.

In contrast to the playful or satirical note struck by many of the depictions of everyday life among the poor by Netherlandish and Italian artists, Velázquez's best and most characteristic *bodegones* evoke a profound emotional resonance. The color harmony and elegance of composition of these paintings contribute to this effect no less than the dignity of both the figures and the objects selected. In works of this kind the young Velázquez was already making a unique contribution to the art of painting. It would be interesting to know about the discerning customers who bought these works in the first quarter of the seventeenth century and, especially, what were the grounds for their appreciation. The skillful mirroring of nature was what impressed Pacheco, and Palomino in the eighteenth century also praised Velázquez's "perfect imitation of nature" in these paintings.[33] Palomino recorded that *The Waterseller* was so famous that it had been kept until his day in the palace of the Buen Retiro, one of the royal residences in Madrid. He described a number of *hosterías* (tavern scenes) by Velázquez, some of which are unknown to us. His reference to a painting of "two poor men eating at a humble little table on which there are different earthenware vessels, oranges, bread, and other things, all observed with singular care" has by some authors been identified with the Apsley House painting (Fig. 12). They may be correct in assuming that Palomino simply erred in some details in describing this picture, as some also believe was the case in his description that differs in some striking details from *The Waterseller of Seville*. But it is at least equally plausible to suppose that there were in fact pictures that conformed with Palomino's descriptions, along with the other lost paintings from this period of Velázquez's activity. However this may be, it is clear that there was a market for paintings that raised to an elevated sphere a type of subject matter that would appear to be alien

33. Palomino, pp. 892 f.

to the interests of those who could afford to be patrons of art in Spain at that time. Yet, as is well known, Spanish naturalistic literature prepared the way for paintings dealing with scenes and objects from life as experienced by ordinary people. Interest in such subjects was widespread, as shown by the popularity of the novels and plays published and performed in Spain in the sixteenth and seventeenth centuries.

The emotional tone, the cast of characters, and the event depicted in Velázquez's earliest painting that has come down to us, *The Meal* in Leningrad, would make it a suitable illustration for an episode in a picaresque novel. The boy featured in the center of the composition could well be a *pícaro*, subject to the trials and temptations of the wandering life of the uprooted poor. The youths as well as the old women and aging men in his other *bodegones* also resemble typical characters in the novels. The first concern of the youth on the road, faced by dilemmas of good and evil, was to provide himself with the food and drink necessary to sustain life. This essential quest is what Velázquez deals with. Except in the first painting, he approaches it with suitable gravity, as if the understanding had come to him that beneath the amusing surface of such stories lay the deepest human concerns. Without exception, the characters do not meet one another's eyes; there is a strong sense of loneliness, existential isolation. The continuity of life implied by the presence of members of different generations was another persistent constituent of these paintings. The intense emotional impact of the pictures stems from the artist's profound intuitions about the human condition that they embody. This, in the last analysis, is what sets Velázquez's *bodegones* apart from paintings by other artists.

It is not known how long Velázquez continued to paint *bodegones*, though we know of none today that could have originated later than his Seville period. Among eighteen pictures for which he was paid in 1634, long after he had settled in Madrid, two were described as *bodegones*. There is no certainty, however, that all of these pictures had been painted by him, nor is it unlikely that he could have taken with him from Seville *bodegones* that he hoped to sell in Madrid. During the rest of his career, court commissions dominated his life. He may therefore have had to renounce the personal as well as the artistic interests so richly revealed in the *bodegones*. The underlying moral of the stories that he might have had in mind, however, may have played a part in encouraging Velázquez to make his way in the world and surmount the difficulties of his career. To persevere and prevail became his life pattern.

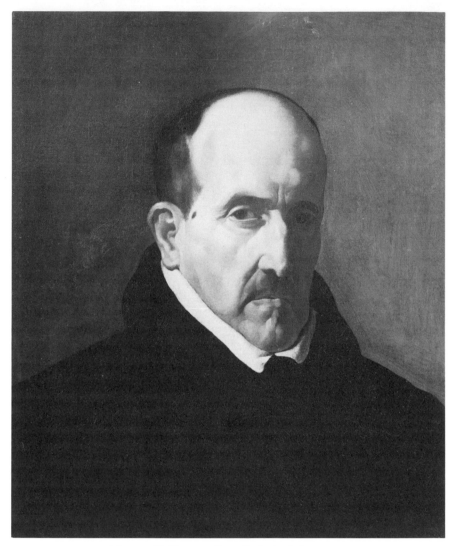

Fig. 13. Velázquez, *Don Luís de Góngora*

2. Art and Patronage in Madrid

The prospects of an ambitious painter from Seville improved in 1621, with the accession of sixteen-year-old Philip IV. The new King appointed as his chief minister his mentor, who is known to history by the title he was later given, el Conde-Duque de Olivares. The Count-Duke was to keep a firm hold on the reins of government for twenty-two years. A member of the powerful Guzmán family from Andalusia, Olivares brought into the Court circle friends from Seville who were familiar with Velázquez's work. Olivares himself may have become acquainted with Velázquez's paintings during visits to Seville. He had certainly been in contact with Pacheco, who had painted his portrait in 1610.[34] In April 1622, Velázquez made his first trip to Madrid, motivated, according to Pacheco,[35] by a wish to see El Escorial. No doubt he would have been attracted by the collection of art housed there—inventories indicate that there were eleven hundred and fifty paintings in the monastery at the time of Philip II—as well as by the famous architectural complex that constituted an unparalleled monument to the Hapsburg rulers of Spain. While in Madrid, we know again from Pacheco, he tried to arrange to paint portraits of the King and Queen, but he was not granted this opportunity to show his mettle in royal portraiture. His fame did profit, however, from the portrait he painted of the celebrated poet *Don Luís de Góngora* (Fig. 13). Departing from the gradual type of modeling that characterized his earlier figures, Velázquez defined the solidity of Góngora's head in a new way, through a pattern of planes. (Compare Figs. 13 and 7.) The result is a marked emphasis on bony structure. Pacheco reported that Velázquez painted this portrait at his request. It was undoubtedly intended to serve as a model for a print to be included in Pacheco's book of portraits. Radiographs of the Góngora portrait reveal that the head of the poet was originally circled by a laurel wreath; this is a feature that is also seen in eight portrait prints made for Pacheco's never-completed book.[36]

If Velázquez suffered disappointment at his failure to gain a royal portrait commission during his first visit to Madrid, it was allayed when in the spring of 1623 Olivares commanded him to come to the

34. Lopez-Rey, 1968, p. 35.
35. Pacheco, Vol. I, p. 156.
36. Trapier, p. 84.

Court. Once in Madrid, he again demonstrated his skill as a portraitist in his painting of his host there, the Sevillian Don Juan de Fonseca, Chaplain to the King, who was instrumental in introducing him to Court circles. The King and his closest associates were so favorably impressed by this portrait that without further delay Velázquez was commanded to portray the sovereign himself. In August 1623, he finished his first portrait of Philip IV, who was to be his chief model for the rest of his life. This painting, now lost,[37] was so satisfactory that Olivares ordered that thereafter no other painter was to portray the King. Also lost is a sketch Velázquez painted at this time of Charles, Prince of Wales (the future Charles I of England), who was a guest at the palace in Madrid during the ultimately unsuccessful negotiations concerning his proposed marriage to the sister of Philip IV, the Infanta María. The Prince paid Velázquez one hundred escudos "and honored him with exceptional demonstrations of affection." [38]

Having thus established his credentials, Velázquez officially entered the King's service on October 6, 1623. In addition to a salary, he was to be paid for each painting. He was not long in arriving at a formula for portraits of the King that underwent little change through the years. The resulting image does not immediately strike one as idealized, as it is so far from a classical canon of facial proportions. Yet it does make the best of Philip's heavy Hapsburg features, without going so far as to disguise him. A number of times he portrayed the King with his head in the same pose, which suggests that rather than painting him from life each time he merely repeated himself, insofar as the King's features were concerned, and varied the portraits by attaching the standard head to different poses of the body and arms, for which another sitter or a lay figure might have served as model. In his royal portraits Velázquez adhered to conventional patterns of official portraiture that had been established in the sixteenth century. Titian was the master of this form, and he had been faithfully followed by Anthonis Mor and Alonso Sánchez Coello and other Court portraitists of the Hapsburgs in Spain. It was in keeping with this tradition that he minimized the flaws in Philip's physiog-

37. According to López-Rey (1963, pp. 37 ff.), X-rays reveal the portrait of 1623 beneath the surface of the portrait of the King that Velázquez painted about three years later (our Fig. 15).

38. Palomino, p. 897. For a rare exception to the chorus of praise, see Harris, 1970. The envious Vincencio Carducho, whom he replaced as favorite Court painter, also criticized naturalism, alluding to Velázquez's works without mentioning his name. These passages can be read in *Varia velazqueña*, Vol. II, pp. 51 f.

Fig. 14. Velázquez, *Philip IV in Armor*

nomy and always gave him the appearance of calm dignity. Philip's impassivity was, in fact, famous, even in the setting of this rigid Court, where expressions of emotion were generally avoided. Letters of the time relate that his face was immobile, like a statue. He rarely smiled, never laughed. Even when he received foreign ambassadors, only his lips moved. The regal image that he cultivated, devoid of emotional expression, was reflected in his portraits.

Despite the stereotyped treatment of the King's face, the royal portraits display Velázquez's inventiveness and a wide range of his

Fig. 15. Velázquez, *Philip IV*, standing

painterly skills. The bust-length portrait of *Philip IV in Armor* (Fig. 14), painted around the middle of the 1620s, makes this clear. Vivid reflections on the gold-damascened black armor, contrasting with the soft gleam of the pinkish-crimson silk sash, give the portrait extraordinary artistic vitality. In striking contrast is the somber dignity of the standing full-length *Philip IV* (Fig. 15), also painted about 1626, with its harmony of blacks and grays. The flowing cloak, which was originally even wider, as pentimenti indicate, adds mass to the tall figure. The aristocratic Spanish *golilla* (a type of collar made of shaped cardboard covered with white or gray silk that had recently been made mandatory by a sumptuary decree designed to eliminate the elaborate and hard-to-maintain ruffs that the *golilla* was to supplant) frames Philip's face and, along with the matching cuffs, mediates between the dark costume and the lighter hues of head and hands. Only the pendant

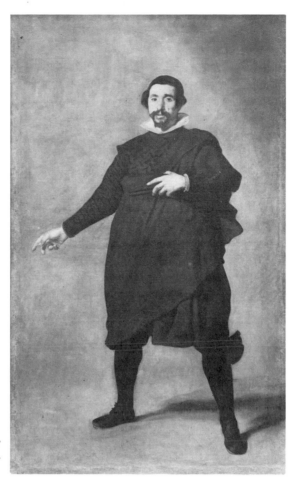

Fig. 16. Velázquez, *The Buffoon Pablo de Valladolid*

of the noble Order of the Golden Fleece, hanging from a black ribbon, breaks the darkness of the clothing. A stronger note of contrast is provided by a paper—totally blank—that the King holds in his right hand. He rests his left hand on a red-covered table which holds his high-crowned black hat. The perspective recession of the table serves to establish the spatial depth represented. The table and the shadow cast by the King's figure are, in fact, the only indications of depth. There is no floor line or any other clue to the three-dimensionality of the setting. Velázquez's daring renunciation of the indications of environment that painters traditionally have used as aids in giving the flat image on the canvas the appearance of solidity has aroused much admiration.

He went even farther in this direction in the portrait of *The Buffoon Pablo de Valladolid* (Fig. 16). Here even the table is omitted. The person depicted exists as a form in space only by virtue of the

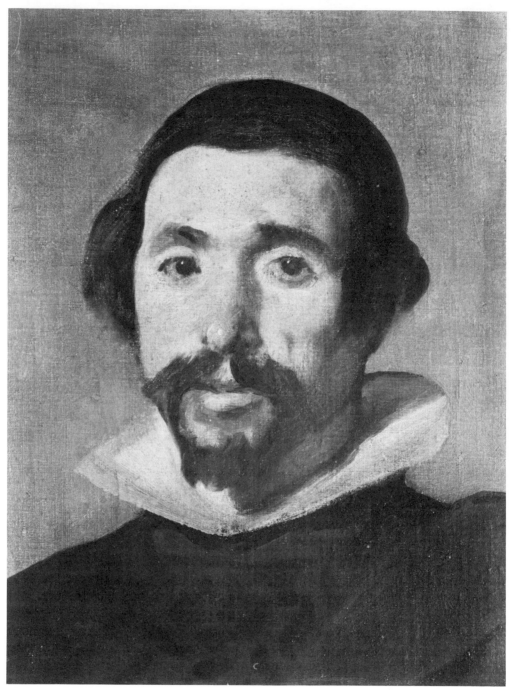

Fig. 17. Velázquez, *The Buffoon Pablo de Valladolid*, detail

shadow he casts on the ground and the painted "air" around him. There is not so much as a floor line, a horizon, a piece of furniture, or an indication of architecture to help to convince us that this image refers to a solid object in a three-dimensional world. Nevertheless, we are convinced of the volume of the figure, and its occupation of space seems indubitable. As Manet wrote in Madrid in 1865: "The background disappears; air surrounds the man, dressed all in black, and alive." [39] Like the standing King, Pablo wears black with a gray-ish *golilla* and cuffs. His figure stands out in strong relief against the ochre background. His stance, with feet widespread, making a rhetorical gesture, in itself gives an effective impression of the figure's extension in depth, into which his right foot and right hand lead our eyes. With his ruddy skin and dark eyes and hair, and his lively glance that meets ours, he is a vivid presence (Fig. 17). The clear-cut contours and firm modeling relate this painting to Velázquez's style of the latter 1620s. Because Pablo is known to have entered the King's service in 1633, it has been assumed by some scholars that this portrait could have been made no earlier than that year. There is no reason to exclude the possibility, however, that he might have been in the employ of some other member of the Court before that date, or that Velázquez might otherwise have been commissioned to paint him. In any case, the stylistic evidence points to an earlier date, perhaps as much as five years earlier.

Velázquez's radical simplification of the background in a full-length, standing portrait was one of the features of his style that impressed, besides Manet, many later artists and connoisseurs. They undoubtedly would have been surprised had it been pointed out that the striking portrait of Pablo de Valladolid had been foreshadowed by a sixteenth-century forerunner. The Utrecht painter Anthonis Mor, known in Spain as Antonio Moro, had painted a portrait of *Pejeron, the Buffoon of the Count of Benavente and the Duke of Alba*, in which the full-length, standing figure is seen, like Pablo, against a uniform background (Fig. 18). This precedent for the lack of distinction between floor and wall was undoubtedly known to Velázquez, as Moro's painting was inventoried in the royal collections from 1600 on. Antonio Moro was a leading portraitist of his generation, but a comparison of these two portraits of buffoons makes it obvious that

39. Letter to Fantin-Latour quoted in R. Goldwater and M. Treves, *Artists on Art*, New York, 1958, p. 303. It should be noted, however, that two slight parallel horizontal black strokes just to the right of Pablo's left leg may indicate an impulse toward a floor line that was aborted.

the seventeenth-century artist was markedly more successful in plac-
ing his figure convincingly in space than his predecessor had been.
Not only the pose of Velázquez's figure, which is typically Baroque in
its diagonal forces, but also the size of the figure in relation to the
picture area and the subtle variations in the color and values of the
background contribute to the sense of air and space in his dramatic
composition.

The contrasts between the two early portraits of the King by
Velázquez (Figs. 14 and 15) and his portrait of Pablo de Valladolid
and other sitters of this period shows how bland Philip appears in con-
trast with the lively interpretations that Velázquez was making in his
portrayals of other individuals, whether courtiers or less aristocratic
figures. The royal portraits represented not just an individual, but an

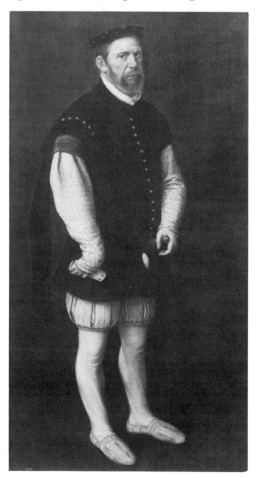

Fig. 18. Antonio Moro, *The
Buffoon Pejeron*

institution. Giving the appearance of the sovereign with minimal variations could contribute to the sense of continuity that the monarchy required. This consideration might have encouraged the repetition of a standard image of Philip IV. Or the reason for the unchanging pose of the King's head might have been simply that the royal patron and his portraitist agreed that this was the single most advantageous view of his physiognomy, and it should therefore be preferred to all others. It might even have been the King's wish that he appear in his portraits with the carefully arranged hair and the invariably white forehead, pink cheeks and pinker nose, and bright red lips with which Velázquez handed him down to posterity. And repetition tends to dull the eye and inhibit the hand of even the most gifted of painters. At the same time, the possibility must be taken into account that if, alongside the incisive Góngora, for instance, Philip looked vapid, a portraitist who prided himself on verisimilitude could not have entirely avoided reporting on what he saw. It is not surprising that the King and Court were nevertheless pleased with Velázquez's portraits, however, for they lent Philip dignity and a degree of facial comeliness that improved on nature. Besides, it was recognized that these pictures were admirable as works of art. As we have seen, these portraits of the 1620s were already richly painterly, though they were marked by sharper contours and more explicit details than was to be the case in Velázquez's later style. The finely modulated neutral backgrounds were thoroughly effective in giving a sense of air and space surrounding the figure.

Portraits of the autocrat Olivares give dramatic evidence of Velázquez's forthright response to a powerful personality. Far from glossing over the defects of his features, Velázquez shows them in all their coarseness. Several versions exist of the full-length standing portrait of him made in the middle 1620s. The *Portrait of the Count-Duke of Olivares* in the collection of the Hispanic Society of America (Fig. 19) shows him as Master of the Horse, holding a long whip in his right hand, an attribute that surely also says something about his driving force. His heavy figure casts a dense shadow on the floor. He is clothed in dark gray, verging on black, and on his doublet and breeches touches of lighter gray indicate a pattern. He wears an ostentatiously heavy gold chain, the gold key of the King's chamber, a gold ribbon, and, on both doublet and cloak, the green cross of the Order of Alcántara. The table cover is deep red. The red drapery at the upper right is certainly a later addition, as is the inscription "el Conde Duque" at the lower

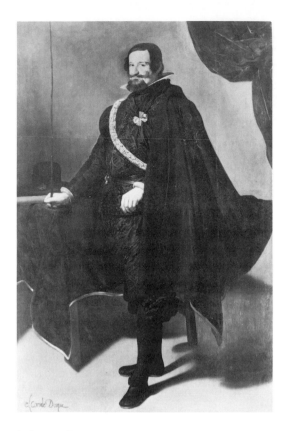

Fig. 19. Velázquez, *The Count-Duke of Olivares*

left.[40] Olivares received this title in 1626. The pose, with its thrust into space, the turn of the head and intensity of the gaze, and the dominance of the space by the figure—all contribute to the impact of this forceful portrait. Though it is in far from perfect condition, with extensive repainted areas, the painting conveys an unforgettable impression of the man who embodied the power behind the throne of the weak King.

The *Portrait of the Infante Don Carlos* (Fig. 20), the younger brother of Philip IV, is similar in style to the Olivares portrait. Both have firm contours combined with a rather free and painterly approach to details of costume and ornament. A similar cast shadow implies the three-dimensionality of the figure. But the pose of the Infante is markedly less dynamic than that of the Conde-Duque. Don Carlos is seen more frontally, with his feet wide apart, a glove (still an aristocratic accessory in the seventeenth century) dangling from his right hand, his hat clutched in his left. Velázquez's conception of him was

40. Trapier (p. 105) interpreted the inscription at the bottom center as "Año 1625," which López-Rey (1963, p. 296) repeated without comment. This inscription is in fact probably not a date but an inventory number.

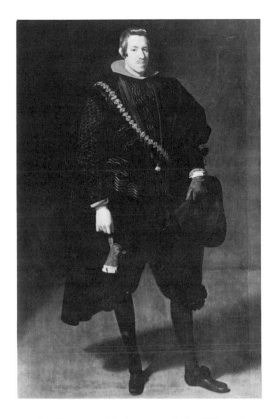

Fig. 20. Velázquez, *The Infante Don Carlos*

much closer to his image of the King than to that of Olivares, in whom he recognized a formidable concentration of energy. It seems likely that the portrait of Don Carlos was painted during the visit of Rubens to the Court in Madrid from September 1628 to the end of April 1629, for the pose of the Infante is the same as that of Philip IV in the portrait by Rubens now in Genoa (Durazzo-Giustiniani Collection).[41]

In the latter years of the 1620s, probably by about 1628, Velázquez produced an important painting on a religious theme, *Christ After the Flagellation Contemplated by the Christian Soul* (Fig. 21). The nude Christ is seated on the floor in the center of the composition, with his wrists still tied to the column to which he was bound by the tormentors who flogged him before the Crucifixion. His sagging body and anguished expression, as well as the bright red blood plentifully splattered, strike a note of pathos not found elsewhere in Velázquez's work. There is also an excess of sentiment in the image of the child who kneels beside the angel at the right side of the picture. The ray of light that represents the communication between Christ's eye and

41. Reproduced in Braham, 1972, p. 22, pl. 11.

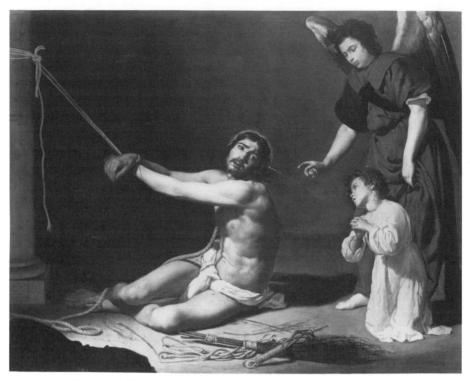

Fig. 21. Velázquez, *Christ After the Flagellation Contemplated by the Christian Soul*

the praying child (or between the child's heart and Christ's ear?) is uncharacteristically explicit. The Italianate quality of the figure and face of Christ and the blackness of the shadows on his flesh add to the alien effect. The unusual iconography was also extraordinary for Velázquez where religious paintings were concerned.[42] Close study of the painting itself and of X-rays leaves no doubt that it was indeed Velázquez who painted it, but one has the impression that he was ill at ease with this subject matter. The thick, rather even paint surface, the treatment of the fabrics, and the careful, finished handling of the scourges and ropes all relate this painting to the period before Velázquez made his first trip to Italy. The illumination and the modeling of forms, particularly the body of Christ, suggest a date close to that of *"Los Borrachos"* (Fig. 23).

The Guardian Angel was one of the concepts rejected by Luther and therefore warmly defended by the Church of Rome. It became a subject for art increasingly after the Council of Trent. In many cases

42. On paintings by or close to Juan de Roelas of similar subject matter see London, National Gallery Catalogues, *The Spanish School*, 2nd ed., 1970, p. 120 and notes 2 and 3.

the Archangel Raphael watching over the young Tobit on his journey was the easily identifiable representation of this theme. But the Guardian Angel has a broader role than that. According to the teaching of the Church, God provides every human being, from the moment of his birth, with an angelic companion who protects him, gives spiritual guidance, and presents his soul to God after he dies. From medieval times the soul of the dead being carried to heaven was represented by an infant. It may be that the praying child in Velázquez's composition represents not simply "the Christian Soul," as it has generally been called, but the soul of the righteous dead being presented to God by the Guardian Angel. The question then arises: Why would God be shown in this unusual guise? Could it have been because the picture was painted for a confraternity of flagellants? Nothing is known of its whereabouts before it was bought in Madrid in 1858 by the Englishman who later presented it to the National Gallery in London.

Velázquez's prodigious painting of *The Crucified Christ* (Fig. 22), formerly in the Benedictine Convent of San Plácido in Madrid, probably was painted not much later than *Christ After the Flagellation*. It has a similar thick, even paint film and strongly defined contours. The modeling of the nude figure and the treatment of the white loincloth bear strong resemblances to the parallel features of the London painting. Richard Cumberland, who wrote in 1787 that he "visited this exquisite production repeatedly and every time with new delight and surprise," believed that "if there were nothing but this single figure to immortalize the fame of Velázquez, this alone were sufficient." Cumberland reported that the picture hung in a poorly lighted cell in the convent, where it could be seen through the iron grate of a window.[43] The monumental painting—over life size—was very likely intended to give the effect of sculpture. Its prototype was the revered sculpture known as the *Christ of Clemency*, carved in 1603 by Juan Martínez Montañés, now in the Cathedral of Seville. The cross and the figure are shown frontally and centrally, against a uniform dark ground. As in the work by Martínez Montañés, the superscription in three languages is clearly delineated, the woodenness of the cross is em-

43. Cumberland, in *Varia velazqueña*, Vol. II, p. 148. Trapier, p. 122, noted that the polychrome wooden statue by Martínez Montañés was Velázquez's model. Palomino, p. 904, wrote that this picture was painted at the same time as Velázquez's portrait of the Duke of Modena, which was done in 1638, but later scholars have proposed various dates, ranging to as much as a decade earlier. The period before the artist left on his first trip to Italy seems to me to be where this painting fits stylistically. The small *Crucifixion* in a landscape background in the Prado is, in my opinion, not by Velázquez.

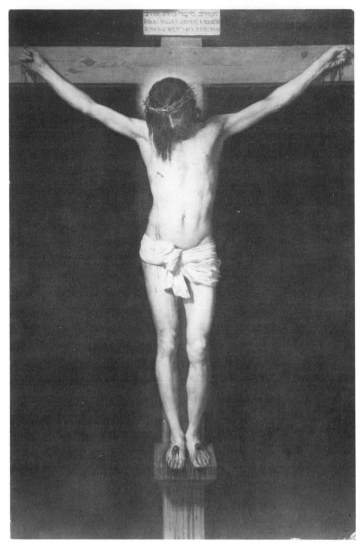

Fig. 22. Velázquez, *The Crucified Christ*

phasized, and the head of Christ is inclined toward his right shoulder. About a painting made by Zurbarán in 1627, following the same model, Palomino noted with approval that "everyone who sees it [in a dimly lighted chapel] thinks it is a sculpture."

Velázquez's status at Court was enhanced in 1627 by his victory in an important competition on the theme of Philip III and the expulsion of the *Moriscos* from Spain. Following this triumph over the

more experienced Court painters Vincencio Carducho, Angelo Nardi, and Eugenio Caxés, he was rewarded with appointment as *Ujier de Cámara* (Usher of the Chamber). This office brought him the fringe benefits of living quarters and the services of a physician and a pharmacist. The winning painting presumably was among the hundreds destroyed in the fire in the Alcázar in 1734.

As his paintings of the 1620s show, Velázquez must have been quick to profit from one of the major advantages of his position at Court, the access it gave him to the royal art collections, assembled mainly by the Emperor Charles V and King Philip II. Among the highlights of the great collections of paintings were outstanding fifteenth-century Netherlandish pictures, an unparalleled series of works by Bosch, and a wealth of Venetian masterpieces. In the course of time, Velázquez's development gives evidence particularly of his responsiveness to the style of Titian: increasing freedom of brushstrokes, vibrant color harmonies, a painterly disdain for contours, and a rich paint surface achieved with the help of the loaded brush. Ambition to depict the nude may also have been stimulated by the paintings by Titian that he studied in Madrid. Specifically, Titian's Bacchic scenes may have given the impetus for the unusual composition combining semi-nude male figures from ancient legend and fully clad peasant types of the sort that always interested Velázquez, in the enigmatic picture known as *Homage to Bacchus* or *"Los Borrachos"* (Fig. 23). This picture is of special interest in view of the fact that in date of origin it is the second large, multifigure composition by Velázquez known to us, later by a decade than *The Adoration of the Magi* of 1619.

Under a canopy of vines laden with grapes sits Bacchus, accompanied by two members of his retinue. (One of the Bacchic figures, seated in the left foreground, was the part of the picture that was most severely damaged in the fire in the Alcázar in 1734; we have no idea of the original appearance of this defaced figure.) The source of illumination is high on the left, reminiscent of Caravaggio's practice; there is no doubt that the painting was done in the studio and not outdoors. The warm light is focused on the nude Bacchus, who is seated on an overturned pottery barrel. A pewter bowl and an earthenware jug are on the ground at his feet. The intense observation devoted to these and the other objects portrayed recalls the magnificent still-life elements in Velázquez's *bodegones*. Rosy-pink and white draperies enhance the glowing skin tones of Bacchus and contribute to the con-

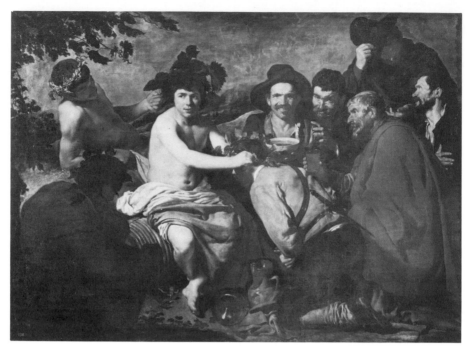

Fig. 23. Velázquez, *Homage to Bacchus* (*Los Borrachos*)

trast between the figure of the god and the dark, seamed faces, work-worn hands, and earth-colored clothing of the peasants. Bacchus's roguish, sidelong glance, his facial features, and his fleshy young body call to mind the figures in which Caravaggio specialized early in his stay in Rome, at which time he produced a number of Bacchic subjects. Looking on over the god's right shoulder is a male figure of similar type, who rests on his right forearm and lifts a stemmed glass of wine in his left hand.[44]

Bacchus is crowning with vine leaves a soldier who kneels before him. The pose of the soldier is similar to the figure of the barefoot peasant in Caravaggio's *Madonna of Loreto* (Rome, Sant' Agostino). The soldier shares the right side of the picture with five peasants who are crowded together, all involved in lively participation in the action. One of them, who looks out at us with a broad smile, is ready to drink from a white bowl that suggests the libation bowls of an-

44. It seems likely that Velázquez's reclining figure was based on Ribera's etching of the *Drunken Silenus* of 1628, as noted by E. duG. Trapier, *Ribera*, New York, 1952, p. 36, Fig. 22. Curtis (p. 18) had earlier pointed out the resemblance of this figure to Ribera's painting of Silenus in the Naples Museum, dated 1626.

tiquity. An older man, kneeling beside the soldier, lifts his full glass in what appears to be the offering of a toast. Woods and distant hills, very simply rendered, are visible in the landscape setting.

This unusual gathering represents a tribute to the god of wine by the country people in gratitude for the vintage. The most suitable name for it is *Homage to Bacchus*. This theme is met with in Netherlandish paintings of Velázquez's time.[45] As was usual with Velázquez in nonreligious subjects, he incorporated his borrowings into a new conception that transformed them.[46] A novel scene is the result. It appears that the kneeling soldier is being playfully inducted into the company of topers (*borrachos*). The fact that Bacchus's legs are crossed, a traditional pose for judges, may indicate that he has judged the soldier the winner of a competition (capacity for wine?) for which this coronation is the reward. The peasant in the upper right, who lifts his hat and extends his palm, has been identified as a beggar. If this is correct, he may represent a warning to the initiates that it is a dangerous game they are playing: overindulgence in wine may lead to poverty and degradation. The peasant at the far right holds bagpipes, which were widely used in seventeenth-century paintings as a phallic symbol, and which here recall the role of Bacchus as god of fertility.

Velázquez was paid one hundred ducats on account for this painting, according to a document dated July 22, 1629. This date suggests that he may have been working on it during the stay of Peter Paul Rubens at the Spanish Court. Though he had come on a mission of state, Rubens found time to paint, and in a studio in the royal palace he worked on copies of paintings by Titian, as well as on commissioned portraits. He made several portraits of Philip IV, and we can only wonder what Velázquez's reaction might have been to this breach of the promise that he was to be the King's only portraitist. Pacheco reported that among Spanish painters the great Flemish master was friendly only with Velázquez, with whom he had previously corresponded,[47] and that the two visited El Escorial together. In April 1629, the King named Rubens Secretary of his Privy Council of the Netherlands. It seems likely that Velázquez would have ac-

45. For example: David Teniers II, *The Wine Harvest: Worship of Bacchus*, England, Firle Place Coll.; C. Couwenberg, *Bacchanal*, Paris, Coll. Paul Marcus, dated 1626; L. de Caullery, *Bacchanal*, Zurich, Private Coll.

46. See Angulo Iñiguez, 1947, *passim*.

47. Pacheco, Vol. I, p. 154.

cepted the superior status of the older, world-renowned Rubens, and
would have welcomed the opportunity to learn from him. Rubens's
admiration for Titian might have confirmed Velázquez in his appre-
ciation for the Venetian master. It would not be surprising if it were
Rubens, learned and reverent as he was toward antiquity, who turned
the Spanish painter's thoughts to legendary and allegorical subjects.
The idea that Velázquez should visit Italy might also have originated
with Rubens or at least have been encouraged by him.

3. The Impetus of Art in Italy

To artists of Velázquez's time a visit to Italy was an educational
experience that few would willingly forego. Italy represented a vast
university of the arts. Higher studies in both theory and practice
were available there to all comers. The renewal of interest early in the
fifteenth century in the legacy of the ancient Romans raised to new
heights admiration for the art and architecture of antiquity. Painters
and sculptors in all parts of Europe were drawn to Rome as by a
magnet. It was widely believed that the ancients knew the secrets of
perfection in the arts and that close study of their works might reveal
their arcane knowledge. In the fifteenth and sixteenth centuries many
artists made drawings and measurements of the surviving monuments
and explored the literary sources that might shed further light on
forgotten attitudes and methods.

Meanwhile, the works being produced by Italian masters of the
time were not neglected. Raphael and Michelangelo were accorded a
place alongside the greatest of the ancients. The frescoes they painted
in the Vatican were used as textbooks by painters of their own and suc-
ceeding generations. The Sack of Rome in 1527 caused a temporary
dislocation in art as in all other activities; many of the artists who fled
from Rome found work in other Italian cities. In smaller measure,
these centers too provided the inspiration of ancient works of art,
works either found locally or acquired by Renaissance collectors. In
many cases these scattered cities had artistic traditions of their own
and offered the stimulus of varied stylistic developments. With the
brilliant creations of Titian, Tintoretto, and Veronese, Venice became
the Mecca for painters. By the last years of the sixteenth century, how-
ever, Rome had regained its primacy as the world's fountainhead of art.

The lavish patronage of Popes and Cardinals, which had played
an important part in attracting artists to Rome, reached new heights

with the accession of Pope Clement VIII in 1592. The recognition of the potency of art in spreading the word of the Counter-Reformation led to ever-increasing numbers of commissions of works for churches. In addition, the palaces of the great papal families were decorated with unprecedented splendor. One of these, the Palazzo Farnese, became the site of one of the seminal works for seventeenth-century painting when Annibale Carracci arrived there in 1595 from his native Bologna to paint a preliminary fresco series in the small *Camerino* and then, between 1597 and 1604, the vault and walls of the *Galleria* (in which he had some assistance from his brother Agostino and others). Works by the other great innovator of this period, Michelangelo Merisi, known as Caravaggio, were to be seen in Roman churches and palaces, as well as in Naples and elsewhere in the south. Annibale painted very little after 1605, and Caravaggio fled from Rome in 1606, but their paintings and the continuing accomplishments of their followers in Rome helped to maintain the position of Rome as the major focus of interest for painters and sculptors well into the seventeenth century. Groups of artists from other countries gathered in Rome around this nucleus and made their own contributions to the life and art of the city.

Rome, then, was Velázquez's chief destination when, in August 1629, with the King's permission and financial support, he started on his voyage. At Barcelona he embarked for Genoa, a great port city, rich in works by Rubens and Van Dyck. He went on to Milan, then under Spanish rule, and from there to Venice, where he copied paintings by Tintoretto. On his way to Rome, he visited Ferrara, Cento, and Loreto. Velázquez traveled not like an ordinary itinerant artist, but as an official of the Spanish Court. Letters of introduction preceded him, and he was received by dignitaries wherever he went. He did not find it necessary to visit all the places for which introductory letters had been provided, however, and it may be that his own desire to see the works of particular artists—Guercino in Cento, for instance—determined his route and his stops. Of course he might at times, like any tourist, have found himself too tired to see any more sights, however interesting, and thus he seems to have gone through Bologna without stopping.

Reaching Rome at last, he remained there for about a year. He was a guest in the Vatican Palace, where he made the most of the opportunity to become acquainted with the great collections of art. Pacheco said that he drew very proficiently after Michelangelo's *Last Judgment*

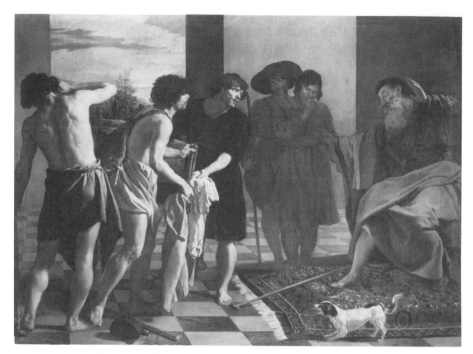

Fig. 24. Velázquez, *Joseph's Bloody Coat Shown to Jacob*

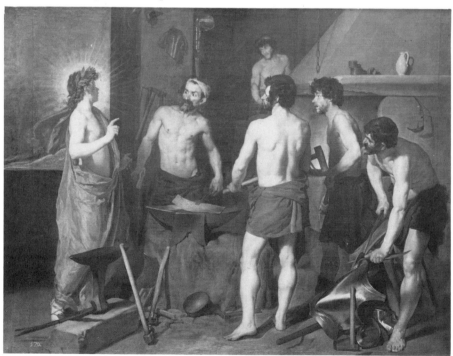

Fig. 25. Velázquez, *Apollo at the Forge of Vulcan*

and the works of Raphael and also that he painted a self-portrait.[48] Polomino reported that Velázquez painted *Joseph's Bloody Coat Shown to Jacob* (Fig. 24) and *Apollo at the Forge of Vulcan* (Fig. 25) while he was in Rome and that he took them back with him to Madrid to present them to the King.[49] Payment for these paintings was not made until 1634, but this would not preclude the correctness of Palomino's statement about their origin, as payment at the Court was often slow. Both of these large pictures show evidence of Velázquez's response to art he saw in Italy. In both the paint is more fluid and loosely brushed and the colors are lighter than was the case with the works preceding his journey; these stylistic alterations were to continue in his subsequent paintings. These two pictures also display a power of narrative depiction and an interest in portraying interior space that set these compositions apart from his earlier works. There was no precedent in Spanish art for such mastery of these aspects of painting. Most extraordinary is Velázquez's success in imbuing these compositions with meaningful intervals of space between the figures.

Each painting depicts a moment of high drama, one from an Old Testament story, the other from Ovid. Jacob is shown reacting with horror to the sight of the bloody coat which is presented as evidence that his beloved son Joseph has been killed. The main actors in the scene are spotlighted, while the supernumeraries are flat and shadowy —as is also the case in other narrative scenes painted by Velázquez. The three young men at the left, in beautifully choreographed poses, recall in physical type the earthy people in the *bodegones*, but the handling of paint is now quite different from the thick, rather pasty surface of the paintings of the Seville period. The effect of spatial depth is fostered by the sensitively varied marble squares of the floor and the opening onto a sketchy landscape. Architectural divisions clarify the organization of the figurative composition; there is a sense of two opposing parties, illustrating the conflict inherent in the story, with neutral bystanders between them. The patterned red rug and the small barking dog are reminiscent of similar notes of color and vitality in paintings by Veronese.

In the Middle Ages this moment in the story of Joseph was understood as a reference to the death of Christ. "This garment covered with blood was the bloody flesh which God himself contemplated

48. Pacheco, Vol. I, p. 160.
49. Palomino, p. 903.

with sadness." [50] This subject, rare in earlier art, was painted numerous times in the seventeenth century by both Italian and Northern artists. Guercino was one of the painters who depicted the scene. For Velázquez, this subject is unique in his oeuvre. It is the only Old Testament theme by him that we know of. It seems unlikely that the subject was selected—by the painter or by someone else—from the point of view of the medieval typological mode of thought. The fact that Rembrandt dealt with this subject in an etching of about 1633 and a drawing of about 1635, and that various members of his circle also depicted this episode, may indicate that there was some reason for particular interest in this tragic scene in the 1630s. In Protestant Holland, where there was intense concern with the Old Testament and where personal perusal of the Bible was more widespread than it was among Catholics, it is plausible to suppose that the artists as well as patrons were interested in the story for its moral lesson about the destructiveness of envy and filial rivalry. Similar didactic considerations might lie behind the Italian and Spanish paintings of this subject as well. No patron or donor seems to have had any connection with the genesis of Velázquez's picture; it was in the royal collection in the Palace of the Buen Retiro by 1637.

Apollo at the Forge of Vulcan (Fig. 25) shows stylistic advances similar to those we have noted in *Joseph's Bloody Coat*. In addition, it reveals other stimuli from the art Velázquez saw in Italy. Here, for the only time in a painting known to us, he dealt with the problem of sources of light within the picture. The fire on the hearth, the red-hot metal on Vulcan's forge, and the glory radiating from Apollo's head required him to depict a range of brilliant lights. Paintings that he saw in Rome by the Utrecht Caravaggist Gerard van Honthorst or by Italian or French followers of Caravaggio who specialized in candlelight scenes might have stimulated this attempt. Twenty years earlier Rubens had shown his masterly response to this challenge, shortly after his stay in Rome. In such paintings the goal was to show the visible sources of light dispelling the darkness and illuminating the objects near them. Velázquez seems to have ignored this point; such effects are minimal in his composition. The beautifully modulated tones that unify the entire picture surface, the rhythm of the figural group, and the fully realized stalwart male figures in action poses combined to produce a painting in which he successfully competed *on his own terms* with a popular mode in modern painting in Rome.

50. Emile Mâle, *L'Art religieux de la fin du Moyen Âge,* Paris, 1951, p. 143.

The delicate-featured young Apollo, whose face is silhouetted in *profil perdu*, is a harmony of soft hues. His exquisite flesh tones are set off by his green laurel wreath, gold-colored drapery, and blue sandals. Vulcan and his helpers, in contrast, have ruddy peasant faces with coarse features. Their expressions, as they stare raptly at Apollo, leave no doubt as to the outrage felt by Vulcan and the amazement of the Cyclopes at the news he is imparting. Apollo is revealing the infidelity of Vulcan's wife, Venus, whose misbehavior with Mars the Sun God was the first to know, for "he sees everything before anyone else," as Ovid relates. Though their faces are unidealized, the figures of the workers in the smithy follow the heroic model of classical sculpture. The poses and arrangements of the groups of figures recall paintings by El Greco,[51] which would have been known to Velázquez before he left Spain.

That *Joseph's Bloody Coat* and *Apollo at the Forge of Vulcan* are almost precisely the same size and are also well matched in settings and scale of figures supports the probability that these two pictures were intended as companion pieces. The same models appear to have served for figures in both. The relationship of their subject matter, however, is more problematic. Joseph and Apollo are both equivalents of Christ. But in this particular episode Apollo is a troublemaker, in no way parallel to Jesus. It would seem strained, though perhaps not impossible, to interpret his tale-bearing as an effort to bring miscreants to justice, which could of course be understood as a reference to Christ's role on Judgment Day. Justi perceived a link in the fact that one of the pictures, *Joseph's Bloody Coat*, deals with successful deceit and the other with the exposure of deceit.[52] Angulo Iñiguez pointed out that in both cases envy is the motive of the story; the brothers envy Joseph because Jacob favors him, while Apollo envies Mars for the favor of Venus.[53] If my suggestion of moralizing implications is correct, the two paintings together may be seen as presenting a case for honor among brothers and between husbands and wives. The events depicted on the two canvases are related also in a more obvious and superficial way: they both deal with moments in which bad news is transmitted and reacted to. The subjects might have been chosen primarily for their dramatic possibilities; to the painter they were studies in expressive

51. Angulo Iñiguez, 1947, pp. 75 ff.
52. Justi, Vol. I, p. 301.
53. Angulo Iñiguez, 1960, p. 179.

Fig. 26. Velázquez, *The Gardens of the Villa Medici: Land-scape with Wall*

Fig. 27. Velázquez, *The Gardens of the Villa Medici: The Loggia*

gesture and posture, figural rhythm, and perspective representation.

To escape the heat of a Roman summer, in May 1630 Velázquez moved to the Villa Medici, with its cooler hilltop setting and surrounding gardens. Here too there were classical sculptures for him to study. During his two-month sojourn, he painted two small, sketchy landscapes (Figs. 26 and 27). Replete with air and natural light, these pictures amazingly foreshadow the *plein-air* paintings of the nineteenth century. The free, painterly style of these two little outdoor scenes has induced some scholars to place them two decades later in Velázquez's career, at the time of his second visit to Italy.[54] In my opinion, however, they differ from his landscape backgrounds in paintings of all periods. The style suggests that this difference rests on the fact that, unlike all his other landscape depictions, these were quick sketches done from life. This explains the impression of observed light on specific features of the two scenes, which gives a unique freshness and immediacy to these paintings. There is no reason to believe that Velázquez was incapable of this vivid response to nature at the time of his first stay in Rome. Since it was during this visit that he stayed at the Villa Medici, it seems reasonable to assume that the landscapes were painted at this time.[55] This dating is also consistent with the fact that the long, straight strokes clearly defining the architectural elements conform to his style of this period rather than to the works of the 1650s, in which broken contours and short brushstrokes prevailed. There may also be some support for this view in the fact that in 1634 Velázquez was paid for eighteen pictures, fifteen of which were probably by himself, among which were listed *Joseph's Bloody Coat, The Forge of Vulcan*, and four small landscapes.

Velázquez left Villa Medici, apparently in late summer, when he was stricken with a fever and moved near the home of the Spanish Ambassador, the Count of Monterrey, to be cared for by the Count's physician. He seems to have remained in Rome through the autumn. At the start of his return trip to Madrid, he went to Naples, an important Spanish possession, which had for Velázquez the added attraction that it was an active art center. The Caravaggist movement was still strong there. The most important artistic personality he

54. The first to propose this was Valerian von Loga, *Die Malerei in Spanien,* Berlin, 1923, p. 294.

55. Among recent authors who have expressed the view that the two landscapes were painted during Velázquez's first trip to Italy were Gerstenberg (p. 66) and López-Rey (1963, p. 176).

might have encountered there was José or Jusepe Ribera. Ribera was
born in southern Spain, near Valencia, eight years before Velázquez's
birth, but he spent practically his entire working life in Italy, mainly
Naples, where he came to be known as *Il Spagnoletto*. He was Court
painter to the Spanish viceroys, and many of his paintings were taken
to Spain by them and other Spanish patrons. Ribera shared Veláz-
quez's devotion to the observation of nature. Velázquez apparently had
a figure by Ribera in mind when he painted *"Los Borrachos"* before
his trip to Italy.[56]

The pleasures in art and artists met in Naples were incidental to
Velázquez's mission there, which was to paint a portrait of the *Infanta
María* (Fig. 28) to take back to Madrid to her brother, the King.
María was in Naples between August 13 and December 18, 1630, on
her way to marry Ferdinand III, and this portrait dates from that
period.[56a] She wears brown with dark gray trimming and a gray ruff
that sets off her reddish-gold curly hair and fresh complexion. As was
usual with commissioned portraits, the facial features are carefully
delineated and firmly modeled. In the costume, on the other hand, the
brushstrokes are free and the details softened. The pliant, downy na-
ture of the ruff provides a particularly delightful contrast with the
clarity of the Infanta's features.

Velázquez's vital portrayal of her was an exercise in anticipation of
his return to his normal tasks as Court painter. He was, after all,
essentially a professional portraitist. Since the advent of photography
relegated portraiture to a minor role at best where painters are con-
cerned, painted portraits in our time tend to be underrated. For Veláz-
quez portraiture was the key to fame and position in life. He arrived
in Italy well known as a portrait painter, and records refer to several
portraits he made while there. His close view of art in Italy, however,
led him to discover and explore new fields. Art theoreticians of that

56. See note 44.
56a. Pacheco (Vol. I, p. 161) states that on his return trip from Rome to Spain
in 1630, Velázquez stopped in Naples, "where he painted a beautiful portrait of
the Queen of Hungary to bring to His Majesty." E. Harris (1976) cites documents
she has found which she interprets as establishing that the *Portrait of the Infanta
María* in the Prado was painted shortly before Velázquez left for Italy. There is
no proof, however, that the portraits discussed in the documents were ever com-
pleted, much less that this is one of them. In my opinion there is reason to believe
that Pacheco's statement refers to the Prado picture. I do not think we can
discriminate so narrowly between Velázquez's portrait style of 1628–1629 and that
of 1630 as to judge with any degree of certainty that the earlier date would be
more appropriate for this portrait.

Fig. 28. Velázquez, *The Infanta María*

time gave top rank among the various kinds of subject matter to "history painting." This term included narrative scenes of all kinds; usually they were based on biblical or mythological stories. Velázquez met and mastered the challenge of this type of pictorial problem in *Joseph's Bloody Coat* and *The Forge of Vulcan*. While in Italy he also found the time and inspiration to paint independent landscapes, another type of subject he had not previously dealt with. His approaches to both of these demanding kinds of subject matter were original, and the results were authoritative. He was already so securely the master of his art that he was able to forge ahead in virtuoso performances from this time forward. The paintings that followed his return to Madrid, where he arrived early in 1631, show how his color and brushwork, his compositional ingenuity, and his creative absorption of existing art profited from his experience in Italy.

4. Painting Prospers While the Realm Decays

Warmly received by his powerful sponsors when he returned to the Court in January 1631, Velázquez set to work to paint the portraits that the King had refrained from commissioning during his absence. As if a creative spring had been tapped by his experience of art in Italy, splendid portraits poured from his brush. His first portrait of the new heir to the throne, *Prince Baltasar Carlos with a Dwarf* (Fig. 29), painted in March 1631, shows the sixteen-month-old Prince as authentically a baby, but a regal baby, magnificently clad, with his left hand resting on his sword hilt, exactly as was customary in portraits of his father, and his right holding the baton of command. The Prince is posed so as to tower over the dwarf of dolorous aspect who accompanies him like a burlesque shadow of his royal self, with rattle and apple substituting for the scepter and orb of sovereignty.[57] (In the Spanish royal family only the heir to the throne was called *Príncipe*. Other sons of Spanish kings were called *Infante* and daughters, *Infanta*.)

Probably during the same year Velázquez painted *Philip IV in Brown and Silver* (Fig. 30), a virtuoso costume study. The pose goes back to the portraits of the King and Don Carlos that Velázquez had painted before he left for Italy. The head of the King is in the familiar three-quarter view toward the right, but now he wears his hair longer,

57. On the basis of the costume of the dwarf, José Camón Aznar identified the little Prince's attendant as female (*Velázquez*, Madrid, 1964, Vol. I, p. 437).

Fig. 29. Velázquez, *Prince Baltasar Carlos with a Dwarf*

Fig. 30. Velázquez, *Philip IV in Brown and Silver*

and he has grown the dashing upturned moustache that adorns his face in all the portraits from this time on. His brown costume glitters with silver embroidery indicated by free touches of paint. (There is a contemporary reference to the King's preference for brown clothing.) The contrasting silvery sleeves are also covered with pattern, and the black cloak is heavily encrusted with silver. On a long chain around his neck hangs the Golden Fleece. His brown-gloved left hand rests on his sword hilt, and in his right hand he holds a paper with the inscription "Señor Diego Velásquez Pintor de V. Mg." This was the wording that would introduce a petition addressed to the King by Velázquez.[58] The King's plumed green hat is on a table at his left. Behind him hangs a red drapery. His customary severe expression is discordant with the festive effect of the painter's light touch on the decorative costume.

The tendency toward lighter colors and freer brushstrokes had been reinforced during Velázquez's visit to Italy, and they were from now on to be the hallmarks of his style. The immediacy and apparent spontaneity that have made his paintings so attractive to modern eyes came increasingly to the fore in the paintings of the decades that followed. There was not an even and steady progress in this direction, however. The style was adapted to the demands of the particular subject at hand. It is therefore not possible to assign precise dates to the paintings of Velázquez's maturity on stylistic grounds alone. The fact that he inscribed dates on very few paintings adds to the difficulty. There are some dated documents that help us to determine when paintings of particular subjects were in existence, but even records of payment and old inventories cannot always be associated with certainty with specific paintings. When there are gaps in our knowledge of the history of a given picture there must always remain some reservations about its identity with a recorded work. In many cases, therefore, the dates ascribed to pictures by Velázquez can only be approximated on the basis of their resemblance to other works by him whose dates can be fixed with more security.

As to Velázquez's personal life during this busy period after his return from Italy, there is little information. His daughter Francisca was married on August 21, 1633, at the age of fourteen, to the painter Juan Bautista Martínez del Mazo, who became his father-in-law's disciple and chief assistant. Velázquez was able to pass on to Mazo his appointment as *Ujier de Cámara*.

58. Beruete, p. 39.

The construction of a new palace in the early 1630s to provide a more cheerful royal residence than the gloomy old Alcázar called for important new works by all the Court painters. The entire project served the purpose of improving the image of the monarchy, and the great hall of the new Buen Retiro Palace was planned as a showcase for the achievements of the current reign. The decorative program for this room (which later came to be known as the *Salón de Reinos* or Hall of Realms) included twelve large scenes commemorating victories by the armies of Philip IV.[59] Velázquez's contribution to this series, *The Surrender of Breda* (Fig. 31), was in place by April 28, 1635. It depicts—with some poetic license—an event that took place on June 5, 1625, a moment of triumph for the Spanish forces in their ultimately unsuccessful efforts to prevent the rebellious Dutch from achieving independence. After a long siege, hunger forced the Dutch, under the leadership of Justin of Nassau, to yield the town of Breda to the Spanish commander, Ambrosio Spínola. In this scene of capitulation, Velázquez stressed the magnanimity of the victor and the humanity of the individuals on both sides of the conflict.[60] The life-size central figures, representing the two famous military engineers who commanded the troops, have the force and directness of portraits taken from life (Figs. 32 and 33). But the painter almost certainly never saw Nassau, who died in 1631, and there is no record that he ever portrayed Spínola from life, though he traveled in his company to Genoa in 1629. Spínola, a member of a prominent Genoese family, was at that time on the way to Milan to become governor and take command of the Spanish forces in Italy. He died in the following year. These facts tell us a good deal about Velázquez's extraordinary power as a portraitist. They also suggest the advisability of caution in making assumptions about how the artist went about his work. Verisimilitude, lifelikeness, even apparent psychological penetration may come from within the painter rather than from contact with actuality.

There is an interesting contrast in ethnic types between the youthful Dutch soldiers on the left and the Spanish, on the right, who appear to be older and more dignified. The figure at the far right,

59. Caturla, 1960, published documents related to payments for the battle pictures, which seem to have been thirteen in number, though descriptions of the ensemble refer to twelve. Above the battle scenes hung ten paintings by Zurbarán of the story of Hercules, according to tradition an ancestor of the Spanish monarch.

60. The terms of the surrender were in fact generous. The document signed on June 2, 1625, was published in Fernando Diaz-Plaja, *El Siglo XVII* (La Historia de España en sus documentos), Madrid, 1957, pp. 125 ff.

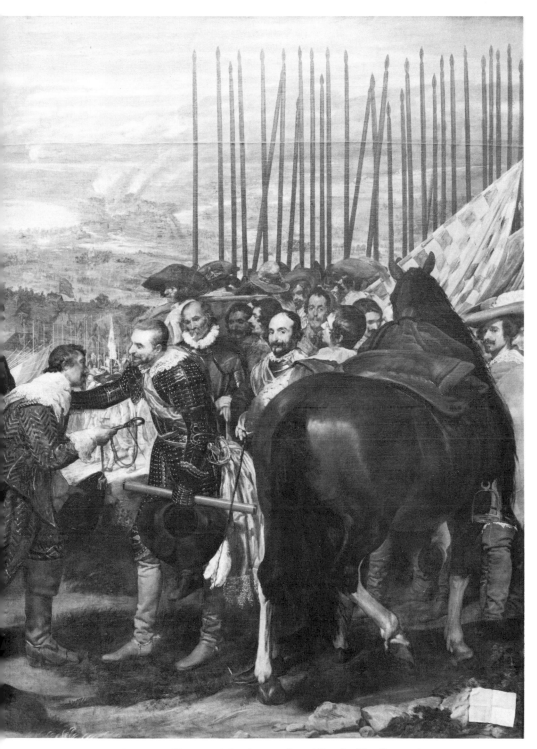

Fig. 31. Velázquez, *The Surrender of Breda* (*Las Lanzas*)

Fig. 32. Velázquez, *The Surrender of Breda*, detail

Fig. 33. Velázquez, *The Surrender of Breda*, detail

wearing a hat, has been assumed to represent the painter, but there are no grounds for this identification. Efforts have also been made, but in vain, to identify the distinguished Spaniard who likewise looks out at us, standing at the right of Spínola. It can hardly be doubted that this figure and some of his companions were intended as identifiable portraits. Other men as well look toward where we observers stand rather than at the ceremony that is taking place, thereby drawing us into the picture. Behind the figures in the foreground can be seen a campsite and battle scene in the middle ground. Beyond that is a panoramic landscape with a view of the besieged city. Thus the whole story of the historic engagement and its outcome is encompassed in this great painting. The dramatic climax, in which the vanquished commander offers the key to the city to the victor, is the central focus. The key is emphasized against a light area composed of the pink and blue uniforms of the troops in the middle ground. A fence of lances in the distance echoes the line of lances that so dramatically pierce the sky on the right; it was the latter that gave the painting its popular name, "*Las Lanzas.*" These weapons played an important role in the success of the indomitable Spanish infantry. As is the case with some other paintings by Velázquez, the *cartellino* in the lower right, which would appear to exist solely for the purpose of holding an inscription, bears no trace of lettering.

Various forerunners have been cited as sources that Velázquez used in composing *The Surrender of Breda*. The entire compositional scheme reflects a composite view of the battle engraved by Callot in 1628 for the Archduchess Isabella Clara Eugenia.[61] The motif of the two central figures and the upright lances seems to have been based on any one of a number of prints representing *Abraham and Melchizedek*, the earliest of which was a woodcut illustration by Bernard Salomon published in Lyon in 1553 in Claude Perrin's *Quadrines historiques de la Bible*.[62] The emotional tone of generosity and mutual respect with which Velázquez endowed the meeting between Nassau and Spínola characterized this Old Testament subject. Magnanimity was also a keynote of the play on the subject of the Siege of Breda that Calderón wrote to celebrate the Spanish victory in 1625. The idea of the handing over the key to the city seems to have been derived from Calderón's play.[63]

61. Saxl, pp. 316 f.
62. Sánchez Cantón, 1960, p. 144.
63. Justi (Vol. I, pp. 358 and 362) was the first to relate Calderón's play to the painting; he pointed out that the lances represented homage to the Spanish infantry as it was praised in Calderón's verses.

Fig. 34. Velázquez, *Equestrian Portrait of Prince Baltasar Carlos*

Though disparate visual and literary sources may have played a part in the genesis of Velázquez's great painting, all of them were transformed by his powerful vision. Light, color, and compositional devices unify all the elements. Aerial perspective produces a convincing view into depth of the extensive landscape. The groups of individually characterized figures are subordinated to the overall composition, and they take their places in space so that the scene as a whole makes a unified impact. The triumph of the Spanish forces becomes a triumph of Baroque painting.

Also designed for important positions in the *Salón de Reinos* were

the equestrian portraits of Prince Baltasar Carlos (Fig. 34) and the King (Fig. 35) that Velázquez painted in 1634–1635. The horse as a source and symbol of power had long been associated with portraits of leaders. The equestrian statue of Marcus Aurelius on the Capitoline in Rome served as model for a long series of such portraits, both sculptured and painted. Horsemen in traditional religious and historical subjects, such as the Journey of the Magi, also provided horse poses that were adapted for equestrian portraits. Medieval hunting and battle scenes in fresco and tapestry served to relate the horse to courtly nobility. Images of knightly saints, on the other hand, especially Saint George and Saint Martin, tended to endow the figure on horseback with the attributes of the Christian knight. Such images became widely known through the distribution of prints, for example those by Dürer. Similarly, engravings of mounted Roman emperors in the guise of statues on pedestals, by or after Stradanus, were published by a number of the best-known Netherlandish printshops before the beginning of the seventeenth century. Stradanus's pupil, Antonio Tempesta, who died in 1630, also made a series of engravings depicting the Twelve Caesars in the form of equestrian sculptures. So the idea of portraying Philip IV on horseback followed an old and still vital tradition. The monumental painting that was undoubtedly taken into consideration by Velázquez as he planned his royal equestrian portrait was Titian's portrait of Charles V before the Battle of Mühlberg, painted for the Emperor in 1548 (Prado). Also known to him were the conceptual and compositional types of equestrian portraits that Rubens had established by the 1630s.

Unlike these predecessors, Velázquez chose to depict the King's horse in the unstable rearing pose that he used in his equestrian portraits of Prince Baltasar Carlos and the Count-Duke of Olivares as well. The impression of incipient change that is implicit in this pose has a Baroque dynamism. Velázquez may have used a small sculpture as his model for the horse in these three portraits, which appear to show the same horse pose seen from different viewpoints. Pentimenti show, however, that he was experimenting with the poses of both horse and rider. He portrayed the King wearing a plumed black hat and black half-armor damascened with gold. In his right hand he holds the baton. The chestnut steed is poised at the summit of a steep slope, beyond which lies a valley bounded by distant hills. The King looks straight ahead, in the direction of the horse's motion. Level stratus clouds provide a stabilizing horizontal force.

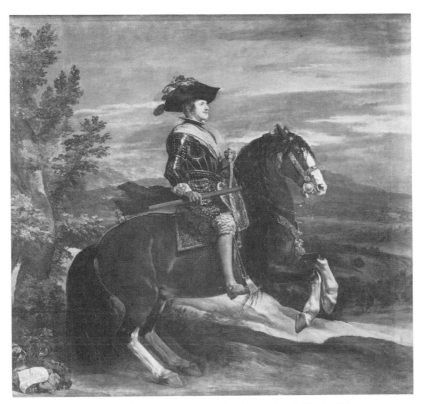

Fig. 35. Velázquez, *Equestrian Portrait of Philip IV*

Prince Baltasar Carlos (Fig. 34) is depicted mounted on a horse whose forelegs are similarly off the ground. This picture was designed to be hung above a door in the Salón de Reinos; this accounts for the form of the horse, which appears distorted when seen at eye level.[64] It was later enlarged by added strips on top and bottom. The little Prince and his curly-maned horse are brought to life with free, animated brushstrokes. The Prince wears a black hat like his father's, a gold-embroidered charcoal-dark doublet contrasting with luminous sleeves of gold hue, and a pink-crimson scarf with gold fringe. The horse's flying mane, forelock, and tail, the scarf and sleeve streaming out behind the Prince, and even the nebulous sky contribute to the effect of swift motion. Like the King, the Prince is placed on an elevation above a valley with mountains beyond, and in both cases the

64. Justi, Vol. II, p. 108.

landscape is painted in a fluid and summary way. There is a striking difference, however, in the fact that the Prince's eyes meet ours as he goes dashing by.

The *Equestrian Portrait of Olivares* (Fig. 36) shows him in three-quarter rear view. He looks back over his left shoulder to meet our gaze. Like Baltasar Carlos, he raises the baton in his right hand in a gesture of leadership. His gleaming black half-armor, the lavish bow at his hip, and his lace collar called forth Velázquez's most vivacious touch. There are striking similarities between this composition and Callot's etching of Louis XIII of France, including the gesture of the rider, the position of the horse with forefeet upraised above a battle scene, and small rushing figures in the distance.[65] Some scholars thought that this depiction of Olivares as the victor in a military engagement must have been painted after the defeat of the French at Fuenterrabia in 1638. It has also been argued, to the contrary, that though Olivares never experienced the heat of battle, he was given credit for earlier successes of the Spanish forces, and, since the style of the picture was in accord with that of the two royal equestrian portraits designed for the Buen Retiro, all three of them had probably been painted in 1634–1635.[66] This seems to be a sound conclusion.

Once the Buen Retiro Palace was completed, the redecoration of one of the King's hunting lodges, the Torre de la Parada, was undertaken, and this too demanded a number of paintings by Velázquez, as well as providing a huge commission for Rubens. Unlike the Buen Retiro, with its overriding public-relations function, the hunting lodge was intended for the enjoyment of the inner circle of the Court, and its decorations were accordingly more intimate, reflecting the personal tastes of the King rather than his public image. Unfortunately, no contemporary description of the ensemble has come down to us.

There seems little reason to doubt that among the paintings Velázquez made specifically for the Torre de la Parada were the life-size standing portraits in hunting dress of Philip IV (Fig. 37), his brother the Cardinal Infante Fernando (Fig. 38), who had been a favorite hunting companion of the King's in their youth, and his son Prince Baltasar Carlos (Fig. 39). Nothing is known of these pictures prior to the listing of them in a 1701 inventory that places them in the hunting lodge at that time. The portrait of the Prince bears a later inscrip-

65. Trapier, p. 236.
66. López-Rey, 1963, p. 63.

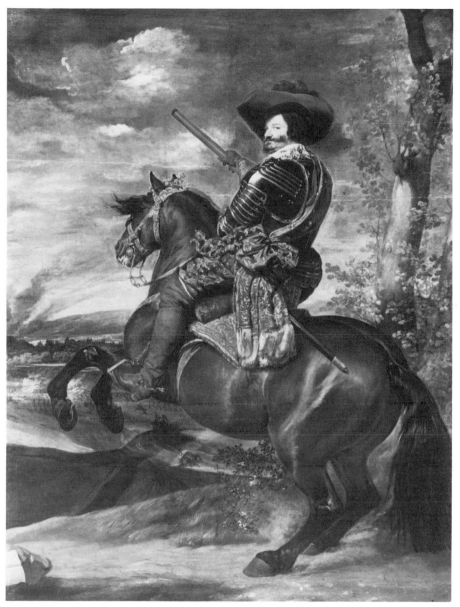

Fig. 36. Velázquez, *Equestrian Portrait of Olivares*

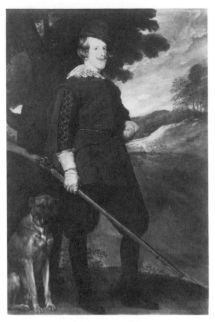

Fig. 37. Velázquez, *Philip IV as a Hunter*

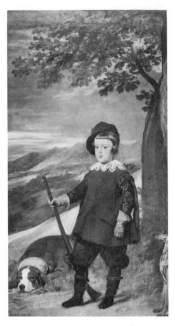

Fig. 39. Velázquez, *Prince Baltasar Carlos as a Hunter*

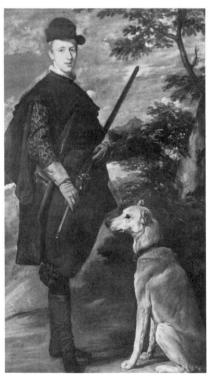

Fig. 38. Velázquez, *The Infante Fernando as a Hunter*

tion: "Anno aetatis suae VI." This seems to conform with the apparent age of the Prince and indicates that it was painted not earlier than 1635 and probably in 1636, at the time when Velázquez was working on the decorations for the Torre de la Parada. It has been argued that the portraits of the King and Don Fernando as hunters were painted a few years earlier, about 1632 or 1633, partly on the grounds that the Infante left Madrid in April 1632, never to return. It may be that these two portraits were painted for the Torre de la Parada before the Infante's departure, and not in connection with the redecoration of the hunting lodge. If that was the case, Velázquez might have retouched them later to bring the style into accord with that of the portrait of the Prince. But it is not impossible that Velázquez painted Don Fernando's likeness at a later date, not from life but using an existing portrait as a model for the head. The fact that the little boy's costume is almost a precise replica of his father's suggests that they were probably painted in close succession. Neither the apparent age of the sitters nor the style permits more precise dating of the portraits of the King and his brother, but, as they and the portrait of Prince Baltasar Carlos as a hunter are all the same height, it appears that they were intended as a series. They are all slightly different widths, possibly cut down. The awkward cutting off of the greyhound at the right of the portrait of the Prince gives particular reason to suspect that it was originally wider. The stance of the King and the background featuring a large tree and extensive view over a valley both recall the famous hunting portrait of Charles I of England by Van Dyck (Louvre). Velázquez's landscape backgrounds are broadly indicated, like theatrical backdrops. The hunt as training and symbolic substitute for the arts of war had special connotations for royalty. To Philip IV hunting was one of the few pleasurable activities that could be guilt-free and even praiseworthy.

Rubens's commission for the Torre de la Parada included a large number of mythological subjects, mostly based on Ovid's *Metamorphoses*. He made oil sketches in 1637 and 1638, on the basis of which assistants executed the finished works.[67] In addition, several individual figures from antiquity were included in the ensemble. Apparently Velázquez's life-size paintings of *Menippus* (Fig. 40) and *Aesop* (Fig. 41) and the over-life-size *Mars* (Fig. 42) joined this company, though

67. According to Alpers (p. 32), Rubens designed over sixty mythological pictures and almost sixty animal and hunting scenes for the hunting lodge. She concluded (p. 100) that no integrated scheme in the arrangement of the paintings could be discerned. She considered Velázquez's *Aesop* and *Menippus* to be unrelated to Rubens' *Democritus* and *Heraclitus* (p. 134).

Fig. 40. Velázquez, *Menippus* Fig. 41. Velázquez, *Aesop*

Fig. 42. Velázquez, *Mars*

they seem to have been hung in different rooms. These pictures were recorded in an inventory of 1701 as in the Torre de la Parada, which is the earliest mention of them. The smiling Menippus and somber Aesop may have been intended as parallels to Rubens's traditionally laughing Democritus and weeping Heraclitus. Velázquez conceived of the two literary figures from antiquity in the guise of "ragged philosophers," who have their minds on higher things and disdain the getting and spending to which ordinary mortals devote their lives. Both of them were reputed to have been born slaves, and both achieved renown through their writings. Aesop was the originator of the literary genre of tales about animals that shed light on human behavior, a type of story that has never ceased to interest and amuse—and teach—successive generations over the centuries. Menippus's writings in prose and verse (all lost) dealt satirically with the follies of humankind and provided a model for many later writers. These two ancient Greeks might have been intended to direct a cautionary note, in a jocular way, toward the amusement seekers at the Torre de la Parada.

Unlike Aesop and Menippus, Mars is not an historical figure but a god. True, Velázquez reveals him as a god in disarray, but still unmistakably the Roman god of war. He sits on the edge of a rumpled bed, looking dejected as he rests his head on his left hand and his elbow on his knee. This is a traditional pose representing both melancholy and indolence.[68] Aside from his helmet, which puts his face in shadow, and the drapery required for modesty, he is nude. His shield and armor lie on the floor before him. The baton (or perhaps handle of a battle ax?) in his right hand rests slackly on the floor, an image of impotence. What a telling contrast with the commanding gesture of Olivares in the equestrian portrait (Fig. 36). The gloom implied by the darkened face and the pose of Mars is belied by particularly cheerful colors. The loincloth is bright light blue, the drapery on which he sits is crimson-pink, the helmet and shield glisten with gleaming golden ornamentation, the shield reflects the pink of the drapery, and a crimson ribbon hangs from the helmet and decorates the muscular right shoulder and chest of the unhappy warrior. The warm flesh tones of the well-lighted body stand out against the virtually black background. The picture was painted with great sweeps of the brush laden with color.

68. On the pose representing melancholy, see E. Panofsky and F. Saxl, *Dürers Kupferstich "Melencolia I"; Eine quellen- und typengeschichtliche Untersuchung* (Studien der Bibliothek Warburg, II), Leipzig and Berlin, 1923. On the vice of indolence or sloth, see M. M. Kahr, "Vermeer's *Girl Asleep: a Moral Emblem*," *Metropolitan Museum Journal*, VI, 1972, pp. 115–132.

Justi noted that the pose of the upper part of Mars' body was inspired by Michelangelo's *Pensieroso* and his legs by the antique sculpture known as the Ludovisi Mars.[69] But the bed on which he is seated makes his situation quite different from that of either of these distinguished forerunners. It calls to mind the humiliating situation of Mars when Vulcan trapped him in bed with Venus and invited the Olympian gods to ridicule him. This is the concluding scene of the story of which Velázquez depicted an earlier episode in *Apollo at the Forge of Vulcan* (Fig. 25). Vulcan responded to Apollo's revelation of the infidelity of his wife by weaving a net so fine as to be imperceptible, so that he could ensnare Mars and Venus and make a spectacle of their illicit love. It is hardly to be supposed that in seventeenth-century Spain Mars would be considered praiseworthy for making love, not war. His obvious lack of preparedness for armed combat could be interpreted as implied criticism of the military leadership of Spain, a satirical counterpoint to the glorifications of the feats of Spanish arms that filled the Salón de Reinos of the Buen Retiro. It seems likely, however, that in the pleasure-oriented context of the Torre de la Parada, where so many amorous adventures from Ovid were represented, it was the erotic overtones of Velázquez's Mars that were appreciated.

A portrait that can be dated in the middle 1630s with a reasonable degree of certainty provides a useful landmark in charting Velázquez's stylistic course. *The Sculptor Juan Martínez Montañés* (Fig. 43) was painted between June 1635 and January 1636. The celebrated sculptor from Seville spent these months in Madrid, having been commanded to come to Court to model a head of the King for the use of the Florentine sculptor Pietro Tacca, who had been commissioned to make a monumental equestrian statue of Philip IV. Velázquez's portrait of Martínez Montañés shows him at work on the clay model that was to be sent to Florence. He was depicted as if working from life, and his intent gaze is directed out of the picture, toward his royal sitter. His right hand is raised in readiness to make the next move with the tool he holds. This hand is fully realized, in contrast to the left hand, which rests on the clay head and is painted roughly, in a few thick strokes. The representation of the sculptured head of the King was left in a barely blocked-in state. In this way the study of the sculptor at work demonstrates that the artist creates form from the amorphous.

The features of the sixty-seven-year-old sculptor are depicted with

69. Justi, Vol. II, pp. 364 f.

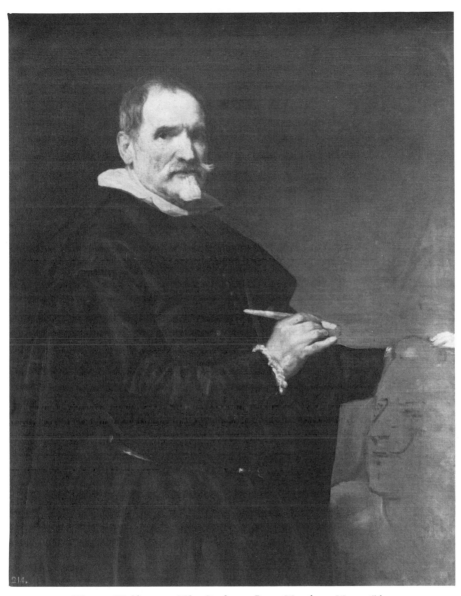

Fig. 43. Velázquez, *The Sculptor Juan Martínez Montañés*

loose and fluid strokes, and the relation of the form to the space around it is expressed with the utmost subtlety. The direction in which Velázquez's style has moved is strikingly shown by a comparison of this picture with the portrait he made in 1622 of the poet Don Luís de Góngora (Fig. 13). That those portrayed are both creative artists of impressive stature, whose personalities and characters are of intense interest in their own right, makes this an especially rewarding comparison.

Portraiture was Velázquez's chief artistic enterprise through most of his career. During the second half of the 1630s and the early years of the following decade he seems to have concentrated on portraits to the exclusion of other subjects. The *Portrait of a Bearded Man* (Fig. 44) has much in common stylistically with the portrait of Martínez Montañés. Transparent shadows establish the bony structure of the head, and the forms are heightened by freely brushed-in light tones that follow the natural contours. The background is sensitively varied to set off the figure.

Also similar in style to the portrait of the famous sculptor is the lyrical *Portrait of a Lady with a Fan* (Fig. 45). Exquisite variations of color and value combine to create the forms of the face, throat, and swell of breasts. The white ruffle around the décolletage consists merely of frugal clues. A necklace of darkly glowing beads—jet? garnet?—garlands the column of her neck. Her head and shoulders are framed by a black mantilla. Her brown dress has blue-white organdy cuffs, finely pleated, that are differentiated in both color and texture from the ivory-white kid gloves. The golden rosary and cross, the light blue bow, and the ribbons threaded through the fan are built up with unmodulated touches of paint. Similarly free in treatment is the silver ornament that in the cleaning completed in 1975 came to light below the blue bow. This ornament had previously been concealed by overpainting; its shape remains uncertain, though it suggests a Jerusalem cross.[70] The hitherto unexplained splotch of red immediately to the right of the lowest loop of the blue bow may represent a ribbon attached to this pendant.

This costume is unusual for Spain in the 1630s. The neckline is lower than one would expect, while the colors and jewelry are rather restrained.[71] Décolletage of this kind is to be seen in a number of paint-

70. Enriqueta Harris (1975) suggests that the ornament is probably a religious medal, "bearing some resemblance to the dove of the Holy Spirit."

71. Priscilla E. Muller (*Jewels in Spain, 1500–1800*, New York, 1972, pp. 105 f.) relates the somber-toned fabrics in Spanish costumes of the 1630s and '40s to sumptuary decrees. She mentions a decree of 1639 limiting exposure of female breasts, which perhaps provides a *terminus ante quem* for the *Lady with a Fan*. Pentimenti show that the neckline was originally less open at both sides.

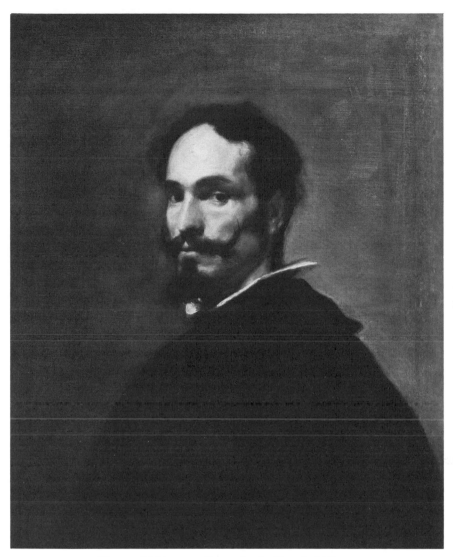

Fig. 44. Velázquez, *Portrait of a Bearded Man*

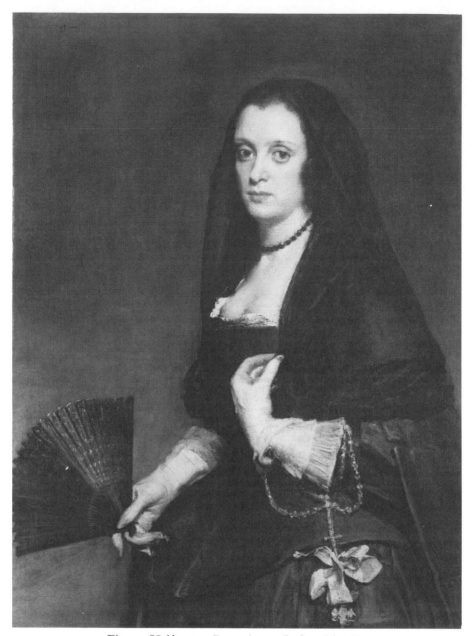

Fig. 45. Velázquez, *Portrait of a Lady with a Fan*

ings of this period by Flemish painters, particularly Rubens, and one wonders whether the lady, for all her "Spanish look," might have been a Flemish or French visitor in Madrid. Perhaps, to take account of all the anomalies, one would have to suggest that she might be a Spaniard married into a Flemish family. This would hardly be more fanciful than the past efforts that have been made to identify her as Velázquez's daughter, for which the only grounds would be the sympathy with the sitter that seems to be implicit in this masterly portrait. Francisca would have been still in her teens if this picture was painted before 1640, and it appears to date from well before that year. The figure takes its place in space against the subtly varied light of the background. In keeping with the style of Velázquez's portraits of the middle of this decade, the flesh is softly modeled and the contours are clear, while all kinds of liberties are taken in the rendition of details of costume and ornament. The effect is one of dynamic vitality. Even the gesture of the left hand suggests incipient motion, a gentle drawing of the mantilla modestly toward the left. The partly opened fan also implies movement.

The charming *Portrait of a Little Girl* (Fig. 46), which seems to date from about the same time as the *Lady with a Fan*, has been thought to represent Velázquez's granddaughter, but there is no basis for this identification. This too is a portrait of vibrant individuality. It is interesting for the evidence it gives (as do some other portraits) of Velázquez's method of procedure. The bust of the little girl is boldly sketched in brown, and these preliminary strokes are visible through the thin paint film of greenish ochre, for the dress remained unfinished. Only the painting of the head was carried farther. The effect is satisfying to the modern eye, and it is tempting to think that Velázquez was content with it. He left a number of pictures in a state not unlike this, and we have no evidence as to whether this was out of choice, dissatisfaction, or lack of time, or whether it was brought about by some other cause. He may, for instance, have made such paintings as sketches in preparation for more finished versions which he or assistants in his studio may or may not have painted, as the occasion demanded or permitted. We can be almost certain that such an unfinished state would not have been considered satisfactory by patrons who commissioned portraits. It may be, however, that Velázquez, like Michelangelo, had a temperamental affinity for the incomplete.

Even his "finished" portraits tended to be daringly abrupt at some points. Note, for instance, the *golilla* of the *Bearded Man* (Fig. 44).

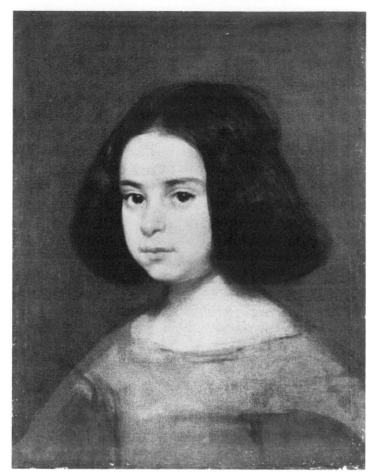

Fig. 46. Velázquez, *Portrait of a Little Girl*

The rosary and other ornaments of the *Lady with a Fan* are equally "impressionistic." Similarly, the silk sash and the Golden Fleece worn by *Francesco II d'Este* in the portrait (Modena, Pinacoteca Estense) that Velázquez started while the Duke was in Madrid in the fall of 1638 are painted with little concern for realistic representation. As time went on, the primacy of the optical impression tended to take over more and more of Velázquez's picture surface, leaving it to the beholder to infer the form beneath the visible surface.

The Dwarf Sebastián de Morra (Fig. 47) must have been painted between the time when he arrived in Madrid from Flanders in 1643 to

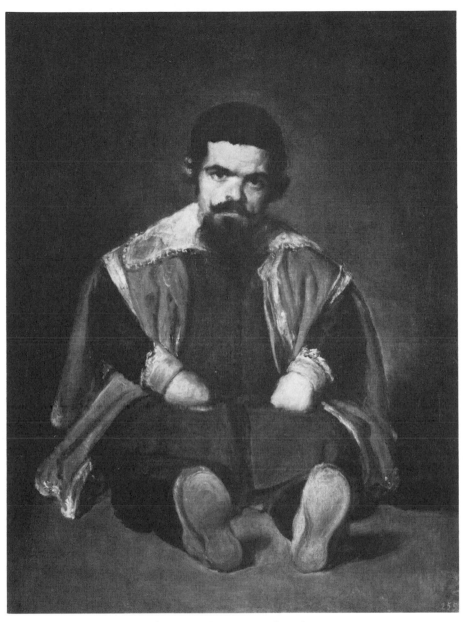

Fig. 47. Velázquez, *The Dwarf Sebastián de Morra*

serve Prince Baltasar Carlos and his death in 1649. He is posed in such
a way as to exaggerate the disparity between the size of his limbs and
that of his head and torso.[72] His legs are projected forward, toward
us, so that they are shown in extreme foreshortening, with the soles of
his tiny shoes pitifully taking the foreground. The full frontal pose
of his head and body presents the dwarf in his widest possible aspect,
and the blocky effect is further broadened by the horizontal line of the
skirt of his green jerkin, the flowing red cloak bordered with gold
braid, and the squared-off collar. It was, after all, Sebastián's abnormal
proportions that made him interesting to his employers, and it is not sur-
prising that the painter saw fit to emphasize his oddity. This is typical
of Velázquez's paintings of the buffoons and dwarfs of the Court; he
made a practice of depicting their physical irregularities of all sorts
without any glossing over of the defects. He painted Sebastián's face,
however, with the same interest and in the same dynamic style as other
portraits of this period.

One of Velázquez's rare religious paintings, *The Coronation of the
Virgin* (Fig. 48), seems to have been in existence by 1644, in which year
it apparently served as a model for a picture of the same subject by
Velázquez's friend Jusepe Martínez.[73] Velázquez painted it for the
Oratory of the Queen, Isabel de Borbón, in the Alcázar. Queen Isabel
lived only until 1644. The composition is on the whole traditional.
The figures are substantial, though the more fluid paint and the soft-
ening of contours illustrate the great changes his style has undergone.
There is more variety in the covering of the surface of the canvas than
in his paintings of the 1630s; it is thinly covered in some places, with
thick impasto particularly in the highlights. The color scheme unifies
the painting in a manner unique in his works. Both God the Father and
Christ wear pinkish lavender cloaks over purple garments. The Virgin
wears a dress of the same pinkish lavender, a white scarf over her
light brown hair, and a blue cloak. Her eyes are modestly downcast as
she receives the ultimate tribute of being received as Queen of Heaven.
She is being crowned with a wreath of flowers instead of the usual gold
crown. The golden glory of light that emanates from the Trinity is re-
flected in the clouds, so that the figures are surrounded by unearthly

72. The canvas bears the mark of an oval shape, but there is no discernible dif-
ference in paint surface, color, or brushwork between the area within the oval and
that outside. In the inventory of 1666 Mazo described this painting as oval, which
López-Rey (1963, p. 267) suggests might have referred to the shape of its frame.
73. Allende-Salazar, pp. 279–280, note on Pl. 104.

Fig. 48. Velázquez, *The Coronation of the Virgin*

Fig. 49. Velázquez, *Venus at Her Mirror* (*The Rokeby Venus*)

light. Freely painted infant angels and cherub heads embellish the lower zone.

Not much later than the *Coronation of the Virgin*, stylistic similarities would suggest, Velázquez painted his only depiction of a female nude that still exists, *Venus at Her Mirror* (Fig. 49). The relation of this composition to the Venetian tradition of reclining female nudes, as well as its sensuous charm, recalling Titian, led to the assumption that it was painted during Velázquez's second trip to Italy, under the immediate impact of Venetian paintings. After the later discovery that it was listed in a Spanish inventory before Velázquez returned from Italy in 1651, the question arose as to whether he had painted it before leaving Madrid or had it done during his stay in Italy and sent it to Madrid before his return.[74]

Female nudes were rarely painted in repressive, Inquisition-ridden Spain. Venus gazing at her mirror, attended by Cupid, was a familiar theme in late Greek and Roman art and was frequently depicted from the Renaissance up to Velázquez's time. There are notable examples by Titian, Veronese, Tintoretto, and Rubens. Velázquez presents this traditional subject matter as freshly as if it had never been thought of before. In his composition the mirror serves a vital purpose. The figure of Venus, parallel to the picture plane, is related to the depths of the picture space through the agency of the mirror toward which she turns her head, as well as through the diagonal that connects her figure with that of Cupid, who holds the mirror. The looking glass gives, besides, a solid sense of completeness, making it possible to see the subject not just from one point of view but in the round. While full credit for the admirable outcome must go to the artist, it may be that it was the request of the patron who commissioned it (not the King!) that gave Velázquez this opportunity to show what a sensitive painter of the female nude he could be.[75] It is interesting to note that even though he was in the employ of the King, Velázquez was allowed to accept commissions and to be paid for paintings he made for other patrons. Perhaps this was a concession made deliberately in order to give him the possibility of income from outside sources, as his salary was often in arrears,

74. Pita Andrade, pp. 226 f. On the various dates that have been proposed and possible models for the motif, see Sánchez Cantón, 1960, pp. 141 ff.

75. Velázquez probably painted other nudes as well. First recorded in a 1686 inventory of the Alcázar in Madrid was a pair of paintings by him, one representing Venus and Adonis, the other, Cupid and Psyche. Early records also suggest that he may have painted other depictions of Venus.

and payment for individual paintings made for the King was sometimes delayed for several years.

So art prospered at the Court, while Spain sank. These were years of financial stringency, aggravated by Olivares's bent for imposing revenue methods odious to all classes. Intolerable economic demands and endless military involvements that infringed on cherished local autonomy had led by 1640 to a situation of extreme instability. Parts of the empire fell away. Portugal succeeded in liberating itself from the Spanish crown. There was revolt in Catalonia, which was finally put down in 1652. But Roussillon, which for centuries had had ties to the Kingdom of Aragón, was never recovered from the French, who for a time had allied themselves with the Catalán independence party. In Andalusia too there was a troublesome move for independence. Early in 1643 the King was finally prevailed on to dismiss the hitherto all-powerful Olivares from office and banish him from Court. It was too late, however, to stave off military disaster. The superiority of the Spanish infantry, which had been a dominant force ever since the progressive days of Ferdinand of Aragón, came to an end when on May 18, 1643, the army of Philip IV was defeated by the French at Rocroi, on the border of the Spanish Netherlands.

Velázquez found no less favor at Court after the departure in disgrace of Olivares, who had been his protector for so long a time. On January 6, 1643, he had been appointed Ayuda de Cámara, and on June 9 of that year the King named him Assistant to the Superintendent of Works, with tasks relating to the remodeling of the old Alcázar. He had less time than ever for painting. In the spring of 1644 the painter accompanied the King to Lérida, which the Spanish forces were trying to recapture from the French, who had occupied the town in support of the Catalán uprising. The royal party made a stop at Fraga, where, in an improvised studio, Velázquez painted Philip in military dress, a costume that sparkles on the canvas in a dazzle of salmon pink and silver; this picture is known as *The Fraga Philip* (Fig. 50). The superb integration of figure with environment and the amazing shorthand indications of embroidery, sword hilt, white sleeves, and pink plume are a revelation of the potentialities of paint. The head—and to an even greater degree the hands—are, to the contrary, treated in a flat and superficial manner. It is true that the King's head and hands were based on only three sittings,[76] while the painter was able to study the costume at

76. Cruzada Villaamil, pp. 143–146. That it was customary for Velázquez to paint only the head in the presence of the sitter was indicated in a case reported by his friend, the painter Jusepe Martínez, in *Discursos practicables del nobilísimo arte de la pintura* (1675), Madrid, 1866, p. 132.

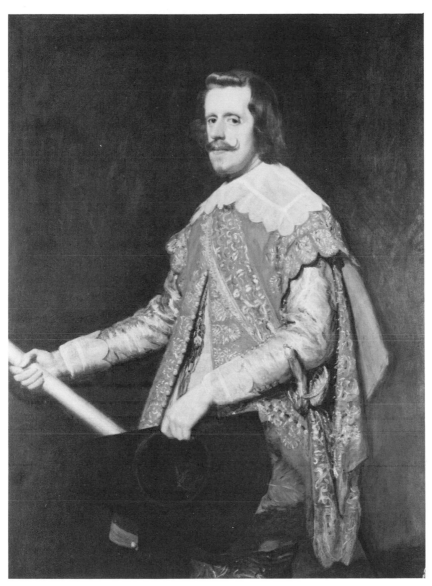

Fig. 50. Velázquez, *Philip IV*, *the Fraga Portrait*

leisure; even in more ordinary circumstances the painting of the costume would not be completed during the sittings. But Velázquez, after years of close association, certainly knew every hill and valley of Philip's features and nearly every shade of expression that might alter their aspect. It might be supposed, besides, that the fact that the King is posed facing toward the left, in contrast to all the other portraits of him by Velázquez that are known to us, in which he invariably faces toward the right, would perhaps have stimulated a fresh look at him that would have resulted in a more closely observed image on the canvas. Yet the flat treatment of the King's features makes him appear even weaker than usual.

The shallowness of Philip's face in the Fraga portrait is in striking contrast with the depth of characterization in the portrait of *The Dwarf Don Diego de Acedo* (Fig. 51) made at the same time as *The Fraga Philip*. Acedo, also known as "El Primo" ("the Cousin"), served the King in a clerical capacity. The large size of his head is emphasized by the black hat that crowns him with a Baroque flourish, while his disproportionately small body and hands are further diminished by the huge book he appears to be hardly able to support on his knee. Hemmed in by the still life of books and black inkpot, with their firm lines and strong contrasts, in the foreground, and the mountain range behind him, he is an odd and strangely impressive figure. The forms of his hands and face are built up with a wonderful variety of tones. His intense characterization as well as the carefully thought-out composition make it reasonable to conclude that Velázquez betrayed a greater interest in the dwarf than in the King while he was painting at Fraga. The dwarf is a person, the King an icon.

In fact, the King was a mere figurehead on a foundering ship of state. His Court painter was hardly to be blamed if he became more a painter of the sovereign's costumes than of his person. The appearance of dignity was maintained. The unfortunate Philip suffered personal as well as territorial losses in the 1640s. Queen Isabel died in 1644. Two years later the short life of Prince Baltasar Carlos, heir to the throne and the King's only son, came to an end. In 1648, the year in which the Treaty of Westphalia ended the Thirty Years' War (but not hostilities between Spain and France) and the Treaty of Münster ratified the independence of the United Provinces, cutting in half Spain's valuable possessions in the Netherlands, the King, at the age of forty-three, was making plans to marry again. The new Queen was to be his thirteen-year-old niece, Mariana of Austria, who had previously been betrothed to Prince Baltasar Carlos. Intermarriage among the Hapsburgs was to

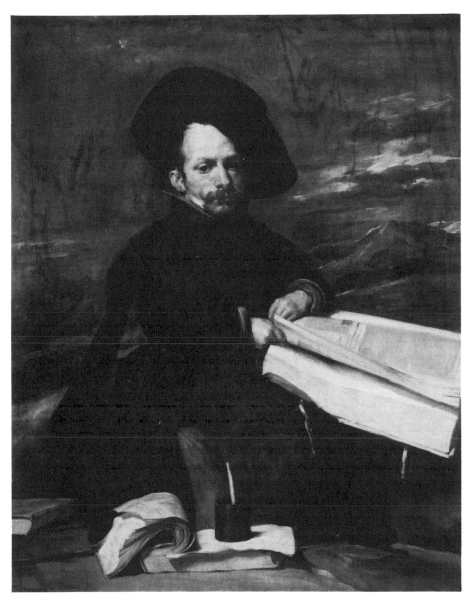

Fig. 51. Velázquez, *The Dwarf Don Diego de Acedo*

bring the dynasty to an end with the mentally and physically deformed offspring of this marriage, who became King Charles II of Spain when Philip IV died in 1665.

A document dated May 17, 1647, reveals that Velázquez's salary had not been paid since 1645. Meanwhile, in January 1647, the King had appointed him supervisor of construction for a new Octagonal Room in the Alcázar. Perhaps it was in connection with the plans for remodeling the old palace that the King made the necessary financial arrangements and ordered Velázquez to visit Italy once again to buy paintings and sculptures for him.

5. Once More to Italy—and New Honors

In the eighteen years since he returned from his first journey to Italy, Velázquez had produced more than half of his known works. Some of his portraits had carried his fame to Courts in various parts of Europe. His rank as a courtier had also advanced during this period. So he could expect to be received on his second trip to Italy with the deference due him not only as an agent of Philip IV but as a personage of considerable prestige in his own right. The King had commanded him to select paintings and sculptures for the decoration of the Alcázar and to arrange to have fresco painters come to Madrid to paint walls of the remodeled rooms.[77] Conscientious fulfillment of the King's purposes would not, however, have precluded the pursuit of more personal aims that might have made this trip a welcome opportunity from Velázquez's point of view. It seems safe to assume that he would have been glad to revisit Italy, to see both the works of art that had come down from earlier times and those that had been produced by his contemporaries in the previous two decades. He very likely would also have anticipated with some satisfaction the chance he might have to enhance his fame by showing artists and patrons in Italy his own present capabilities. And this in turn, he had reason to hope, could serve to further his ambitions for still higher status.

Late in 1648 the arrangements were finally complete, and Velázquez departed from Madrid. He was in the southern port city of Málaga from December 7, 1648, until January 21, 1649, when he set sail for Genoa. This voyage, which appears so short on the map by today's standards, took until March 11. Once ashore in Genoa, again, as on his earlier visit, he took an art tour from the north to the south of the

77. See Bonet Correa.

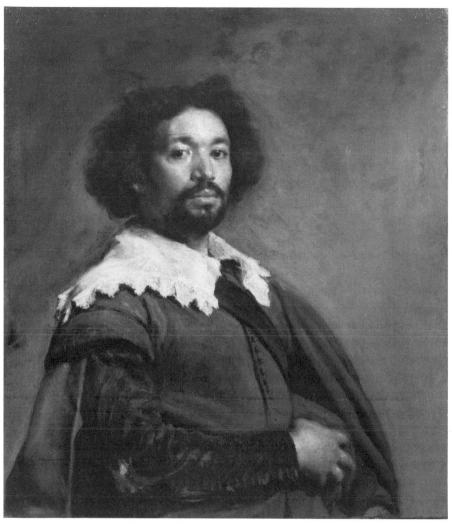

Fig. 52. Velázquez, *Juan de Pareja*

Italian peninsula. He visited Milan, Padua, Venice, Parma, Modena, Bologna (where he engaged the frescoists Michele Colonna and Agostino Mitelli to paint for the King in Madrid), perhaps Florence, and Rome. He left Rome almost immediately for Naples, where by order of the King, the Viceroy was to pay Velázquez money the King owed him. In Naples he chose some antique statues from which molds were to be made for shipment to Madrid. He undoubtedly also met Ribera again and examined—and perhaps acquired—paintings by him.

By July 1649 Velázquez had returned to Rome, where he was welcomed by high functionaries in the Papal Court and by outstanding artists. Again he worked at his task of selecting sculptures for the King. He also painted a number of portraits during his stay in Rome, which lasted until November 1650. It was in preparation for painting a portrait of the Pope, according to Palomino, that he painted from life his portrait of *Juan de Pareja* (Fig. 52), "his slave and clever painter." Pareja, who apparently was of Moorish descent, was not a slave but an assistant to Velázquez, whom he had accompanied from Madrid on this trip. There is no record of an association between them before this time, but this would not preclude prior activity by Pareja in Velázquez's studio, as we know very little about his workshop associates. It is known that Pareja had passed his examination as a painter in Seville. The portrait done from life immortalized Pareja as no amount of documentation could ever have done. Palomino says that it was such a vivid likeness that Velázquez sent Pareja with the painting to several friends to astonish them with the comparison between the original and the portrait. He goes on to report that Pareja's portrait was exhibited at the Pantheon on March 19, 1650, to the great admiration of painters of all nationalities, and that it was on the strength of this that Velázquez was elected a member of the Roman Academy in 1650. Velázquez had in fact already been honored by the painters of Rome by admission to the Academy of Saint Luke in January 1650, and to the *Congregazione dei Virtuosi al Pantheon* on February 13.[78]

Velázquez's portrait of *Innocent X* (Fig. 53) proved to be even more impressive. It is a tour de force of incisive characterization and coloristic audacity. The painting itself lends credence to the old story that the testy Pope responded to it with the exclamation: "It's too real!" Surely Velázquez did not soften his forbidding countenance. Proof of this is to be found by comparing the picture with the portrait bust Bernini made of Innocent X (who was no friend of his!) in about 1647. Bernini, Velázquez's equal as a portraitist, created an image of the stern-visaged Innocent that conveys the intensity and dignity of his personality, but lacks the strong earthiness of Velázquez's portrait. Color of course played a large part in Velázquez's striking conception. Setting off a series of bold reds against a limitless range of "whites," the artist transformed into an image of painterly beauty a florid old man whose features were no more distinguished than those of the humble types he had portrayed in his early days in Seville. The manner of the

78. Palomino, p. 913. See also Harris, 1958, pp. 189 ff.

portrayal is very different from that of the paintings of the early period. Now color creates form. The individual brushstrokes retain their primacy. The shadows are fluid and transparent, in contrast to the thick impasto of the highlights. There is no firm line between the figure and the chair or between the chair and the red curtain that hangs behind it. All parts of the surface of the canvas partake of a varied texture of paint surface.

There can be no doubt that Velázquez's portrait of *Innocent X* was received with enthusiasm by the patron and also by artists and the public at large. It is one of the few of Velázquez's works that never left the hands of the family of the sitter, in this case, the Pamphili family. It is now in the Galleria Doria-Pamphili in Rome, along with Bernini's bust of the same Pamphili Pope, who reigned from 1644 to 1655. Copies—the sincerest form of praise by colleagues—were not long in appearing. They joined replicas, usually only bust-length, from Velázquez's own workshop and in some cases in part or entirely from his own brush. He himself took a copy of this work with him, along with works by other masters, when he returned to Madrid. This was an important success for Velázquez, and it is clear that he recognized it as such, for he did not fail to grasp the opportunity it provided to enlist the Pope's aid. It appears that he even recorded his appeal to the Pope in the painting itself, for the paper Innocent holds in his left hand is inscribed "Alla San^ta di N^ro Sig^re / Innocencio X^o / Per / Diego de Silva / Velásquez dela Ca- / mera di S. M^ta Catt^co." This seems to be the salutation that introduces a petition. It is perhaps of some significance that this is the only case in which he inscribed a painting with his signature in this form and that he never signed a painting after this. The cause in which he sought the help of the Pope was his campaign to become ennobled. Innocent X did in fact instruct his Nuncio in Madrid to urge the King to grant Velázquez's appeal for admission to one of the three Spanish Military Orders.[79] He also gave the painter a portrait medallion on a gold chain, "in recognition of his great virtue and merit." [80]

In composition Velázquez's portrait of *Innocent X* appears to reflect the portrait of *Cardinal Fernando Niño de Guevara* (Fig. 54) that El Greco painted in about 1600. The El Greco shows a full-length figure facing in the opposite direction. Not only the pose of head, body, and arms and hands, but also the extraordinarily forceful depiction of the

79. Harris, 1958, p. 186.
80. Palomino, p. 912.

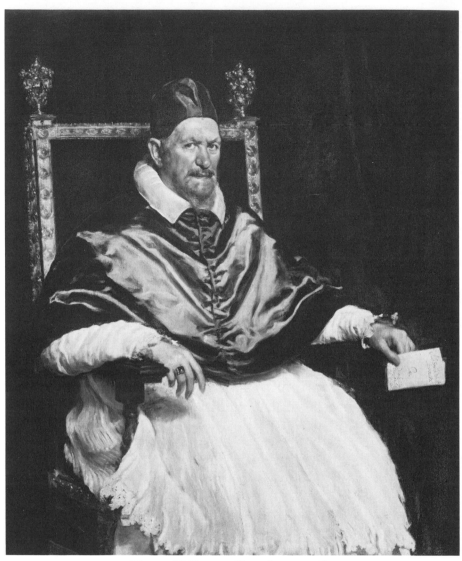

Fig. 53. Velázquez, *Pope Innocent* X

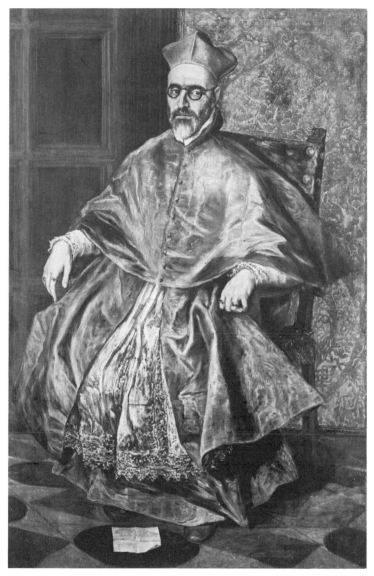

Fig. 54. El Greco, *Cardinal Fernando Niño de Guevara*

bone structure of the head and the intensity of the gaze that meets ours seem to have inspired Velázquez's rendition of Innocent X. El Greco's signature is also inscribed on a paper, which he placed at the feet of the sitter. Cardinal Fernando Niño de Guevara was Archbishop of Seville from 1601 to 1609; Velázquez would surely have been aware of

him as a personality, might very likely have seen him, and would thus have found El Greco's portrait of him particularly memorable. As it happens, it is, even without these associations, an unforgettable portrait. The higher back of Pope Innocent's armchair and its thronelike, elaborately carved and gilded chairback and finials both strengthened Velázquez's composition and added to the sense of luxury that pertains to the high rank of the sitter.

While in Rome, Velázquez also painted portraits of several members of the Pope's household. The bust-length portrait of *Camillo Astalli, known as Cardinal Pamphili* (Fig. 55) is an excellent example of the works of this period. The favorite and "adopted nephew" of Innocent X, Camillo Astalli was made a Cardinal on September 19, 1650, officially known as Cardinal Pamphili.[81] Early in 1654 the Pope officially deprived him of the name and revoked "all dispositions in his favor." Since Velázquez was in Modena on December 12 of 1650, he might have painted this portrait either before leaving Rome for Modena or after returning to Rome early in 1651. The small image of the youthful Cardinal, in his brilliant scarlet biretta and mozzetta, is painted with the same splendid assurance as that which marks the larger, more imposing portrait of the Pope.

Velázquez continued to be occupied as well with the King's business. In Venice in 1651 he is reported to have bought five paintings, two by Titian, two by Veronese, and a preliminary version of Tintoretto's *Paradise*. After this he returned to Rome, again to carry out the King's commands. But as early as February 17, 1650, the King had already been urging his return to Madrid. In a letter to his Ambassador to Rome he wrote:

I have seen your letter of November 6 of last year in which you give me an account of what Velázquez was doing concerning the tasks entrusted to him, and, since you know his phlegmatic temperament, it would be well for you to see that he does not exercise it by lingering in that court but hastens the conclusion of the work and his departure as much as possible, so that by the end of May, or the beginning of June, he can take passage to this kingdom, as I am ordering him to do, if the work is in a state to permit it. . . . I am sending an order to the Count of Oñate [Viceroy in Naples] to help him with the money which he will have stopped sending him, as much as he needs in order that he may have neither excuse nor pretext which might make him put it off and because at the same time I have ordered him to have Pietro da Cortona, fresco painter, come to this court . . . Since both have to make their journey by sea you will also arrange the way in which they are

81. Trapier, pp. 308 ff.

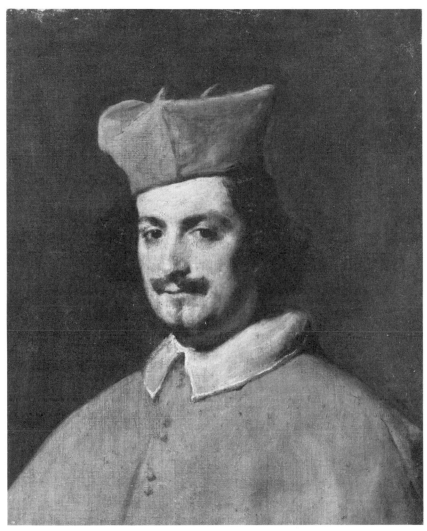

Fig. 55. Velázquez, *Camillo Astalli, Cardinal Pamphili*

to make the voyage, because I am sending an order to Velázquez not to come by land for fear that he might linger on the way, the more so because of his nature.

For more than a year thereafter the King sent repeated messages in his efforts to hasten Velázquez's return to Madrid.

The King's letter gives us one of the few contemporary comments on Velázquez's personal qualities that have come down to us. The mention of the painter's *flema* (slowness, coolness, or even sluggishness

and dullness are among the connotations of this word) may reflect the monarch's impatience as much as his painter's immutability. But there is some outside evidence that others as well considered Velázquez a slow worker.[82] The freshness and apparent spontaneity of his paintings give quite a different impression. Yet it seems to be true that he tended not to finish paintings promptly. Some were never "finished." Many of them appear to have been worked on over a period of time. To do this without "overworking" them is, of course, an achievement in itself. Perhaps Velázquez, like Cézanne, gave long consideration to the color, value, size, shape, texture, and placement of each individual brushstroke, a procedure that can prove to be virtually endless.

It is also interesting to learn from the King's correspondence that his favorite Court painter evaded his orders over a rather long time, despite repeated remonstrances. Surely only a person very secure in his position would have dared to do this. This too provides some insight into Velázquez's actual status. It seems likely that he was able to exercise such freedom only while he was at a distance from the Court. At home he seems to have been consistently at the King's service. It is tempting to suppose that this would have made him all the more reluctant to go back to the comparative bondage of Madrid from the freedom that Italy represented to him. It is not known when he finally left Italy; certainly Pietro da Cortona did not leave with him, as Philip IV had expected. Velázquez was back in Madrid on June 23, 1651.[83]

6. Work and Rewards in the Service of the King

Back at Court before the end of June 1651, after his prolonged sojourn in Italy, Velázquez was probably given little chance to be "phlegmatic" in taking up his manifold duties. On February 16, 1652, he was appointed *Aposentador Mayor del Palacio* (Chamberlain of the Palace), an appointment that brought him an increase in salary and an apartment in the *Casa del Tesoro* (Treasury), one of the buildings of the palace complex, connected with the Alcázar by a passageway. The new post burdened him with added services and frequent absences from Madrid as the King moved from one to another of the royal residences.

Painting portraits of the royal family was certainly among his

82. Gustavo Frizzoni, "Intorno al secondo viaggio del Velázquez en Italia," *Rassegna d'Arte*, 17, 1917, pp. 106–116.
83. Letter written by the King. See *Varia velazqueña*, Vol. II, p. 276.

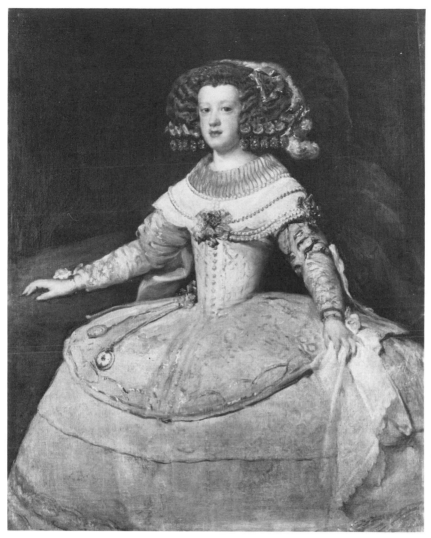

Fig. 56. Velázquez, *The Infanta María Teresa*

pressing obligations as soon as he had returned to the Court. The surviving child of Philip IV's first marriage, the Infanta María Teresa, was on the marriage market, at the ripe age of thirteen. Her portrait was needed to advertise her charms to the royal families with which a dynastic marriage was a possibility. The new Queen, Mariana of Austria, had been married to Philip on October 7, 1649, while Velázquez

was in Italy. Mazo had painted her portrait before the end of that year, but he would hardly have been considered a worthy substitute for the chief Court painter, and a portrait of her must have been high on the list of demands on Velázquez's time. Mariana, who was only about four years older than her step-daughter, produced a new subject for Velázquez's brush, the Infanta Margarita, on July 12, 1651. He and his assistants painted a number of portraits of these three ornaments of the royal house. In some cases replicas and workshop copies were made, assiduously following the models originated by Velázquez, but the paintings from his own hand show a degree of sensitive observation, freedom of brushstroke, and subtle unification of figure with space that no imitator could equal.

The portrait of *The Infanta María Teresa* (Fig. 56), painted in 1652 or 1653, demonstrates the pose and artistic qualities as well as the fashion in attire that characterized Velázquez's series of portraits of the female members of the royal family at this period. (This canvas has been cut at the bottom and probably at the top as well.) The Infanta, at the age of about fourteen, is shown with brightly rouged cheeks and scarlet lips. Her elaborate light-brown wig is decorated with pink and silver ribbons and a white plume, matching her white dress decorated with pink and silver ornaments and pearls. The wide tulle collar (*valona cariñana*), tight bodice, and hooped farthingale (*guardainfanta*), as well as the complicated headdress and exaggerated makeup, compose a feminine type that epitomizes the Court of Philip IV and is identified with the name of Velázquez. His coloristic preferences and sure, unmodulated brushstrokes achieved unhindered consummation in subjects such as this.

The portrait of *Queen Mariana* (Fig. 57) similarly exemplifies the fluent style with which he brought to life with sparkling vividness the rich and artificial Court dress of this time. The flagrant ignoring of royal sumptuary decrees practiced in the Court set the tone for all those who could manage such extravagances. The rigidity, formality, and conspicuous consumption reflected in this fashion belied the poverty and weakness that actually afflicted the monarchy. The elaborate wig and unnatural makeup, as well as the figure-distorting dress, with its tight bodice and exaggerated farthingale, make the wearer appear more like a puppet than like a human being capable of emotion and action. The fashion prevailing at the Court partook of the systematic denial of reality by which the regime sustained itself. It may have been Velázquez's idea to include in this composition the clock that

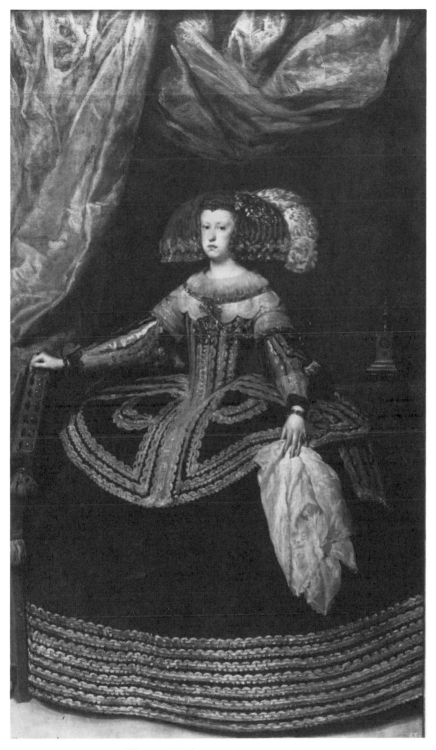

Fig. 57. Velázquez, *Queen Mariana*

stands on the table behind the young Queen. The clock is a symbol of an orderly and controlled life, hence of the virtue Temperance. It is also a universally recognized reminder of the transience of earthly life: *el tiempo va; la muerte viene*. In introducing the clock into the portrait, Velázquez may have been following the example of Titian's *Knight with the Clock* (Prado), a painting that was listed as early as 1666 in the inventory of the Madrid Alcázar.[84]

Close in date to these portraits of Queen Mariana and María Teresa is the portrait of the *Infanta Margarita* at the age of about three, thus presumably in 1654 (Fig. 58). Her pose is almost precisely the same as theirs. Though her stance and costume are not much less formal and elegant than those of her elders, her childish charm is represented with touching naturalness. In place of the vast kerchiefs that the royal ladies display, the little girl holds a folded fan in her left hand. Black lace provides a note of contrast with her salmon pink and silver dress and her golden hair and pale complexion. Against the blue curtain of the shadowed background, Margarita is luminous. The blue rug on the floor, patterned with red and ochre, adds to the liveliness of the image. And if the Infanta is as fresh and tender as a flower, to what can one compare the exquisitely painted pink, blue, and yellow flowers in a glass vase on the table beside her? Surely they were not to be equaled in painting before a few extraordinary works appeared late in the nineteenth century. Unique in Velázquez's body of work, this apparently casual still life passage gives proof, if proof were needed, of his ability to lead the way in any artistic task to which he set his hand.

The *Bust Portrait of Philip IV* (Fig. 59), painted at approximately the same time, in about 1654, gives a different picture of the state of the royal house. Though depicted, as always, with reserve and discretion, Philip is clearly aging. His eyelids droop, the circles under his eyes have deepened, and his chin has grown still weightier. The King was preoccupied with troubles, both inner and outer. Ridden with guilt and incapable of mending his erring ways, he expressed his despair in letters to the pious Sor María de Agreda.[85] He was equally impotent in dealing with problems of state. And his new marriage had not yet provided an heir to the throne. His trusted Court portraitist did not disguise the somber mood of his sitter. The black costume is only roughly blocked

84. On the meanings of clocks in Titian's portraits, see Erwin Panofsky, *Problems in Titian, Mostly Iconographic*, New York, 1969, pp. 88 ff.

85. María Coronel de Jesús de Agreda, *Cartas de la Venerable madre sor María de Agreda y del Señor rey don Felipe IV*, Madrid, 1886.

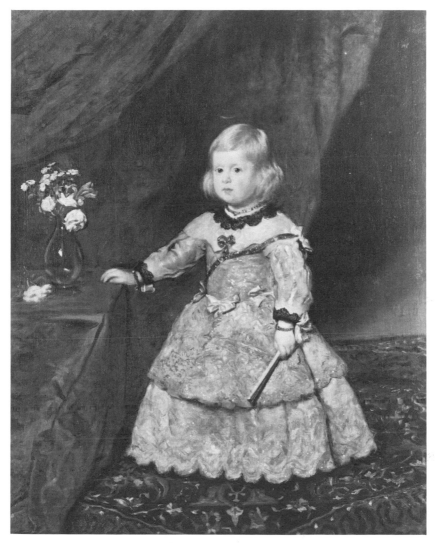

Fig. 58. Velázquez, *The Infanta Margarita*

in, and there is no indication of ornament to brighten the gloom. But the painting of the head is free and fluid.

Widely different dates have been suggested for the large painting *Saint Anthony Abbot and Saint Paul the Hermit* (Fig. 60). The brushwork and color suggest a date late in Velázquez's career, and the composition increases the likelihood that it was created in the period after his return from his second trip to Italy. A date around 1655 or later, after he had fulfilled his portrait obligations, seems plausible.

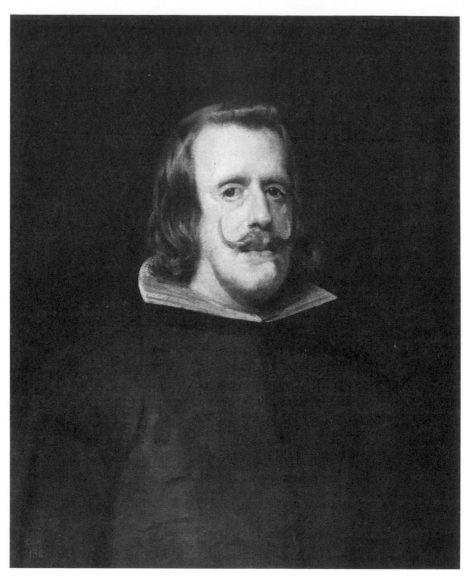

Fig. 59. Velázquez, *Bust Portrait of Philip IV*

With the exception of the Villa Medici landscapes, in which the figures are mere *staffage*, this is the only painting that can firmly be attributed to him in which the figures are so small in proportion to the picture space. This compositional scheme may reflect works he saw in Italy. The picture has much in common with Giovanni Bellini's *Saint Francis in Ecstasy* (Fig. 61). In both cases the right side of the composition is dominated by an escarpment, in the wall of which the entrance to the saint's dwelling is visible. In both the figures are placed in front of the looming cliffs, while on the left side the landscape falls away to a valley with a winding stream and mountain peaks beyond. The donkey in Bellini's painting has its parallel in the lion in Velázquez's, and both pictures include distant, small figures. It would not be surprising if the format of Velázquez's composition had been suggested to him by the Bellini *Saint Francis* or some other religious scene similarly set in a landscape that he saw in Venice. The *Saint Francis* is recorded in a Venetian collection in 1525, and it was still in Italy in 1845, but there is no certainty as to its whereabouts at the time when Velázquez was in Italy. In any case, Velázquez used this pattern to resuscitate the medieval practice of depicting simultaneously a series of events in a story.

According to the *Legenda Aurea*, Saint Paul, the first hermit, dwelt for sixty years in the depths of a cave in the boundless desert.[86] Saint Anthony, having learned of his existence in a dream, set out in search of him. He met a centaur, who told him to go to the right; this meeting was depicted by Velázquez in the far distance, on the bank of the curving river. Next (on the brightly lighted hillside behind the dark escarpment in the painting) he met an animal with the upper part of its body like that of a man, but the belly and feet of a goat, which identified itself as a satyr. Finally, Saint Anthony came upon a wolf, which led him to Saint Peter's cell, where he knocked at the closed door, as he is seen doing in the picture, to the right of the foreground figure of Saint Paul. As noon approached, a crow flew down bringing a loaf of bread, double the quantity of God's daily provision that had enabled the hermit to survive. This is the moment to which the main scene in the painting is devoted. As the crow approaches with the loaf, Saint Paul looks heavenward in an attitude of prayer, while Saint Anthony expresses his amazement at the divine intervention. To the left is shown the last event of the legend: after Saint Paul's death, two lions came out of the forest to dig his grave and help Saint Anthony to bury him.

86. Jacobus de Voragine, *The Golden Legend*, New York, 1941, pp. 88 f.

Fig. 60. Velázquez, *Saint Anthony Abbot and Saint Paul the Hermit*

Fig. 61. Giovanni Bellini, *Saint Francis in Ecstasy*

Originally semicircular at the top, the large canvas depicting Saint Anthony Abbot and Saint Paul the Hermit was apparently painted as an altarpiece for a specific place. According to the inventory of 1701, it was at that time in the Ermita de San Antonio, one of the buildings decorating the grounds of the Buen Retiro. This may well have been its original destination, though Palomino wrote, probably erroneously, that it was in the Oratory of the Ermita de San Pablo, an "hermitage" dedicated to the other hermit saint commemorated in the painting, likewise in the Buen Retiro grounds.[87] Velázquez's brilliantly advanced style brought optical unity to a compositional mode that belonged to the past. Prints by Dürer and paintings by Pintoricchio, Patinir, and Savoldo have been proposed as possible sources for Velázquez's interpretation of this subject.[88] No forerunner, however, could account

87. Palomino, p. 925.
88. Angulo Iñiguez, 1947, pp. 63 ff.

for the luminosity and the integration of the entire picture surface that make this picture unique.

The brushstroke throughout is extraordinarily free, even for the mature Velázquez. Much of the canvas (of a very fine weave) is covered by only a thin wash of paint. The landscape and the small figures are sketchy; the first touches of the brush remained unrevised. The head of Saint Anthony, who wears brown with a black cloak, is sketched in with thin, transparent shadows and boldly stated patches of light. Saint Paul, with his ecstatic expression and marvelous yellow-white translucent garment, is the focal point of the picture. Saint Anthony's left hand and the trajectory of the descending bird both point toward him, and the branch of the tree provides a leafy canopy for him. His head is more solidly rendered than any other part of the composition. The touching story of the meeting of the two saintly hermits is told with the most remarkable economy. Exalted religious sentiment has rarely been so perfectly expressed by its artistic equivalent. It is a visualization of the spiritual beauty of simplicity and renunciation that is the heart of the legend of the old hermit saints whose faith alone sustained them.

Thus as Velázquez went on into his advanced years he continued to search for and find solutions to different pictorial problems. He was undeterred by the fact that he was busy with interior decorating, making travel arrangements, and otherwise serving his sovereign, following his appointment in 1652 as *Aposentador Mayor del Palacio*. He also had personal preoccupations in these years. In 1652 his daughter died, soon after giving birth to her seventh child. One of his granddaughters was married in 1654 and went to live in Naples, where her husband was appointed magistrate by Philip IV, a concrete and practical tribute to the painter. After her husband died three years later, their little son was taken into the home of Velázquez, where he too died at the age of two and a half, on March 27, 1658. Meanwhile, Mazo had been appointed assistant to the *Aposentador Mayor* and was permitted to pass along to his son the post of *Ujier de Cámara*, which Velázquez had transferred to him soon after his marriage, in 1634. In this way the advantages that accrued to Velázquez as a favorite at Court became a family legacy.

In 1656 Velázquez summed up his life and work and gave voice to his highest ambition in the perplexing painting known as *Las Meninas (The Maids of Honor;* Fig. 62). From the time of Palomino this picture has been acclaimed as Velázquez's most celebrated work,

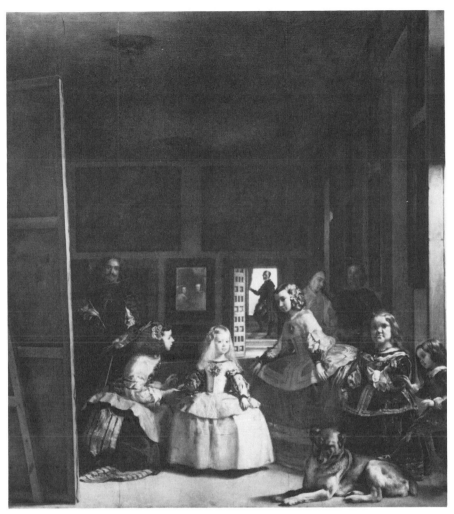

Fig. 62. Velázquez, *The Art of Painting* (*Las Meninas*)

and it is to this day one of the most widely appreciated works of art in the world. Few paintings have had so fruitful an influence on artists of succeeding centuries. The reticent Velázquez at last literally put himself into the picture. "He stands there looking so proud," as a young American visitor to the Prado remarked recently, on seeing *Las Meninas* for the first time. "It's as if he is saying: 'Here *I* am, and *I* made *this.*'" What led him to make this personal statement? What did he mean by it?

III.

Interpreting *Las Meninas*

1. Cast of Characters

When Diego Velázquez placed an image of himself standing boldly before his easel in the painting now generally known as *Las Meninas*, he provided a clearly personal clue to the puzzle of the meaning of this great picture (Fig. 62). The huge canvas that dominates the left side of his composition underscores the significance that the painter intended his presence in this scene to convey. He depicted himself—and this is the only sure self-portrait of him that we know—as a painter at work (Fig. 63). But he is looking neither at the canvas before him nor at any of his companions. His steady gaze is directed toward where we are, outside the picture. What, then, is his relation to the other figures in the scene?

The cast of characters represents a strikingly wide range of ages and physical types. In the right foreground lies a massive, somnolent dog. On the dog's back rests—lightly, it appears—the tiny foot of a childlike male midget. In contrast to the midget's dainty proportions is the blocklike form of the female dwarf who stands beside him. These three figures, by their position in space and their compositional unity, form a group apart (Fig. 64). Behind them is the central group, likewise three in number (Fig. 65). A concentration of light is reserved for the golden-haired girl dressed in gleaming silk who stands in the center. Bracketing her are a young woman at her right, who kneels and offers her a clay drinking cup on a tray, and a second young woman inclining deferentially at her left. Farther to our left and more distant from us in space is the painter. Corresponding to him at the right, somewhat farther removed from us than he, are an older woman in religious habit and a man with whom she appears to be in conversation. In the rear wall of the room, which is parallel to the picture plane, a door stands open and reveals a man pausing on a stairway, silhouetted against a brightly lighted wall. He too may be said to be part of a group of three, for on the rear wall, next to the doorway, hangs a mirror in

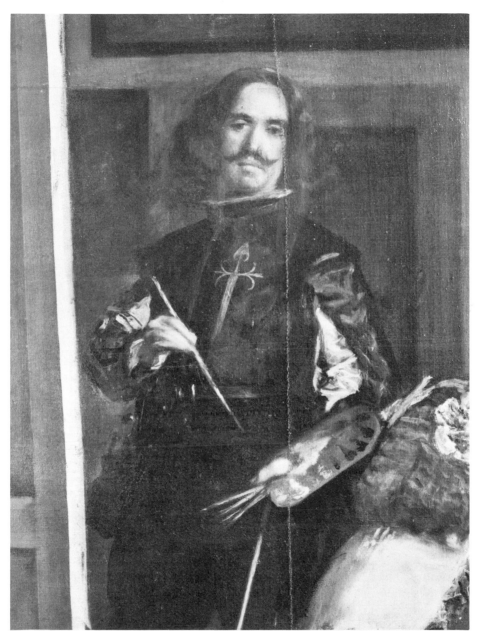

Fig. 63. Velázquez, *Las Meninas*, detail

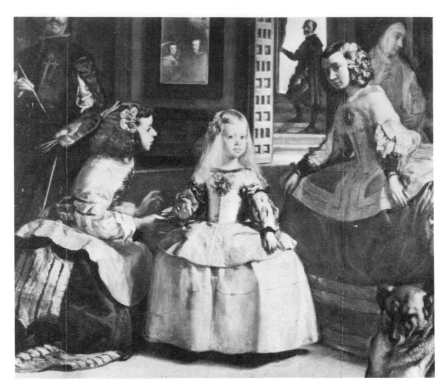

Fig. 64. Velázquez, *Las Meninas*, detail

which half-length figures of a man and a woman are reflected (Fig. 66).

These individuals were identified by Antonio Palomino in Book III of his *Museo Pictórico*, which was first published in 1724. Palomino refers to this painting, "among the most marvelous that Don Diego Velázquez made," as "the portrait of the Empress (at that time Infanta of Spain) Doña Margarita María de Austria, at a very young age."[1] (The Infanta Margarita was about five years old when this picture was finished, which, according to Palomino, was in 1656.[2] In 1666 Margarita was married to the German Emperor Leopold I.)

To continue with Palomino's description: Kneeling at the feet of the Infanta and offering her water in a *búcaro* is a *menina*, that is, a lady-in-waiting to the Queen, Doña María Agustina, daughter of Don Diego Sarmiento. On the other side of the Infanta, gesturing as if speak-

1. Palomino, p. 920. Palomino's comments are here translated and condensed.
2. Palomino, p. 921.

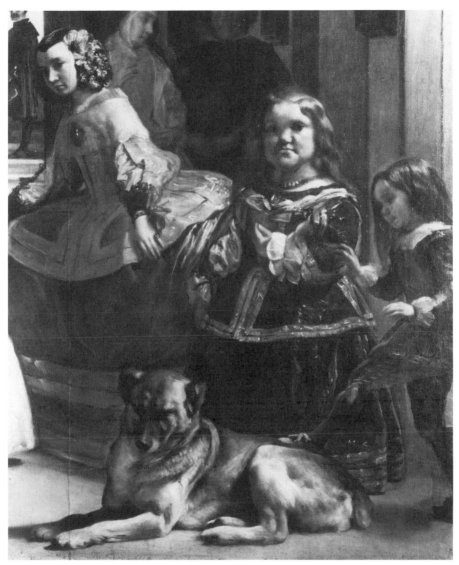

Fig. 65. Velázquez, *Las Meninas*, detail

ing, is another *menina*, Doña Isabel de Velasco, daughter of Don Bernardino López de Ayala y Velasco, Conde de Fuensalida, *Gentilhombre de Cámara* to the King. The midget who treads on the dog is Nicolasico Pertusato, who is demonstrating that the beast is tame and tolerant despite his ferocious face. The "dwarf of dreadful appearance" who stands behind the dog is Mari Bárbola. On a more distant plane is Doña Marcela de Ulloa, Lady of Honor. (She wears a nun's habit, cus-

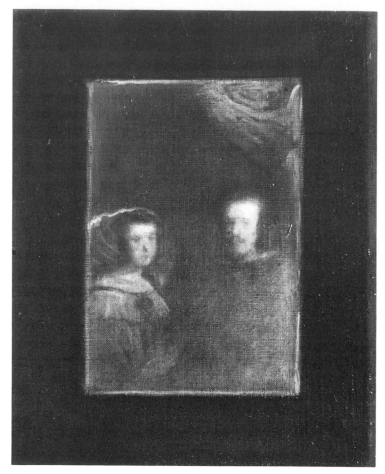

Fig. 66. Velázquez, *Las Meninas*, detail

tomary attire for widows at the Court in this period.) With her is a
guardadamas (an escort for ladies of the Court). At the other side is
Don Diego Velázquez painting. He holds the palette in his left hand
and in his right the brush. In his belt are the key of the royal chamber
and that of *Aposentador*. The Cross of the Order of Santiago is on
his breast; this "was painted after his death at the order of His Majesty,
and some say that His Majesty himself painted it, for when Velázquez
painted this picture he had not yet been granted this honor by the
King." King Philip and Queen Mariana are reflected in the mirror at
the back of the room, "painted with rare genius." And to the right of
the mirror, seen through the open door, is José Nieto, *Aposentador*
of the Queen, "easily recognizable despite the distance and the decrease
in size and light."

What these figures have in common is that they are all members of the royal household. In taking his place among them in the picture, Velázquez indicates that he too belongs to this exalted circle.

2. In the Footsteps of Apelles

Velázquez was indeed at home with the family of Philip IV. His father-in-law, Francisco Pacheco, wrote that after Velázquez's return from his first trip to Italy, in 1631, he was treated with "incredible liberality and affability by this great monarch, who continually visited him almost every day to see him paint in the workshop that he had in the King's gallery." [3] Pacheco stated that the King had a key for Velázquez's workshop in the royal palace. Palomino enlarged on this remark, explaining that the King's purpose was to see the painter quickly, "as Alexander did with Apelles, often going to see him paint, honoring him with such singular favor, as Pliny tells in his Natural History (lib. 31, cap. 10), and as Charles V with Titian and Philip II frequently went to see Alonso Sánchez Coello paint (Pacheco, lib. 1, cap. 6).[4] Imitating and even exceeding his heroic predecessors," Philip IV honored Velázquez with the office of *Ayuda de la Guardarropa*, Palomino goes on, "one of the highly esteemed appointments in the Royal House, honoring him likewise with the key of his room, a thing much desired by noblemen of the court." Continuing his rise, Velázquez attained the position of *Ayuda de Cámara* in 1643.

In 1652 the King appointed Velázquez *Aposentador Mayor* of his palace, in which post he remained until his death in 1660. Palomino (whose observations I give in condensed translation) stresses that this was not a purely honorific post.[5] Indeed, it required a great deal of activity, thus interfering with Velázquez's practice of his art. In this sense the honor was a punishment in the guise of a reward.

The King's regard for Velázquez, as Palomino recorded, was based not only on his artistic preeminence, but also on his character and his ability in Court business. This relationship was understood to redound to the credit of both parties. Like other writers who sought to gild the lily of esteem, Palomino invoked historical parallels of a kind that had become common currency. It was not unusual in the seventeenth century to praise a painter by referring to him as "the new

3. Pacheco, Vol. I, p. 161.
4. Palomino, p. 904.
5. Palomino, pp. 918 f.

Apelles," nor was it extraordinary to flatter a monarch by comparing him with Alexander the Great. The legendary friendship between Alexander and his favorite painter, as described by Pliny, was the customary model for later Court painters and their royal patrons.[6] In Pacheco's *Arte de la Pintura* there were no fewer than forty-one references to Apelles. Pacheco notes that Jan van Eyck was secretary and companion to the Duke of Burgundy and on personal terms with him, like Apelles and Alexander in antiquity.[7] Charles V, he says, allowed no one other than Titian to paint his portrait, as Alexander did with Apelles.[8]

Although already trite in Pacheco's day, the comparison of Velázquez with these illustrious predecessors was not mere empty flattery. In describing the splendid reception accorded Velázquez when he returned from Italy to the Court in Madrid in 1631 (about which he very likely was personally informed by his son-in-law), Pacheco reported that the Count-Duke of Olivares sent Velázquez to thank the King for not having permitted any other painter to paint his portrait during the year and a half of his absence.[9] It might appear that Velázquez, recognized as the favorite painter and respected companion of a great sovereign, like Apelles, Jan van Eyck, and Titian before him, would have had no need, late in his distinguished career, to paint a picture that could serve as a claim to status. Yet this is what he did, in 1656, in *Las Meninas*. On the basis of the record of events of the time, there is reason to believe that he was motivated by his long-unfulfilled ambition to achieve the aristocratic rank of membership in a noble order.

6. References to this legend generally ignore this part of the story: "Alexander gave him a signal mark of his regard: he commissioned Apelles to paint a nude figure of his favourite mistress Pankaspe [Campaspe], so much did he admire her wondrous form, but perceiving that Apelles had fallen in love with her, with great magnanimity and still greater self-control he gave her to him as a present, winning by the action as great a glory as by any of his victories. He conquered himself and sacrificed to the artist not only his mistress but his love, and was not even restrained by consideration for the woman he loved, who, once a king's mistress, was now a painter's." C. Plinii Secundi Nat. Hist. XXXV, 86–87. K. Jex-Blake, transl., *The Elder Pliny's Chapters on the History of Art*, Chicago, 1968, p. 125.

On the tradition of the regard of kings for painters, particularly the anecdote of Alexander and Apelles, see Ernst Kris and Otto Kurz, *Die Legende vom Künstler*, Vienna, 1934, pp. 48 ff.

Matthias Winner discusses Apelles as the personification of *Pictura* in *Die Quellen der Pictura-Allegorien in gemalten Bildergalerien des 17. Jahrhunderts zu Antwerpen*, Diss. Cologne, 1957, Chapter I.

7. Pacheco, Vol. II, p. 61.
8. Pacheco, Vol. I, p. 107.
9. Pacheco, Vol. I, p. 161.

The idea that Velázquez immortalized himself by associating himself with the Infanta Margarita in this painting goes back at least to Palomino. He pointed out the parallel with Phidias, who placed his own image in his statue of Minerva, and with Titian, who painted himself holding the portrait of King Philip II.[10] Thus, he said, the name of the artist will go down through the ages along with that of the exalted figure with whom he portrayed himself. Palomino arrived in Seville about twenty years after the death of Velázquez, some twenty-four years after this picture was painted. His information came from a pupil of the master as well as from the writings of Pacheco.[11] It seems likely, therefore, that Palomino's view of the ennobling of the artist by his presence in the picture was not far from the attitude that Velázquez himself would have had. Most later scholars, however, tended to ignore this implication of the painting. Perhaps this is because they considered Velázquez an immortal in his own right and the Infanta relatively negligible.

3. The Artful Composition

Interpretations of paintings, like the works of art themselves, bear the mark of the time when they were produced. Carl Justi, in his fundamental contribution to Velázquez studies, *Diego Velázquez und sein Jahrhundert*, published in 1888, described *"Das Gemälde der Familie Philipp IV (Las Meninas)"* as really a portrait of the Infanta Margarita as the center of a recurrent scene of palace life.[12] Such a gathering, he believed, could have occurred only by chance. When, one day, the King and Queen granted their painter a sitting in his workshop, their little daughter was brought in to mitigate the royal boredom. The light from the first window at the right, whose shutters

10. Carducho had cited these examples in his preface (though of course not with reference to Velázquez).

11. Juan de Alfaro y Gámez, born in Córdoba in the 1640s, was a pupil of Velázquez, probably in the latter 1650s (Palomino, p. 999). Palomino mentions that he made use of notes by Alfaro on the life of Velázquez, among others (p. 1002).

12. Justi, Vol. II, p. 311. The painting was called *The Family of Philip IV* in the list of paintings saved from the fire in the Royal Palace in Madrid in 1734, in which it was slightly damaged. López-Rey prefers the title *The Royal Family;* he notes that the title *Las Meninas* did not enter the Prado catalogue until 1843 (1963, p. 204). The earliest mention known, in an inventory of 1666, refers to "a portrait of the Empress with her ladies." A description differing substantially from the painting as we know it was written in a manuscript completed in 1696. See George Kubler, ed., 1967, p. 458.

had been left open to illuminate the painter's subjects, flowed also on the Infanta standing before her parents. The painter asked Nieto to open the door in the back, to see whether front lighting would be suitable. The King, who was himself "half a painter," noticed, as he sat relaxed in this intimate circle, that something like a picture lay before his eyes. He murmured: "That is a picture!" And the following instant the wish arose to retain the scene. Only a moment later, the artist was at work sketching the composition that chance had created.[13]

Justi was satisfied that this singular picture, "which would be inexplicable as an invention," was a realistic depiction of a casual event. Since the subject is simply what the King happened to see as he posed for Velázquez in the studio, the King—and the Queen, who sat beside him for their portrait—are outside the picture. Their presence is made visible by the attitudes of the other figures, Justi pointed out. The Infanta looks at her mother as she accepts the *búcaro*. Doña Isabel, curtseying, casts a sidelong glance toward the royal couple where they sit, here on our side of the picture plane. Mari Bárbola's eyes, doglike, seek the eyes of her master. The *guardadamas* likewise meets the eye of his sovereign. Nieto looks back from the doorway with a questioning glance. *We* see them all from the standpoint of the King. The position of the royal couple is confirmed by their reflection in the mirror on the wall in the back of the room. Justi recognized the compositional value of this device, but he accounted for the presence of the mirror not in terms of its formal contribution, but as an element of his anecdotal account of the origin of the painting: the King had placed himself opposite the mirror so that he could judge his pose.

How, then, would the painter have been able to see and sketch the scene that became the subject matter of *Las Meninas?* "Perhaps in fact he used a mirror," Justi says. "It is the picture of the production of a picture," the latter being the double portrait of the royal couple that they were posing for when this fortuitous grouping presented itself. Therefore the painter would have had to be standing within the picture space and looking out toward his royal sitters, just as he is shown in the painting, according to Justi.

Justi's explanation ingeniously accounts for the composition as a whole and for many of the details. But it has—rightly—been rejected

13. Justi, Vol. II, p. 315. Justi believed that Velázquez immediately made a sketch of the scene. He identified as this sketch a painting that had belonged to Don Gaspar de Jovellanos and that was known to Justi himself as in the Collection of Ralph Bankes in Kingston Lacy, Wimborne, Dorset, where it still remains. This picture is in fact an old reduced copy, as López-Rey pointed out. Reproduced in López-Rey, 1963, Pl. 232.

as anachronistic.[14] The Impressionist painters of Justi's time created paintings in the way that he described, fixing on the canvas a momentary visual experience. Nothing was farther, however, from the practice of Velázquez, whose compositions were thoroughly planned and controlled.[15] Certainly a design as complex and as subtle as that of *Las Meninas* must be attributed to artistry and not to chance.

At first glance one sees why Justi—and many others—have been carried away by the painting's striking effect of realism.[16] It appears to be a moment of life, magically arrested, living on eternally. A longer and more critical look at the picture, however, reveals anomalies that belie the verisimilitude. One source of doubt is the reflection in the mirror. As shown by the location of the lamp hooks in the ceiling, the mirror is at the center of the far wall, precisely midway between two doorways, with the top of its frame level with the top of the doorframes. If the room depicted is assumed to be a real room, the mirror must be understood as a permanent feature of the room's decorative scheme. It is highly improbable that the royal couple could have been placed exactly the right distance from the mirror and in such a position that their half-length portraits, complete with the red drapery (a standard feature of aristocratic portraits as formulated by Rubens and Van Dyck), would be reflected in the mirror as the unobstructed, perfectly balanced composition that appears there. It might be slightly more plausible to argue that the mirror reflects a portrait hung on the opposite wall at a level above the heads of the occupants of the room. In this connection, however, it must be borne in mind that no such double portrait of Philip IV and Queen Mariana exists or is known ever to have existed, nor is there *any* formal double portrait of similar composition by Velázquez. Equally difficult to account for is the position of the painter himself. He could hardly move forward to approach his canvas without tripping over Doña María Agustina's skirt.[17]

14. See Emmens, pp. 52–53, with references.

15. Angulo Iñiguez, 1947, p. 7. Having found prototypes that inspired several of Velázquez's important paintings, Angulo was certain that a model for *Las Meninas* also existed, but he was unable to discover it (pp. 100 ff.).

16. "Waagen sagte, man glaube hier die Natur in einer Camera obscura zu beobachten, Stirling erschien es wie 'eine Anticipation der Erfindung Daguerre's,' Mengs nennt es 'den Beweis, dass die vollendete Nachahmung der Natur etwas ist, das alle Arten von Betrachtern in gleicher Weise befriedigt.'" Justi, Vol. II, p. 316. A number of recent writers also espouse the "snapshot theory."

17. The importance of the painter and his canvas in Velázquez's composition makes it impossible to accept the opinion of Birkmeyer (p. 78, n. 16) that "the self-portrait of the artist is a later insertion." Birkmeyer saw this point as contradicting "any interpretation as pure 'realism.'"

Once we recognize that the composition contains a number of arbitrary features, and that it is not a snapshot of a real event, it becomes clear that it would be unprofitable to try to decide what it is that Velázquez is painting on his huge canvas.[18] It appears that Velázquez did not intend to be explicit about this. What he did make clear was that the pictured canvas is an attribute of the working artist. What is represented, it seems, is not the creation of a particular painting, but the act of painting in a more general sense.

The setting of *Las Meninas* appears to be Velázquez's studio. Palomino said that this room was in the *"cuarto del Principe,"* [19] that is, the suite in the Royal Palace that had been assigned to Prince Baltasar Carlos, who had died in 1646. If Velázquez had intended to make a realistic depiction of this room, which he used for some years as his workshop and office, it is incredible that he would have shown it entirely devoid of furniture, as the room appears in the painting. If in fact some other room in the palace was the scene, it too would undoubtedly have been furnished. The lack of even so much as one chair or table supports the theory that it was not Velázquez's intention to reproduce an actual event or to produce an historical document.

Velázquez did include in his painting "various paintings on the walls, though not at all clearly," which, according to Palomino, were known to be stories from Ovid's *Metamorphoses* by Rubens. In fact only the two large paintings hanging high on the rear wall have discernible subjects. These represent *Minerva Punishing Arachne* and *Apollo's Victory over Marsyas*. The presence of numerous additional paintings is indicated; they serve only to show that there are many paintings in the room in Velázquez's composition, whatever may have been the case with the actual room in which he painted. From the

18. Some observers, including Palomino, Justi, and Tolnay (p. 36), have thought that he was painting the double portrait for which the royal couple, according to this theory, were sitting. Bartolomé Mestre Fiol advanced the extremely unlikely proposition that a full-length double portrait of the King and Queen was the subject on the canvas and that the upper portions of the figures in this painting are reflected in the mirror ("El 'espejo referencial' en la pintura de Velázquez," *Revista Traza y Baza*, 2, 1973, pp. 16 f.). Others (for example Lafuente, p. 30; Soria, p. 268; Kehrer, pp. 11 ff.), judging that the canvas was too large for such a subject, have conjectured that he was painting what we see in *Las Meninas;* presumably he could have done this by looking beyond the King and Queen at the reflection, in a mirror behind them, of the scene that they were facing. It has even been suggested that he was working on a portrait of the Infanta. See also G. F. Hartlaub, *Zauber des Spiegels*, Munich, 1951, p. 105 and p. 193, n. 36.

19. Palomino, p. 921. On various opinions as to the room pictured, see Kubler, 1966, p. 212, n. 2, and López-Rey, 1968, pp. 134 ff.

point of view of their function in the design, the succession of
feigned paintings in their black frames on the right wall plays an im-
portant role in the highly persuasive perspective recession that is one
of the celebrated marvels of *Las Meninas*. The picture frames, along
with the other geometric shapes in the composition, also provide a reg-
ular rhythmic pattern against which the diverse natural forms in irreg-
ular placement have the effect of syncopation.

In this extraordinary view of a room, the ceiling occupies roughly
the top third of the composition, lending airiness as the sky would do
in a landscape painting. On the basis of the architectural and decorative
features of the room as well as the sharply diminished sizes of the
increasingly distant figures, a convincing linear perspective is produced.
In addition, there is an effect of aerial perspective that, it seems safe
to say, is unsurpassed in a painting of an interior. The subtle variations
in value and color contribute richly to this effect. The dog and the
monumental canvas function as *repoussoir* elements, that is, they es-
tablish the foreground plane of the picture space, thus implying the
increased distance that intervenes between us and the figures behind
them. The strong modeling of the foreground figures endows them
with apparent three-dimensionality. Crispness of fabrics, gleam of
jewels and embroidery, softness of hair and suavity of youthful com-
plexions—all are brilliantly indicated. In contrast with the relief of
these forms, whose tactile values press us into close proximity, the
lady of honor and her escort, in their more distant and dimly lighted
position, are wraithlike. The figure of the artist himself, somewhat
closer to us and better lighted, is given definition by fluid and sum-
mary strokes; with a kind of optical magic, fragmentary clues build
solid forms. Framed in the doorway of the dark rear wall, Nieto ap-
pears as a virtually flat silhouette against the sun-washed wall beyond
the stairway. The reflected figures in the mirror are insubstantial,
evoked through closely related values. Still less differentiated are the
subjects of the paintings on the wall above the mirror, which hang
close beneath the dark ceiling. Thus each element in the composition
is characterized by its particular distance from the beholder. Through
rigorous control of color, light, and brushstroke, the artist created an
image not only of figures, but of the space in which they exist.

The boundaries of the figures are repeatedly lost and found and
lost again. The diffuse contours of the forms knit them to their en-
vironment; this is the essence of Velázquez's painterly sensibility. The
semblance of stopped action that results has the air of something both

inevitable and unalterable. The exquisitely controlled tensions of the design also contribute to the impression that *Las Meninas* is a mirror image of a moment in life. It was this intense impression of realism that made it possible for even sophisticated observers to be satisfied with casual explanations for the subject matter of the painting. The proto-Impressionist effect of the broken brushstrokes helped to associate *Las Meninas* with the new tendencies in painting that became dominant in the latter part of the nineteenth century.

Quite to the contrary, the composition is in fact true to its own time. The eye of the onlooker grasps the *whole* at a glance. *Las Meninas* is the objective correlative of Wölfflin's summing-up of the formal features of Baroque style:

> The painterly is the deliverance of the forms from their isolation; the principle of recession is no other than the replacement of the sequence of separate planes by a uniform recessional movement, and a-tectonic taste dissolves the rigid structure of geometric relations into flux.[20]

Strongly contributing to the impression of intrinsic unity is the color scheme, which was no less carefully calculated than the composition. The lucent white dress of the Infanta, with its contrasting black lace and salmon-pink ribbons, is echoed in modulated tones in the costumes of the *Meninas*. Mari Bárbola wears dark blue with silver braid and white undersleeves, a counterpart to the costume of Doña María Agustina, who balances her at the other side of the canvas. The warm reddish tones of Nicolasico's costume blend with the siena and ochre of the dog, and together they claim kinship with the lofty stretcher of the canvas in the left foreground and its diminutive partner, the coffered door in the back wall, which matches it in color. There, at the most distant point visible, like the light at the end of the tunnel formed by the shadowy room, is the golden patch of sunshine that sharply stops the retreat into distance by providing—surprisingly—contrasts in color and value equal to those in the foreground. Always an individual colorist, Velázquez in this product of his ripe maturity used his mastery of hue and value in a new and peerless way.

The handling of paint too shows what a long way he had come from the thick, pasty paint films of his early works. The grain of the canvas is visible through the thin paint of the dark and middle tones, while the highlights are formed with bold impasto. The individual brushstrokes remain independent, leaving it to the beholder to infer

20. H. Wölfflin, *Principles of Art History*, New York (Dover) n.d., p. 159.

the form. The artist was able to ignore the usual preconceptions of details, such as facial features, deferring instead to the visual experience, in which contours are generally blurred. There was no precedent for Velázquez's mature style, nor has it since been matched.

4. Homage to the Visual Arts: A Flemish Tradition

It by no means detracts from our appreciation of *Las Meninas* to acknowledge that even in this masterpiece Velázquez conformed to artistic practice of the time in which he produced it. Always alert to existing art, he drew on and adapted a tradition that shared the aims he had in mind and provided a suitable compositional pattern for the picture he was planning. It was the precedent of Flemish gallery pictures that lay behind his conception.

Paintings of groups of people engaged in everyday activities in an interior setting were a Netherlandish specialty that came to fullest flower in the seventeenth century. There was a related class of paintings that flourished through most of the century and was limited mainly to Antwerp painters. The works that belong to this category are known as gallery pictures or paintings of *Cabinets d'Amateurs*. They are usually pictures of modest proportions and thus differ from *Las Meninas* in size and scale. In many other respects, however, they are markedly similar to Velázquez's picture. Many of them show a room with a series of windows dominating one side wall and paintings hung between the windows as well as on the other walls. Almost invariably the far wall of the room is parallel to the picture plane, and it is often opened to a further vista by a door or archway. A major element is the collection of art and curiosities depicted, usually in profusion. Besides paintings and sculptures, there are often coins and medals, exotic shells, and other objects valued for their rarity. In many cases visitors are seen enjoying the collections. Sometimes the figures are identifiable portraits. Both contemporary and legendary rulers are among them. In other examples sovereigns are represented by portrait paintings or sculptures. Often a painter is present, either showing works of art to a visitor or actually at work on a painting.

Though they may look like documentations of real places and events, gallery pictures customarily combine the real with the imaginary. Real, identifiable paintings may be on the walls, for instance, in a room in which Joseph is fleeing from Potiphar's wife, or Alexander the Great is watching Apelles paint a portrait of Campaspe, or the Olympian gods make themselves at home. Indeed, the collections de-

picted were often fictional; the same paintings appeared in altered arrangements or in various room settings in individual gallery pictures. Or identical rooms housed different art collections and different people. Thus it appears that these pictures were generally intended as something other than reliable historical records.

As has often been the case with the emergence of a new type of subject matter in painting, gallery pictures properly speaking, with their explicit major emphasis on collections of art works, developed gradually. Many of the features that were later to characterize gallery pictures were established in antecedents with somewhat different focal interests that were produced in Antwerp in the early years of the seventeenth century. The painter and architect Abel Grimmer was the originator of the earliest examples that have come down to us. His interest in architecture may have been the prime stimulus directing him toward this novel type of composition, in which the precisely executed details of architecture and decoration have a more professional look than do the small and insubstantial figures. As with the architectural details and furnishings, he took care to reproduce clearly the pictures hanging on the walls. He depicted the same interior, with only minor changes in details, in two paintings. In the first of these, which is inscribed "Abel Grimmer fecit 1608," [21] the room is occupied by a party of well-dressed men and women of the kind often referred to as "A Merry Company," which was a popular type of subject matter in Netherlandish painting in the seventeenth century. It seems likely that this group in fact constitutes an allegory of the Five Senses, which, like "A Merry Company," would have been understood at the time as having a moralizing intention. Though earthly pleasures may make attractive paintings, they were to be avoided in real life.

Seven years later Grimmer used the same room as the setting for three figures representing a religious scene, *Christ in the House of Martha and Mary* (Fig. 67). Again the figurative elements are subordinate to the architecture and furniture. This time, a banqueting scene is visible through the archway in the rear wall, which is parallel to the picture plane, and in the courtyard seen through the doorway at the right, a servant hurries by carrying silver cups on a tray in his left hand and a jug in his right. In this picture there is also increased emphasis on the paintings on the walls. The same painting of *The Fall of Man* hangs over the mantel on the left wall as in the 1608 picture. On the far wall, hung close under the ceiling, are paintings of *Joseph*

21. S. Speth-Holterhoff, *Les Peintres Flamands de Cabinets d'Amateurs au XVIIe Siècle*, Brussels, 1957, p. 50; repro. Fig. 2.

Fig. 67. Abel Grimmer, *Christ in the House of Martha and Mary*

Cast into the Well, *The Tower of Babel*,[22] *The Crossing of the Red Sea*, and, on the right wall, *The Angel of the Lord Destroying the Armies of Sennacherib*, inscribed "4 Rois 19." The story of Joseph was understood as a prefiguration of the Resurrection of Christ. Babel represented God's thwarting of human plans to contravene his purposes. The latter two Old Testament subjects, both of which were also depicted in the 1608 painting, illustrated the Christian theme of Salvation through divine intervention. Providence was also the theme of the New Testament subject above the credenza on the right wall, *The Rest on the Flight into Egypt*. On the panel beneath it is the inscription "Abel Grimer [sic] Fecit 1615." The paintings on the walls contribute to the evidence of the power of faith which is the message of the parable of Christ's visit to the home of Martha, the *Salvatoris hospita* (she who offers hospitality to the Saviour). These pictures are an essential part of the content of the whole, rather than mere interior decorations. They are apparently depictions of paintings that actually existed, and thus directly foreshadow the gallery pictures that were to follow. A dog in

22. As Speth-Holterhoff (p. 51) recognized, this is the well-known painting by Pieter Breugel the Elder that was in the inventory of the Antwerp banker Nicolas Jonghelinck in 1566.

Fig. 68. Jan Brueghel I, *The Sense of Sight*

the foreground is among the homely touches that were to find their way into gallery pictures and *Las Meninas* as well.

Soon after Grimmer signed his *Christ in the House of Martha and Mary*, Jan Brueghel the Elder painted the series of allegories of the Five Senses that were the immediate forerunners of the Flemish gallery pictures. Fantasy played a large role in these. The first of the series, *The Sense of Sight* (Fig. 68), is signed and dated 1617.[23] A pensive, nearly nude Venus gazes at a painting of *Christ Curing the Blind Man*—surely the most appropriate of subjects for a celebration of the joys of vision—which Cupid holds before her. Optical instruments of many kinds are scattered on the floor and tables. An abundance of jewels and coins, silverware, and tapestries enrich the scene, and there are also shells, small animals, and flowers to represent the world of natural forms that delight the eye. The chief embellishments, however, are sculptures and paintings. The paintings give priority to Brueghel's great colleague and neighbor, Peter Paul Rubens. The *Bacchanale* in the right foreground and the *Tiger and Leopard Hunt* on the rear wall are based on Rubens compositions. In the large painting on the extreme right, the Virgin and Child are by Rubens and the garland by Brueghel himself.

In addition, portraits by Rubens served to introduce the Regents of the Spanish Netherlands, the Archduke Albert and the Archduchess Isabella Clara Eugenia. As they were in fact patrons of the arts, and

23. The entire series is in the Prado. Speth-Holterhoff (pp. 52 f.) attributes the figures to a collaborator, probably van Balen, and erroneously states that Venus is looking into a mirror.

especially of Rubens, it was appropriate to make allusion to them in this composition, thereby honoring both the rulers and the arts. Both the double portrait of Albert and Isabella on the table at the left and the equestrian portrait of Albert that stands on the floor near Cupid are reduced versions of works by Rubens.

The architectural details and the room setting in general, as well as the disposition of the objects in the collection, in this painting by Jan Brueghel I, were reflected in many of the gallery pictures that followed. The rear wall, parallel to the picture plane, is broken on the left by an arched opening through which a palace and its gardens are seen. On the right it opens onto a vaulted room with an opulent display of paintings and sculpture. The opening of walls to further vistas was frequently adopted in the later paintings.

Among the early specialists in gallery pictures were Frans Francken II and his elder brother, Hieronymus II (also known as Jeroom or Jérôme), both of whom worked in the studio of their father, Frans I. After his death in 1616 they continued together until Hieronymus died in 1623. That works of this type from the Francken studio were widely known and highly regarded in their own time is indicated by the fact that one was included in the collection of Charles I of England, according to an inventory drawn up in 1639.[24] Gallery

24. Oliver Millar, ed., *Abraham van der Doort's Catalogue of the Collections of Charles I* (Walpole Society, Vol. 37), Glasgow, 1960, p. 65. B. M. Add. MS. 10112, f⁰. 8, no. 17: "Item a peece of painting of a Cabbonett wherein all sorts of painting are painted as if some pictures were hanging at the wall as also of severall sorts, of drawings soe well in redd as in black Chalk Boxes wᵗʰ books and manie other things painted upon Board. Don by Ffrancks Brought by the Lord Marquesse of Hambleton from Germany and given to the king." Millar noted (p. 232): "Possibly the picture by Frans Francken II in the royal collection or conceivably the picture by him in the collection of the Duke of Northumberland."

Wurzbach, I, p. 551, lists in his entry on Frans Francken I: "Der Kat. de Reus (Brüssel 1777) erwähnt ein Bild von Fr. Francken: Der Gemäldesaal der Erherzoge Albert und Isabella, welchen der Künstler selbst einige Bilder zeigt;—Ein ähnliches Bild ist im Kat. König Karl I (p. 154, N ɪɪ) angeführt." It is presumably to this that Speth-Holterhoff refers (pp. 61–62) in stating that Frans Francken I "fut sans doute le premier peintre flamand qui exécuta un Cabinet d'Amateur. Le catalogue de la collection de Charles Iᵉ d'Angleterre mentionne une de ses oeuvres: *La Galerie de Tableaux des Archiducs Albert et Isabelle, auxquels un Peintre montre des Tableaux.* Cette production, si intéressante du point de vue documentaire, a malheureusement disparu, de même qu'une de ses répliques, signalés dans la vente de Reuss [sic] à Bruxelles en 1777." The catalogue of the de Reus Collection sale, Paris, May 23–24, 1777, No. 18, lists the painting in question as by "F. Franck."

Since Frans I died in 1616, if he had been the first Flemish painter of a *Cabinet d'Amateur*, his gallery pictures would have antedated the series of *The Senses* by Jan Brueghel I, which, as we have noted, were dated 1617 and 1618. The fact is, however, that neither the catalogue of the collections of Charles I nor that of the de Reus sale identifies any particular Frans Francken as the painter of these pictures. It is highly probable that they were painted by Frans Francken II.

depictions from the Francken studio display paintings almost exclusively by Flemish artists. They also include many antique sculptures or casts. The personages present range from the Regents to a well-to-do collector and his family and various anonymous gentlemen.

Three paintings, one in Baltimore (Fig. 69), one, known as *The Arts and Sciences*, in the Prado, and an exact replica of the latter, recently in a Brussels collection, have identical settings, which suggests that gallery backgrounds were prepared, like stage sets, by a painter in the studio who made a specialty of this finicky task. Figures and other details—which differ in the two compositions—could later be added either by the same painter or by one or more others.[25] The setting is lofty and grand, enhancing the splendor of the objects displayed. The glories of antiquity, the standard of excellence for seventeenth-century artists and collectors, are evoked by the marble columns of the doorway and the statues of Minerva, Mercury, and a River God that surmount it. All the paintings appear to be Flemish, most of them more or less contemporary. It seems that the Baltimore painting transformed the ready-made setting into a tribute to Albert and Isabella as patrons of the arts and learning. Reciprocally, the presence of the Regents dignifies the arts and intellectual endeavors. In contrast to their enlightened protection is the barbarous behavior of the animal-headed creatures who destroy paintings and musical instruments in the painting on the floor near the center of the composition. This subject, a favorite of Frans Francken II, conveys satirically the same message that the gallery picture proclaims in a positive way. Art pertains to the higher functions of humanity. To destroy it is stupid and bestial. The beasts-in-human-form that the artist had in mind may have been Protestant iconoclasts.

The Gallery of Sebastian Leerse (Fig. 70) can readily be accepted as a representation of a real collection in the home of the wealthy Antwerp businessman who is pictured seated with his wife and son amidst his art treasures. On the basis of a portrait of this family group painted about 1634 by Van Dyck (Cassel, Museum), Speth-Holterhoff identified these figures as Sebastian Leerse, his second wife, and his son

25. In the Prado catalogue, 1972, p. 651, no. 1405, the Madrid picture is attributed to Adriaen van Stalbent (or Stalbemt). Speth-Holterhoff attributes it to Hieronymus Francken II, with some collaboration by his brother, Frans II, on the figures (pp. 69 f.). The Walters Art Gallery attributes its picture to Jan Brueghel I. Hieronymus Francken may have painted the settings of both pictures. In the Baltimore picture, the major figures appear to be by Frans Francken II, while the animals and flowers suggest the style of Jan Brueghel I.

Fig. 69. Francken Studio, perhaps with Jan Brueghel I, *The Regents Albert and Isabella Visiting a Collector's Cabinet*

Jean-Baptiste.[26] The age of the little boy suggests a date of about 1628 or 1629 for the painting, a date that is consistent with the mature style of Frans Francken II. In Leerse's collection, pride of place is given to an *Adoration of the Magi* by Frans Francken II; its protective curtain emphasizes the value placed on this canvas. Visibly signed—"F FRANCK IN ET F"—is the picture of *Apelles Painting the Portrait of Campaspe* that stands on the floor in the right foreground (Fig. 71).[27] The prominent placement of this picture and the fact that the artist conspicuously claimed it with his signature indicate its importance in the conception of the gallery picture in which it appears. Alexander, the

26. Speth-Holterhoff, p. 78.
27. According to Speth-Holterhoff, p. 79, the original is in Chatsworth, Duke of Devonshire Collection. This composition also appeared in a painting that was sold in New York, Parke-Bernet Galleries, Nov. 5, 1942 (37); in this case it was bordered by a series of small scenes from the life of Alexander, in grisaille. Frans Francken II's painting of this subject is similarly prominent in other gallery pictures painted by him, e.g., one dated 1625 in the Charles de Beistegui Collection, Château de Groussay, Montfort-L'Amaury (Speth-Holterhoff p. 75 and Fig. 15).

Fig. 70. Frans Francken II, *The Gallery of Sebastian Leerse*

Fig. 71. Frans Francken II, *The Gallery of Sebastian Leerse*, detail: *Apelles Painting the Portrait of Campaspe*

pagan patron saint of the art of painting, sheds luster on the collector whose appreciation of Frans Francken II is here made visible. Apelles is the model of the respected painter; his sovereign valued his companionship as well as his work. Like the seventeenth-century writers on art who made use of this story from Pliny, painters found it a ready reference to the exaltation of the art of painting and to their own worth.

A drawing which similarly shows Alexander watching while Apelles paints a portrait of Campaspe was included in a gallery painting of approximately the same period by a younger contemporary of Frans Francken II, Willem van Haecht II. In this picture, *The Gallery of Cornelis van der Geest Visited by the Regents* (Fig. 72), the largest drawing on the table in the center of the foreground (Fig. 73) represents the famous scene in the studio of Apelles. Julius S. Held recognized that it reproduces a drawing by Johan Wierix (Fig. 74).[28] The image of Alexander the Great in the role of protector of the art of painting is paralleled by the portraits of the Regents of van Haecht's country, Albert and Isabella, whom he depicts not as reflected in a work of art, but as live visitors to the gallery. With them is a large group of individuals, most of whom have been identified as either members of their entourage or other prominent persons of the time. A group of well known painters is on the right.

Like Frans Francken, van Haecht placed his signature on one of the feigned paintings, the *Danaë* in the center foreground, and added the date, 1628. Many of the other paintings are recognizable works, mostly by artists of the Antwerp school. The motto over the doorway, "Vive l'Esprit," confirms the identification of the collector whose gallery is depicted as Cornelis van der Geest, who earned a place in art history in 1610 through the part he played in commissioning Rubens to paint the *Erection of the Cross* for the Church of Saint Walburga. (*Esprit* is the French equivalent of the Flemish *Geest.*) He owned a famous house and a celebrated collection of paintings. It is documented that on the occasion of a visit to Antwerp on August 23, 1615, Albert and Isabella called on him. This appears to be the event that was commemorated in the painting finished thirteen years later.[29]

28. Joz. de Coo, *Museum Mayer van den Bergh, Catalogus I*, Antwerp, 1960, pp. 202 f., No. 748. Professor Held very kindly lent me the photograph of the drawing.

29. Julius S. Held ("Artis pictoriae amator: an Antwerp Art Patron and his Collection," *Gazette des Beaux-Arts*, Series 6, Vol. 50, 1957, p. 61) pointed out that some of the pictures shown were painted later than 1615.

Fig. 72. Willem van Haecht II, *The Gallery of Cornelis van der Geest Visited by the Regents*

The van der Geest gallery picture is a valuable historical document for the evidence it gives as to cultivated taste in Antwerp in 1628. Netherlandish works of the fifteenth and sixteenth centuries hang alongside Venetian paintings and advanced contemporary works. Paintings dominate the scene, but there are also excellent small bronzes. Coins and prints, books, globes, and optical instruments—tributes to learning as well as to the arts, which were essential parts of a seventeenth-century collector's cabinet—are lavishly provided.[30]

The personages depicted have not all been assembled for the Regents' visit.[31] Most of their images were based on portraits by van Dyck. The proportions of the room may, like the distinguished company, have been augmented by the artist's imagination. The height of

30. See R. W. Scheller, "Rembrandt en de encyclopedische kunstkamer," *Oud Holland*, 84, 1969, pp. 81–147.

31. The only man other than the Archduke who wears a hat is Ladislas Sigismund, King of Poland, who in fact visited the van der Geest house in 1624, while Crown Prince. (Speth-Holterhoff, p. 101.)

Fig. 73. Willem van Haecht II, *The Gallery of Cornelis van der Geest*, detail

Fig. 74. John Wierix, *Apelles Painting the Portrait of Campaspe*, drawing

the ceiling may well have been exaggerated to accommodate rank on rank of paintings on the walls. The doorway in the right wall, here giving on a courtyard with an elaborate arcade, and the window wall on the left, with pictures between the windows, are common to many gallery pictures. So is the rear wall, parallel to the picture plane, with a buffet in the center. It was of no significance that the objects and persons were assembled not in reality, but only in the artist's imagination, so far as the purpose of the picture was concerned. It was intended as a tribute to connoisseurship. That the rulers of the Netherlands are shown in the company of artists, enjoying their shared interests, implies a social status that few artists could claim, but others could aspire to, at that time. For about ten years, until his death in 1637, Willem van Haecht was curator of the collection of Cornelis van der Geest.[32] His tasks included the physical care of the paintings, restoring, and the like. It may be that he therefore had special reason to insist that as an artist he was not a mere manual worker, but a connoisseur and intellectual, worthy to meet and discuss art with even the most exalted members of society, as artists are seen doing in his gallery pictures.[33]

Van Haecht's concern with the status of the art of painting and its practitioners is explicitly expressed in his painting *The Studio of Apelles* (Fig. 75).[34] As in Frans Francken's conception (Fig. 71), Alexander stands close beside the painter and appears to be instructing him or at least taking an active interest in the progress of the painting.

32. Held (p. 62) observed that the painting "seems to be a condensation into one picture of van der Geest's role in society and as a friend of the arts" and also (p. 72) that "there seems to be a close correspondence between the social hierarchy and the compositional plan of the work." Held also suggested (p. 71) that the figure approaching the doorway on the right from outside may be a self-portrait of van Haecht, who was thirty-five years old in 1628. Van Haecht (or Verhaecht) was the son of the painter Tobias Verhaecht, who taught Rubens.

33. Leo van Puyvelde ("Willem van Haecht en zijn 'Galerij van Cornelis van der Geest,'" *Revue Belge d'Archéologie et d'Histoire de l'Art*, 24, 1955, p. 160) stated that van der Geest did not commission this painting. He based this conclusion on the fact that the will of van Haecht, dated July 11, 1637, specified this legacy: "An Sr. Cornelis van der Geest, eerst de grootste constcamere by den testateur geschildert." As Held pointed out, however, this was not van Haecht's largest gallery picture, and his will might well have referred to another "constcamere."

34. The architecture depicted may reflect that of the Rubenshuis. The Mauritshuis catalogue (French Ed., 1935, pp. 108–116, No. 266) suggests that this picture "may be intended as an allegory on the talents of Rubens." There is a smaller, simpler version in the Charles de Beistegui Collection, Château de Groussay, Montfort-L'Amaury.

Fig. 75. Willem van Haecht II, *The Studio of Apelles*

The figures closely resemble those of the Emperor Maximilian and the painter in an early-sixteenth-century woodcut (Fig. 76). Hans Burgkmair designed this for the *Weisskunig*, a book of prints celebrating the lineage and excellence of the Emperor. The popular legend of Alexander was one of the sources behind this visual equivalent of Machiavelli's book *Il Principe*. The woodcut showing the Emperor, accompanied by his dog, visiting Burgkmair's studio provides a direct link for the references to Alexander and other rulers in the gallery pictures of seventeenth-century Antwerp, allusions which likewise relate to *Las Meninas*. It also gives evidence of the relationship of these later works to the medieval tradition of the Mirror of Princes, which the *Weisskunig* translates into Renaissance language. It glorifies the ruler, indicates his interest in all the arts and sciences, and sets a standard of the virtues appropriate to royalty.

Both in the room in which van Haecht's Apelles is painting and in the adjoining gallery, visitors are seen busying themselves with the paintings and sculptures. At the same time, scientific investigations are being conducted. As in Cornelis van der Geest's gallery, a group

Fig. 76. Hans Burgkmair, *The Pleasure and Aptitude the Emperor Shows for Painting*, woodcut

of men gathered about a globe discuss astronomy or geography. The association of the visual arts with scientific interests and intellectual pursuits is clearly set forth in a number of other gallery paintings by various artists. It is evident that an effect of this association, repeatedly asserted, was to testify that the visual arts were not mere crafts but pertained to the most respected mental endeavors.[35] It can hardly be doubted that the painters who conceived these compositions intended this effect.

The tradition of extolling art collections by making them the subject matter of new works of art was enriched in quantity, variety, and quality by the following generation of Antwerp painters. Chief among

35. E. H. Gombrich (*Symbolic Images*, London, 1972, p. 76) dealt with similar efforts during the Renaissance. "Two ways were open to the artist to make good his claim for a higher position. He could try to demonstrate his equality with the scientist, the way to which Leonardo devoted his life; or he could stress his kinship with the poet and base his claims on the powers of 'invenzione.'"

them was David Teniers II, whose experiences in some ways strikingly paralleled Velázquez's. His long career was blessed by the genii of time and place. If he had been working a generation earlier, his considerable abilities would have been eclipsed by the great Flemish painters of that time; Rubens, Van Dyck, even Jordaens and Jan Brueghel surpassed him in their various ways. When he came to maturity, the art of Antwerp profited by their example and their still-reflected glory, but it was no longer dominated by giants. Teniers had a greater gift for both color and composition, as well as a more ingratiating, freer brushstroke than his immediate predecessors and the contemporaries whose artistic goals were similar to his.

The son of an artist, from the start he was close to the families of painters in which Antwerp was exceptionally rich. At the age of twenty-seven, in 1637, he married Anne Brueghel, the daughter of Jan Brueghel the Elder and granddaughter of the great Pieter Bruegel. Rubens's wife, Helena Fourment, was godmother to the first of their seven children, in 1638. Soon after his marriage, he began to rent the castle of Drij Torens, near Perck, where he enjoyed the life-style of the landed gentry. His paintings show him and his wife making a stately appearance at the festivities of the local peasants and enjoying the aristocratic life on their own domain. He received important commissions. In 1635 Teniers became Dean of the Guild of Saint Luke.

The Archduke Leopold William, who became Governor of the Spanish Netherlands in 1646, selected Teniers to paint and to buy paintings for him and to serve as curator of his collection, where he took care of the paintings and escorted distinguished visitors through the galleries. Teniers's personal relationship with the Archduke became even closer when, as Court painter, he moved to Brussels in 1651. Two years later, Leopold William was godfather to his sixth child. The Archduke gave him a gold chain with his portrait medallion suspended from it, a gift that not only was of considerable material value but also was a token of special esteem. The fact that such superlative masters as Titian and Rubens had been the recipients of similar gifts from royal patrons augmented the pride that an artist might justly take in this traditional sign of favor. Teniers had the extraordinary privilege of being honored twice in this way. Queen Christina of Sweden gave him a gold chain with her portrait when in 1654 she visited Brussels, where in the Archduke's palace she converted to the Catholic Church. Philip IV was said to have bought so many of Teniers's pic-

Dauid Teniers Antuerpianus Sereniss.^s Leopoldo Archiduci, & Ioanni Auſtriaco
Belgy Gubernatoribus Pictor familiaris, & Vtriq; à Cubiculis. A.M.D.C.LIX. Æ tat: 49.

Herous faciles aditus in limina Regum:
Sanguis habet. Faciles fecit Oliua tibi,
Artificesque, oleo ducti, fecere colores;
Nec tamen in dubio ſtat tua fama loco.
Sors metuenda alys. Oleâ Pax gaudet amicâ
Pax Oleo ſemper gaudeat iſta tuo. Sic amico vouit G.D.H.

Petrus Thys pinx. Abraham Teniers excudit. Lucas Voſterm: Iun: ſculpſ.

Fig. 77. Lucas Vorsterman, *David Teniers II*, engraving after a
painting by Peter Thys

tures that he had to build a special gallery for them in his palace in Madrid.[36]

Leopold William had been brought up in Spain, where he had the advantage of developing his taste in art on the basis of the paintings collected by Charles V and Philip II, with their preference for the great Venetians. He had brought more than five hundred Italian paintings to Brussels with him and wished to have engravings made after his favorites among them. For the use of the engravers, he had Teniers paint reduced copies of these pictures. The large folio book published in 1660 contains two hundred forty-four engravings after individual paintings, a general view of the Archduke's gallery, and a portrait of Teniers, as well as an engraved frontispiece dated 1658.[37] Teniers's portrait, engraved by Lucas Vorsterman after a painting by Peter Thys, is dated 1659 (Fig. 77). Teniers wears two gold chains, and the medallion with a profile portrait of the Archduke is clearly in evidence.[38] The large key that hangs from a cord at his waist is also an impressive status symbol. It is the insignia of his office as *Ayuda de Cámara*.

In the course of executing for Leopold William so large a number of copies of works by many masters, Teniers developed unusual skill at imitating even in much reduced scale the style of each artist. His special proficiency in this regard is evident in the many paintings he made of the Archduke's gallery. These paintings spread the fame of the collection—and of Teniers—to Courts all over Europe, where Leopold William sent them as gifts to his relatives and friends. Many of the tiny replicas displayed in these gallery pictures are easily identifiable; in some of the pictures Teniers made the attributions doubly sure by inscribing the names of the artists on the frames of their compositions. This conveyed a full measure of glory to the individual painters as well as to the patron who had assembled the prodigious collection and to the art of painting as a proper concern of the well-born and knowledgeable.

36. Arnold Houbraken, *De groote Schouburgh*, Amsterdam, 1718–1721. (A. von Wurzbach, translator and editor, Osnabrück, 1970, p. 149.)

37. *Theatrum Pictorium Davidis Teniers*, Antwerp, 1660. Brunet 9421.

38. Adolf Rosenberg (*Teniers der Jüngere*, Bielefeld and Leipzig, 1901, p. 67) correctly identified the portrait on the medallion. Roger Peyre (*David Teniers*, Paris, 1932, p. 63) stated that the medallion was the one given to Teniers by Queen Christina. The costume *all'antica* may have led to the misconception that female dress was depicted.

Fig. 78. David Teniers II, *The Archduke Leopold William in His Picture Gallery in Brussels*

One such picture, *The Archduke Leopold William in his Picture Gallery in Brussels,* now in the Prado, was sent by the Archduke to his cousin Philip IV (Fig. 78). It was probably early in his tenure as Court painter that Teniers proudly signed "David Teniers fec/Pintor de la Camera de S.A.S." This painting was in the Royal Palace in Madrid in 1653.[39] The Archduke stands to the right of the doorway in the rear wall. He is distinguished by the broad-brimmed hat he wears and the gold chain from which hangs the cross of the Teutonic Order, of which he was Grand Master. The man at the left of the doorway, wearing a cloak and holding his hat, has been identified as the Count of Fuensaldaña, a patron of Teniers.[40] Beside him, holding a print, stands the painter. In bearing and attire, he appears as austere and

39. It was seen there by Lázaro Diaz del Valle, *Varones illustres,* 1653, MS., fᵒ. 107, as cited in Exhibition Catalogue, Brussels, Musées Royaux des Beaux-Arts, May 7–July 13, 1975, *Maîtres Flamands du XVIIᵉ Siècle du Prado et de Collections privées espagnoles,* p. 140, No. 39.

40. Prado catalogue, p. 669, No. 1813. The date of the painting is given as about 1647.

aristocratic as his companions. Only the two dogs lend a note of in-formality. Pictures glimpsed on the wall of the adjoining room through the half-open door hint that only a fraction of the collection is visible in the picture. The important works reproduced here, how-ever, in themselves constituted a rare assemblage.

In other paintings of the Archduke's gallery Teniers likewise de-picted himself in the company of the Archduke. Among the pictures shown, again mostly by Italian artists, are some of the same works as in the Prado painting, but the arrangement of the pictures is in each case entirely different, as is the architectural setting. It appears, then, that even when dealing with an actual collection, the painter had some leeway regarding his composition. The four gallery pictures by Teniers in Munich support this impression. In relation to *Las Meninas,* it is interesting to note that in the painting known as *Brussels Gallery III* the partly opened door in the middle of the rear wall appears. In this case a man stands in the doorway with his hand on the knob, but he does not appear to be entering the gallery from the adjoining light-filled room. On the contrary, like Nieto in the doorway of *Las Meninas,* he seems simply to be standing there.

Brussels Gallery I (Fig. 79) displays some of the paintings seen in the other Teniers pictures of the Archduke's collection, in another different arrangement and setting. Here a painter clearly someone other than Teniers himself—is seated at his easel in the left fore-ground, looking intently at his model. A dog is, as usual, in the foreground, at the right side. Beside the artist three visitors look on. The poses and placement of these figures closely resemble the depic-tions of Alexander and his courtiers standing beside Apelles, and the pose of the sitter as well, in van Haecht's *Studio of Apelles* (Fig. 75). At the left is the familiar motif of a man at an open door. The Arch-duke is not present in this scene. Instead, a part of his collection is shown in a room in which a painter is at work. It may be that this picture was not commissioned by Leopold William and that it reflects Teniers's interests. This may account for the fact that Flemish paint-ings are given greater prominence. It may likewise explain the image of the working painter. "If works of art are worthy of honor," this picture seems to say, "should not the men who create them share in the approbation?"

Brussels Gallery II, which, like the others in Munich, came there from the Castle of Nymphenburg, is known as *The Archducal Gal-lery with the Royal Portraits* (Fig. 80). In this case the figures are mere

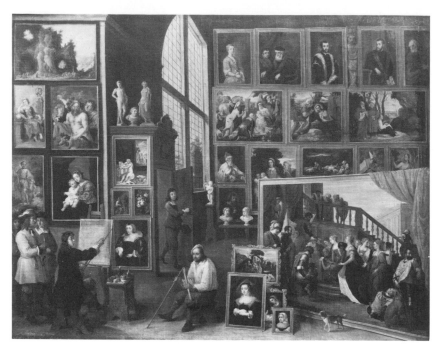

Fig. 79. David Teniers II, *Brussels Gallery I*

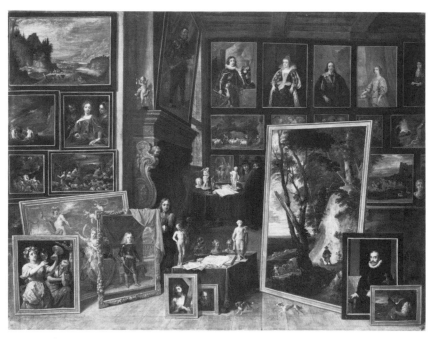

Fig. 80. David Teniers II, *Brussels Gallery II: The Archducal Gallery with the Royal Portraits*

staffage, hardly diverting our attention from the display of paintings that constitute the subject that interested the painter. These pictures imply a tribute to Flemish art, and there are grounds for suspecting that in this case it was likewise the taste of Teniers rather than that of the Archduke that dictated the choice. The large portraits of royalty, based on works by Rubens and Van Dyck, that fill the upper zone of the rear wall were in the palace in Brussels when Leopold William arrived there, and he did not remove them and take them along when he retired to Vienna.

The display of royal portraits has the effect—surely not unintentional—of calling to mind the importance of the painter's role as Court portraitist. The painting of images of the high and mighty had a long tradition in European art. Such portraits served manifold purposes. They could spread the fame and provide a focus for the adulation of the leader. They could in a sense immortalize the dead, preserving them for history with a particularity that words could never equal. They could serve to inform participants in dynastic marriages about the appearance of the stranger who was the prospective spouse. A painter's prestige greatly profited from these varied services, and royal portrait commissions were coveted.[41]

The selection of royal portraits that Teniers included shows at a glance the widespread demand for works of this kind from the studios of the two great Antwerp masters who led the field in the first forty years of the seventeenth century.[42] Rubens and Van Dyck had been the preferred portraitists for Courts all over Europe, and they had been richly rewarded, both financially and socially, by their powerful

41. As Leon Battista Alberti wrote in his treatise *On Painting* (1435), Book II: "Painting contains a divine force which not only makes absent men present, as friendship is said to do, but moreover makes the dead seem almost alive. Even after many centuries they are recognized with great pleasure and with great admiration for the painter. Plutarch says that Cassander, one of the captains of Alexander, trembled through all of his body because he saw a portrait of his King. . . . Thus the face of a man who is already dead certainly lives a long life through painting." (Alberti, *On Painting,* translated and edited by John R. Spencer, New Haven, 1966, p. 63.)

42. The portraits on which the series at the top of the rear wall were based were, from left to right: Louis XIII of France and Anne of Austria, attributed to Rubens; Charles I of England and Henrietta Maria, by Van Dyck; Isabella Clara Eugenia, by Rubens. The full-length figure in armor over the mantel represents Van Dyck's portrait of Count Johan of Nassau-Siegen. On the floor at the right is Rubens's portrait of the Archduke Maximilian of Austria, brother of the Archduke Albert. The small boy wearing armor and holding a baton, in the left foreground, is certainly also a member of a royal house; perhaps he is Charles II of Spain, who inherited the throne at the age of four, in 1665.

patrons. Both had been knighted. It would not be surprising if David
Teniers, official painter to the Governor of the Spanish Netherlands,
hoped to follow in their illustrious footsteps. Over a period of years
Teniers did, in fact, exert every effort to become ennobled, as Veláz-
quez did. And, again like Velázquez, he seems to have succeeded
toward the end of his career.

As John Smith wrote of Teniers in 1831:

Thus patronized by kings and princes, his name stood high in the world;
and wealth, the natural consequence of such favor, poured in abundantly
upon him. . . . No stranger of any consideration arrived in Flanders without
visiting the entertaining artist.[43]

Perhaps the desire to stand on a more nearly equal footing with the
distinguished visitors played a part in Teniers's drive for official recog-
nition of his status. He may also have been spurred on by the fact that
in October 1656, less than six months after the death of his first wife,
he married a well-born young woman, Isabella de Fren. The daughter
of André de Fren, Secretary of the Council of Brabant, she was of
higher social rank than the painter.[44] He petitioned the King of Spain
to grant him a patent of nobility on the basis of his official position
and his descent, through his mother, from Admiral Platvoet. On No-
vember 4, 1657, the King replied that he would be glad to grant the let-
ters of nobility if Teniers would pledge himself to renounce all
trade in paintings. It would hardly have been feasible for him to re-
fuse payment for his paintings; indeed, even Rubens had never ceased
to paint for pay.[45]

Teniers certainly continued to sell his pictures. His privileged rela-
tionship with the Governor's Court in Brussels apparently did not suf-
fer, however. In 1662, the year in which he became owner of the castle

43. John Smith, *A Catalogue Raisonné of the Works of the Most Eminent
Dutch, Flemish and French Painters*, Vol. III, London, 1831, p. 250.
44. Rubens's choice of a second wife, as described in his letter to Peiresc of
December 18, 1634, provides a striking contrast: "I have taken a young wife of
honest but middle-class family, although everyone tried to persuade me to make a
Court marriage. But I feared *commune illud nobilitatis malum superbiam praeser-
tim in ille sexu*, and that is why I chose one who would not blush to see me take
my brushes in hand." (*The Letters of Peter Paul Rubens*, translated and edited by
Ruth Saunders Magurn, Cambridge, Mass., 1955, p. 393.)
45. And Rubens, too, had been penalized for earning his living by his art. In
1630 his name was one of three suggested for appointment as envoy to London.
Despite his proved skills as an ambassador, Rubens was not selected by the Council
of State because a member of the Council raised the objection that he "practised
an art and lived by the product of his work." (Magurn, p. 358.)

Drij Torens, the third of his four children with Isabella had as god-father the Spanish nobleman who was the third Governor whom Teniers served. In 1663 he renewed his efforts to be admitted to the ranks of the nobility. And a deposition by the King of Arms of Brussels dated May 13, 1680, stating that the painter of the King of Spain has the authority to bear a coat of arms, seems to indicate that at long last Teniers's campaign was successful.[46] He was then, at the age of seventy, still painting, and he lived for another ten years.

Teniers's concern for his own status entailed an equal considera-tion of the estimation in which the art of painting was held. If painting was a mere craft, a manual labor, then it was an activity fit only for the servile, by a tradition that went back to ancient Greece. If it was a trade, no gentleman could practice it. If, on the contrary, it could be numbered among the liberal arts, that would establish the art of paint-ing as an activity appropriate even for those of the highest social standing.

5. The Status of the Art of Painting

The struggle to have the visual arts recognized as liberal arts had been carried on vigorously and with some success in Italy during the fifteenth and sixteenth centuries. Theoretical writings by artists and others stressed the intellectual aspects of artistic creation. They as-serted that the artist needed to be learned not only in mathematics and perspective, but also in literature and virtually all branches of knowl-edge.[47] As for the fact that his hand does have to participate in his work, Leonardo dealt with this by pointing out that the poet too must set down with the pen what is in his mind, yet poetry has an unchallenged position among the liberal arts.[48] Following in the direc-tion that Leonardo had indicated, artists and their apologists insisted

46. Rosenberg, p. 78.
47. "The purpose of art theory as it was developed in the fifteenth century was primarily practical. . . . It aimed at nothing more than, on the one hand, to legiti-mize contemporary art as the genuine heir of Greco-Roman antiquity and to wrest a place for it among the *artes liberales* by enumerating its dignity and merits; and, on the other hand, to provide artists with firm and scientifically grounded rules for their creative activity." (Erwin Panofsky, *Idea: A Concept in Art History*, Columbia, S.C., 1968, p. 51.) See also Anthony Blunt, *Artistic Theory in Italy 1450–1600*, Oxford, 1962, pp. 48 ff.
48. Blunt, p. 52. Pacheco (Vol. I, p. 15) remarked: "Geometry too requires use of the hands . . . but no one has said that geometry is a mechanical art, and the same with music and the other arts."

that it was in the painter's mind rather than in the brushstrokes on the canvas that the essence of his creation lay. The contrast between *disegno interno* (the mental conception) and *disegno esterno* (the visible work of art) carried the burden of this argument in the later sixteenth century. The establishment of academies of art at that time in Italy served to support the definition of art as a learned profession and to free it from the control of the guilds, with their medieval roots and association with crafts. It was in the seventeenth and eighteenth centuries that academies as teaching institutions came into their full development. The Netherlands joined this movement when David Teniers II took the lead in founding an academy in Antwerp that began its teaching program in 1665. At this time Teniers was actively engaged in his campaign for a patent of nobility. The establishment of the academy, which, like all art academies, was intended to improve the status of artists, might have been helpful in this campaign.[49]

The many gallery pictures that Teniers painted also served this purpose. "The glorification of the plastic arts is the central theme of our *Cabinets d'Amateurs*." [50] Along with the art, the artist too was glorified. The most skilled and active painters of gallery pictures, including Jan Brueghel I, Willem van Haecht II, Frans Francken II, and David Teniers II, were all members of families long identified with the art of painting in Antwerp. They were the sons of painters, the fathers of painters, and related to other families of painters by ties of blood or marriage. It would not be surprising if such men tended to be profoundly concerned with the conditions of life, both social and economic, that artists faced. This concern might have played a part in their choice of specialized subject matter, which offered the opportunity to promote the status of artists in a number of ways.

The most obvious effect of a gallery picture is to immortalize a collection as an expression of the personality of the collector. Since many of the pictures, however, do not reflect real collections at all, or else take liberties with collections that existed, the artist's personality

49. Since the fourteenth century, painters in Antwerp, along with sculptors, goldsmiths, glass painters, and embroiderers, had belonged to the Guild of Saint Luke. "As early as 1480 the guild had made a first attempt to rise above the other crafts and trades on to the plane of the Artes Liberales. It had amalgamated with one of the Chambers of Rhetoricians. . . . The words used in carrying out the amalgamation, namely that Pictura and Poësis should go together, show that the guild was quite aware of what their step meant." (Nikolaus Pevsner, *Academies of Art, Past and Present*, Cambridge, 1940, pp. 126 f.) Pevsner found no trace of other academies in Belgium before the eighteenth century (p. 129.)

50. Speth-Holterhoff, p. 49.

may have come into play more forcefully than the patron's. The painter often included his own works and even gave them special prominence, a promotional device that is not surprising to us today. He likewise sometimes took the opportunity to give a boost to the works of his friends and colleagues. Exhibiting paintings of which their creators can be proud is one way of soliciting admiration for the art of painting.

Including the image of a ruler, either as a person viewing the works of art or as the subject of a painted or sculptured portrait, gives proof of the suitability of art as an interest of the most exalted personages; such patrons set the example for those beneath them. When an artist or a group of artists is shown in the company of nobility, this indicates both the social acceptability and the valued services of the artist; this is the most direct kind of reference to the artist's status that gallery pictures provide. The association of the arts with science and intellectual endeavors in the pictured galleries is a less explicit but no less effective claim to the artists' status as learned practitioners of one of the liberal arts.

Velázquez's day by day association with Philip IV and his collection of art would almost certainly have brought him into contact with the picture by David Teniers II of *The Archduke Leopold William in his Picture Gallery in Brussels* (Fig. 78), which was in the Alcázar in Madrid in 1653. Thus it could very well have been fresh in Velázquez's mind when he undertook to paint *Las Meninas*. It would be surprising if Velázquez had not already been aware of the Antwerp tradition of gallery pictures long before this time. Aside from their other attractions, anyone interested in art would have welcomed the opportunity they provided to acquaint himself with their fascinating reproductions in full color of numerous works of art. In addition, any professional artist might have been intrigued by the information gallery pictures gave as to what kinds of paintings were popular with collectors in general or in specific cases.

The proposition seems tenable, then, that the features that place *Las Meninas* within the tradition of gallery pictures were not fortuitous. The room setting as a whole is one of these features. The wall of windows on one side; the pictures on the walls; the rear wall parallel to the picture plane that closes the scene and at the same time, by way of a partly opened door, permits a view into a farther, light-washed space —all were frequently repeated in gallery pictures. The image of the sovereign, which was introduced into gallery pictures in the form of

painted or sculptured portraits or living beings, at the hands of Veláz-
quez takes a novel form—a mirror image. Other elements familiar
through the long series of gallery pictures are the visitors of high
rank and the presence of the artist himself.

The implication is unavoidable that Velázquez shared not only the
forms but also the goal of the painters of gallery pictures: to testify to
the dignity of the art of painting in order to justify higher status for
the artist. This confirms the insight that Palomino recorded so long
ago, that *Las Meninas* glorified Velázquez by projecting him into his-
tory in the company of the Infanta Margarita.

More than two hundred years after Palomino's publication, it was
again suggested, on different grounds, that *Las Meninas* has to do with
the status of the artist. Charles de Tolnay wrote in 1949: "The ideas of
Velázquez on Fine Arts and craftsmanship as they are incarnated in *Las
Hilanderas* are complemented by his conception of the dignity of the
artist as a creator in *Las Meninas*." [51] It was Tolnay's view that the self-
portrait in *Las Meninas* shows the artist concentrating on the *disegno
interno* "in a state of dreamy rapture." [52] The purpose, as he saw it,
was to avoid undignified manual execution in favor of "the subjective
spiritual process of creation" that "demonstrates the supremacy of
spirit over matter." [53]

While I too have come to the conclusion—primarily on the basis of
the kinship of *Las Meninas* to the gallery pictures—that "the dignity
of the artist as a creator" was a dominant concern in the genesis of
Las Meninas, in my opinion Tolnay misread the action. Velázquez
portrayed himself looking intently before him, at a moment when he
had stepped back from his easel in order to compare his subject with
his canvas. In his left hand he holds his palette, brushes, and maul-
stick, and in his right hand the brush that is in use. This seems to me
to depict the act of painting just as surely as if he were touching
brush to canvas. This difference of opinion is substantial. I believe that

51. Tolnay, pp. 32 ff.
52. Tolnay, p. 36.
53. Tolnay, pp. 37 f. In 1959 Martin Soria, p. 268, repeated Tolnay's idea. Veláz-
quez, he wrote, "showed himself not as actually putting the brush to the canvas,
but as reflecting, brush in hand. The *Maids of Honour* thus becomes not only a
glorification of Philip IV's court but of Velázquez, as part of that court, in the
act of pondering an idea. In this way the *Maids of Honour* is the artist's defence
of the nobility of painting as a liberal art, an art of the mind rather than merely
of the hand."

what Velázquez showed was the dignity of the painter *as painter*.[54]
He did not flinch from the fact that in the end, after thinking, the
painter must act. And, he seems to assert, the painter should be none
the less respected for that.

In 1966 George Kubler published the observation that the reflec-
tion in the mirror in *Las Meninas* indicates that the royal couple were
on the same level as the painter and the other figures.

> In this sense, another message of the *Meninas* concerns the nobility of paint-
> ing as proclaimed by Romano Alberti and other theorists until Felix da
> Costa in 1696; a nobility proved by the familiar association of painters with
> kings, and by the taste of kings for paintings; a taste documented by many
> prior generations.[55]

Kubler proposed as "an example of the kind of picture Velázquez
might have adapted for the *Meninas*" a miniature executed in 1570 by
Hans Mielich of Munich. (As Kubler conceded, it is virtually certain
that Velázquez never saw this miniature or a copy of it.) This illus-
tration in Orlando di Lasso's *Psalmi poenitentiales* portrays a concert
at the Court of Albrecht V of Bavaria. This comparison, together with
the subjects of the two paintings on the far wall in *Las Meninas*, led
Kubler to suppose that "Velázquez may have intended the *Meninas*
to suggest the equal rank of painting (*Pallas and Arachne*) with music
(*Apollo and Pan*), in his contribution to the contemporary campaign
to secure recognition of painting as a liberal art under Spanish taxa-
tion." The fact that financial as well as social benefits were at stake,
as Kubler emphasized, was certainly on the minds of some of the
artists who participated in this campaign. Velázquez must have been
cognizant of the struggle and the reasons for it. Whether he would
have been concerned with the problem of the sales tax is another
question.

In 1603 El Greco won what Palomino described as the first lawsuit
involving a painter who refused to pay the sales tax.[56] "And thus all
who practise this art owe endless thanks to Dominico Greco for having
been the one who with such success broke the first lances in defense

54. Tolnay states that from the High Renaissance to the period of Classicism
and Romanticism in the nineteenth century, artists were portrayed only in "a
dignified, noble attitude, no longer in the process of execution" (pp. 37–38), but
innumerable Dutch and Flemish paintings of the seventeenth century show artists
at work, often in very humble circumstances. See Figs. 88–91.

55. Kubler, p. 213.

56. Palomino, p. 841, erroneously gave 1600 as the date of this judgment.

of the exemption of painting [from the tax]; all the later judgments were based on this judicial decision." The "mechanical arts" were subject to the tax, whereas the "liberal arts" were not; it was for this reason that the official acknowledgment that painting is a liberal art was important to the painters in terms of immediate profit.

The battle won by El Greco merely marked one stage in a long war, in which words were the most plentiful weapons. "Theoretical writers on painting in the fifteenth century searched out every instance in antiquity and in more recent times of favour shown to painters by kings, princes, or popes." [57] Classical texts had long since been combed for references that would prove the contention that in antiquity painting had been a respected profession, that great rulers had not only taken an interest in it but had even practiced it, and that it entailed knowledge and mental effort that clearly removed it from the sphere of the mechanical arts and qualified it to be included among the liberal arts. The first book of this kind to appear in Spain was by Gaspar Gutiérrez de los Rios, *Noticia general para la estimación de las artes* (Madrid, 1600). In 1629 Vincencio Carducho published seven briefs written by distinguished Spaniards in support of a plea for the exemption of paintings from the tax.[58] These were included with Carducho's *Diálogos de la pintura*, published in Madrid in 1633,[59] in which he dealt explicitly with the problem of the tax on paintings. In this case the verbal argument was supported by a visual one in the form of allegorical engravings accompanying each of the eight dialogues.[60] A useful compendium of quotations was provided by Franciscus Junius in *De pictura veterum*, which was published in Amsterdam in 1637 and, in the author's own English translation, in London in 1638. This book "is truly a rich storehouse of all the examples, opinions, and precepts which, relating to the dignity and honor of the art of painting, scattered everywhere in ancient writings, have been preserved to our day and to our great advantage," as Rubens wrote to Junius on August 1, 1637.[61]

Pacheco, who dated the completion of his manuscript January 24, 1638, praised Gutiérrez for proving that painting is a liberal art. "Who

57. Blunt, p. 49.
58. The title was *Memorial Informatorio por los Pintores*.
59. On the date of publication of the *Diálogos*, see López-Rey, 1968, p. 46, n. 1.
60. See Kubler, 1965.
61. Magurn, p. 407.

is not saddened," Pacheco inquired, "to see an Art so noble and so worthy of being esteemed and noticed, buried in oblivion in Spain?" [62] He noted that the art fared better in other countries, and particularly in Italy. He clearly intended his book to improve the status of painting in Spain. "Two things (among others) make a man illustrious and ennoble him," he wrote, "the pure nobility of his lineage and, at the same time, its antiquity." So it is with all the sciences, and "for this reason it is appropriate to treat at the beginning of this book (after its definition) the antiquity and origin of painting." His son-in-law seems to have taken these words to heart, both as to his person and as to his art.

Meanwhile, the struggle was also being carried on in the courts. Along with the text of the *Diálogos*, Carducho published a judgment rendered on January 11, 1633, by the Royal Council of the Exchequer on an appeal by Carducho himself. The verdict affirmed that painters did not have to pay the tax on paintings made by them.[63] But this victory was still not the end of the campaign, for as late as 1677 the great dramatist Pedro Calderón de la Barca testified in yet another lawsuit that painting, as a liberal art, should be exempted from the tax.[64] It is clear, then, that at the time when Velázquez painted *Las Meninas*, artists were still finding it necessary to press their claims to rank superior to that of craftsmen.

Velázquez, however, was playing for higher stakes. Far from being involved in the antitaxation campaign, he faced the problem of proving that he did not paint for money at all. This was necessary if he was to succeed in gaining admission to one of the Military Orders, his long-standing ambition. Velázquez may have had this aspiration in mind by the time of his first journey to Italy, in 1629.[65] The full-

62. Pacheco, Vol. I, p. 4.

63. The judgment required them to pay the tax, however, on paintings that were not made by them, whether sold in their houses, at auction, or elsewhere. Carducho, f. 229v.

64. Kubler, 1965, p. 445 and n. 25.

65. Rodríguez Villa (pp. 27–28) quotes one of the newsletters written by his unidentified source, dated "de Madrid, día de la Porciúncula, año de 1636," as follows: "A Diego Velázquez han hecho ayuda de guardaropa de S. M., que tira á querer ser un día ayuda de cámera y ponerse un hábito á ejemplo de Ticiano."
Soria (p. 257) connected Velázquez's social ambitions with his association with Rubens during the Flemish painter's visit to Madrid in 1628–1629. "Rubens was knighted by Philip IV in 1629; Velázquez henceforth laboured towards the same goal in order to escape the galling inferiority of his rank. . . ." López-Rey (1968, p. 139) stated: "The hope of being knighted must have entered Velázquez's mind rather early, not later than his first Italian journey."

length portrait of Philip IV that he painted about 1631–1632 (Fig. 30)
shows the King holding a paper inscribed in the form of a petition
addressed to the King.[66] Could this reflect a petition actually
made by the painter at that time, perhaps already aspiring to be en-
nobled? Rubens's presence in Madrid for about eight months in 1628–
1629 might well have sharpened Velázquez's appetite for this honor,
for the famous Fleming was permitted to infringe on the monoply that
had been promised Philip IV's favorite Court painter; he made five
portraits of the King, not to mention others of the Queen and mem-
bers of the royal family. Having already been ennobled by Philip IV,
Rubens was knighted by Charles I of England when he went to Lon-
don on a diplomatic mission after his stay in Madrid. The ambitious
young Spanish Court painter would undoubtedly have been made in-
tensely aware of the difference between his own status and that of
Rubens during the time they spent together in Madrid, where, accord-
ing to Pacheco, Velázquez was the only painter with whom Rubens
was friendly.[67] This might have spurred his efforts to achieve noble
rank himself.

During his second sojourn in Italy, when he painted the portrait of
Innocent X in 1650, this ambition was certainly on Velázquez's
agenda, for he enlisted the support of the Pope. But it was not until
June 6, 1658, that the King nominated his painter to the Order of
Santiago, thus setting in motion the inquiry that was prerequisite to his
appointment.[68] Philip did not have the power to bypass the formalities
required by the statutes of this exclusive Order. Unlike Alexander the
Great, he could not simply give his Apelles what he longed for.

Membership in the Military Order was restricted to men of un-
blemished noble Christian descent on both sides, untainted by Moorish
or Jewish blood or by an ancestor convicted by the Inquisition. Hav-
ing conducted a business or engaged in a menial craft would also dis-
qualify an aspirant. One hundred forty-eight witnesses testified in
the extensive investigation of Velázquez's ancestry and personal his-
tory. A number of artists were among those who somehow found it
possible to declare that he had never sold his paintings. With his accept-
ability still in doubt because of the lack of proof of the nobility of his
paternal grandmother and his maternal grandmother and grandfather,

66. Beruete, p. 39.
67. Pacheco, Vol. I, p. 154.
68. The royal decree was published by D. de la Válgoma y Díaz-Varela in
Varia velazqueña, Vol. I, p. 683.

on April 3, 1659, the Council of the Order advised the King to have his Ambassador in Rome apply to the Pope, Alexander VII, for a dispensation to permit Velázquez's appointment.[69] The very next day the King wrote to the Ambassador, instructing him to do this. The Pope signed the requested dispensation on October 1, 1659. On November 27, the King conferred on Velázquez the title of Knight of the Order of Santiago. On the following day, by royal decree, Velázquez became an *hidalgo*, as the Council of the Order required. He had but little more than eight months to live.

In 1656, frustrated in his long campaign for this honor, Velázquez painted *Las Meninas*. What better way to show that as a painter he was neither a craftsman nor a tradesman, but an official of the Court? What more powerful way to persuade that his blood and breeding qualified him for acceptance on familiar terms by the royal family? And what more convincing evidence could be produced to prove that painting is an art that is nourished by rare and subtle intellectual capacities?

The old titles that have been attached to the picture shed no light on its fundamental theme. Indeed, they do not even describe it in any meaningful way. To call it "a portrait of the Infanta Margarita as a young child," as Palomino did, is a radical oversimplification. "The Royal Family" is also inappropriate. As for naming it for the *meninas*, or maids of honor, those two young women are only incidental to the theme. The subject of the picture, stated most succinctly, is *The Art of Painting*, and this would be the most appropriate title for it.

6. The Royal Household

Both the choice of the individuals to be portrayed and the apparent informality of the gathering were meaningful in Velázquez's plan for his great demonstration of his own dignity. As the central figure he

69. According to Válgoma ("Una Injusticia," p. 199), all the reports on the investigation of Velázquez's lineage, without exception, conformed with the claim that his parents and his maternal and paternal grandparents were of pure and noble blood. Since many of the witnesses were "high in rank and moral responsibility," Válgoma concluded (p. 210) that there was in fact no question as to Velázquez's qualifications on this score, and that the haughty members of the Order in whose hands the decision lay rejected the painter because of prejudice about his profession, using as an excuse the lack of proof of the nobility of his paternal grandmother and his maternal grandparents. One cannot help wondering, however, whether the testimony as to the unblemished nobility of Velázquez's ancestors should be accepted as true, in view of the implausible assurances that were given—also by highly respectable persons—that he had never practiced painting as a trade from the time he received his diploma.

selected the young Infanta, representing the ruling house of Spain. The rigid etiquette of the Spanish Court precluded the depiction of the King or Queen in such a relaxed situation; their child was the most exalted possible substitute. Her image provided, besides, the engaging combination of the natural charm of childhood and the proud bearing of a Spanish noblewoman. In conveying this rare blend of attributes, Velázquez had no peer. He had had ample opportunity to study Margarita in painting portraits of her, including one that was very close to *Las Meninas* in date (Vienna, Kunsthistorisches Museum). To include her in a group portrait, however, was a novelty in Spanish art. Group portraiture had developed as a Netherlandish specialty in the sixteenth century and played an impressive part in both Dutch and Flemish painting in the seventeenth. In Flemish gallery pictures, as we have seen, group portraits of visitors to the gallery and their hosts, who in some cases were painters, were often featured.

Margarita is a focus of light, like a gem, and all else is her setting. From her gossamer golden hair to the hem of her gleaming dress, she is radiant. Partaking of her brightness are the two maids of honor, *las meninas*, who caught the eye of nineteenth-century observers so effectively that they gave the picture the title by which it is still generally known. As Carl Justi pointed out, beauty was a qualification for appointment to the post held by these "dark-eyed children of their race, beautiful young blossoms of the old Castilian family tree." [69a] These graceful aristocrats are shown in attitudes of suitable deference and watchful care of their young mistress. The painter stands just beyond this central group, so that his head, hands, and sleeve also catch the light. The vivid definition of these forms makes the artist a far more vital presence than the two courtiers who stand at the right, wholly in shadow, so that they tend to fade into the background. The intense contrasts of the edge of the tall canvas and the stretcher underline the figure of Velázquez, whose head is higher than any other in the painting. He *must* be noticed. The lady of honor and the male escort with whom she chats are, on the other hand, mere accessories in the picture; yet a scene of everyday life in the Court would have been incomplete without them.

Don José Nieto Velázquez (to give the *Aposentador* to the Queen his full name), seen on the steps beyond the open door, a dark shape against brilliant light, plays a striking part in the composition, forming

69a. Justi, Vol. II, p. 312.

both the apex of a major triangle in the design and the meeting point of lines of recession. In addition, the patch of light against which he is silhouetted abruptly breaks the infinitely subtle modulation of values that has led our eyes ineluctably back into deep space. The contrasted values in the back are equated with those in the foreground, bringing about a whole new system of compositional tensions. The fact that Nieto's oblong of space is paired with the oblong in which the images of the King and Queen appear adds another interplay of forces. It cannot be by chance that his arm points directly toward the image of the King's face.

To the modern observer, and particularly to the modern artist, this supremely sophisticated composition may be the picture's chief claim to attention. But it is not to be supposed that in the seventeenth century it was devised for its own sake alone, without regard for the meaning of the whole. The figure seen through the doorway is not merely a shape, not an abstract dark patch against an oblong of light, but the image of a specific person. As Palomino noted, despite the small size of the figure and the distance at which it is seen, it is "easily recognizable" as José Nieto, *Aposentador* of the Queen. Nieto had also been head of the Queen's tapestry works. His Court duties suggest two possible reasons for his inclusion in the scene. The first is that he would normally have been in attendance on the Queen and that his watchful stance at the entrance indicates the presence of the Queen in Velázquez's studio. As he stands on the stairway he looks into the studio and either rests his right hand on a wall or doorjamb or pushes back a curtain whose location and function cannot be discerned. His gesture accords, however, with the fact that he appears to be neither ascending nor descending, but lingering. The second possible reason for the introduction of Nieto is his relation to the art of tapestry weaving, about which more will be said in connection with the subjects of the paintings depicted on the wall above him.

Compositionally Nieto is linked, by way of the inclined figure of the *menina* at the right, with the group in the right foreground. Dog, dwarf, and midget—these are the pets of the Infanta. The physically and mentally abnormal had by long tradition been accorded a unique place in Court life.[70] In the role of fools and jesters, they were per-

70. Erica Tietze-Conrat (*Dwarfs and Jesters in Art*, London, 1957, p. 25) refers to both Mari Bárbola and Nicolasico as hydrocephalic, and to Mari Bárbola as a cretin. An assumption of severe mental deficiency is unwarranted. Both of them appear to be alert. It seems likely that Mari Bárbola suffered from achondroplasia, which is "among the more common types of dwarfism. . . . The appearance of

mitted liberties that would have been unthinkable to any normal cour-
tier. They might imitate, ridicule, and defy the sovereign, or even tell
him the truth. As the alter ego of a royal master, a dwarf might be in-
separable from him and share his privileges. The Court of Philip
IV had an extraordinary collection of such bizarre figures. Justi
pointed out that "as the society of dogs flatters men with the feeling
of absolute dependency and fidelity, so the normal man is cognizant
of his own size and power alongside the dwarf, and that suited the
sensibility of those aristocratic centuries." [71] In the middle of the seven-
teenth century, with his Empire shriveled away, his succession in
doubt, and his own competence hardly grounds for confidence, the
King might have taken comfort in the presence of these unchalleng-
ing companions. The old notion of the "fool of God," with his direct
line to supernatural wisdom and to divine mercy, might well have lin-
gered on in this tradition-bound Court and added to the attachment of
the royal family to their abnormal companions. Handsomely dressed,
well fed, and well groomed, Mari Bárbola and Nicolasico would have
been plausibly included in the picture of members of the royal
household gathered in the studio of the Court painter. Their gro-
tesqueness is a visual asset from the painter's point of view, as it con-
trasts with the charm and grace of the central group. Velázquez had
similarly included a dwarf as a foil in his portrait of *Prince Baltasar
Carlos* in 1631 (Fig. 29).

Velázquez's paintings of the dwarfs and buffoons of the Court are
notable for the objective rendering of their defects. No abnormality is
masked or glossed over.[71a] The paintings appear to reflect an interest

short limbs with a normal trunk is characteristic, accompanied by a large head,
saddle nose, and an exaggerated lumbar lordosis. The disease is usually recognized
at birth. Those who survive the period of infancy have normal mental and sexual
development, and longevity may be unimpaired." (*Harrison's Principles of In-
ternal Medicine*, Vol. II, New York, etc., 1970, p. 1938.) Nicolasico's appearance
fits the description of pituitary infantilism, in which infantile proportions of the
head, limbs, and trunk are retained. "These dwarfs have been likened physically
to the description of 'Peter Pan'; they fail to grow or to develop sexually. Their
mental development tends to keep pace with their physical development rather
than their chronological age." (Sir Stanley Davidson, *The Principles and Practice
of Medicine*, Baltimore, 1968, p. 685.)

71. Justi, Vol. II, p. 353.
71a. Velázquez's portraits of mentally deficient sitters show awkward postures,
foolish expressions, and shadowed eyes that seem to symbolize their mental state;
this is true of *Calabazas* and *Francisco Lezcano*, known as the *Niño de Vallecas*
(both in the Prado), which I consider to be the portraits of such subjects most
fully acceptable as by Velázquez. The dwarfs who are not mentally defective, on
the other hand, look intelligent in his portraits, as we have seen with *Sebastián de
Morra* (Fig. 47) and *Don Diego de Acedo* (Fig. 51). The jesters too are portrayed

more scientific than sentimental. This would be in keeping with a general curiosity during the seventeenth century about exceptional objects of all kinds, from whales to bi-cephalic calves, from exotic shells to foreign costumes. As for Velázquez specifically, he looked upon everything from water jugs to princesses with the same clear-eyed objectivity, and in this respect dwarfs were no exception.

In *Las Meninas* the dwarf and the midget, so different in appearance both from each other and from the other figures, add to the sense of the infinite variety of human beings who might all find a rightful place under the roof of the sovereign. As for the dog, he had many forerunners in gallery pictures, as well as in royal portraits. Symbol of faithfulness and companion of Kings, he too is at home.

7. The Mirror's Tale

Las Meninas is a visual statement of the social rank of the painter. To give this statement official ratification, Velázquez had to produce evidence that the King himself sanctioned it. It was not easy to do this without overstepping the bounds of Court decorum, which foreclosed the possibility of simply depicting the monarch as a member of the informal gathering that showed the artist on equal standing with other constituents of the royal household. Velázquez solved the problem with the help of the mirror. Through this fountainhead of ambiguity, it was feasible to have the King be *there* and yet *not there*.

It would in any case have been appropriate to include the representation of a mirror in this composition that is so intimately concerned with the art of painting, for the mirror is a symbol of the sense of sight and, by extension, of the visual arts.[72] What a clever stroke it was to use this potent symbol as a kind of seal of approval. Jan Emmens explained the mirror and mirror image of the King as personifying the virtue *Prudentia* and representing the Mirror of Princes.[73]

like any other normal subjects. This is evident in the portrait of *Pablo de Valladolid* (Fig. 16), as well as in that of the jester *Don Juan of Austria* (Madrid, Prado).

72. As Heinrich Schwartz pointed out ("The Mirror of the Artist and the Mirror of the Devout," in *Studies in the History of Art Dedicated to William E. Suida*, New York, 1959, pp. 94 ff.), in many depictions of artists' workshops a mirror appears as a useful accessory. A mirror was required particularly in the painting of self-portraits, and Velázquez's portrayal of himself in *Las Meninas* was presumably based on the image he saw in a mirror.

73. Following Palomino, Emmens started with the idea that "the princess is the central theme." He constructed an elaborate allegorical exegesis of the picture, involving the concepts of the Education of the Princess, the Mirror of Princes,

Without endorsing Emmens's allegorical interpretation of the picture, one can accept the implication that the mirror image was intended as a tribute by the painter to his sovereign. This aspect of the reflection of the King stands in a nice reciprocal relation to its usefulness as a sign of the King's respect for the painter, which, in my opinion, was its primary function.

The essential ambiguity of mirrors endows them with almost endless potentialities for art. The power of mirrors to deceive has long been a stock-in-trade of masters of legerdemain. In contrast to their value in illusionistic artifice, however, they are also credited with being sources of truth. In folk tales of many cultures, mirrors prophesy the future, answer questions, fulfill dreams. As against optical illusions employing mirrors, there is the common assumption that "mirrors never lie." Even in relation to present reality, mirrors engender paradox. A clear and faithful facsimile of nature is often spoken of as a mirror image. As long ago as 1435 Leon Battista Alberti had suggested the use of a mirror to check on the accuracy of what had been painted from nature.[74] Perhaps a half century later, Leonardo in his notebooks recorded the utility of the mirror not only in testing the correspondence between the painting and nature and gaining objec-

and the Triumph of Wisdom over Folly. Though informed with the learning and originality that characterized all of Emmens's scholarly contributions, his explanation of *Las Meninas* seems to me unacceptable. To refute it briefly, rather than with the detailed treatment it deserves, I would point out that the relationship he asserts to Education of the Princess iconography is tenuous, to start with. Then, as to the mirror, it may invoke numerous and in some cases contradictory associations, ranging from the virtue of *Prudentia* to the vice of *Luxuria* or the general disparagement of earthly satisfactions encompassed by the notion of *Vanitas*. Its specific meaning in this composition, as in any other, must be understood in terms of the context. Emmens based his theory that the medieval topic of the Mirror of Princes was crucial to Velázquez's conception on a print in which *"Prudentia"* was inscribed beneath the image of Philip IV. In fact the attribution of Prudence to rulers was a commonplace and bore no special relationship, to Philip IV; not he, but Philip II was known as "The Prudent." The presence of the Queen beside the King would also not be in accord with Emmens's interpretation. Further, his reading of the three faces of Prudence and other allegorical interpretations, including that of Good Judgment opposed to Folly, strain credulity. In the end, the Infanta, far from emerging as "the central theme," is lost in the shuffle.

74. "By preserving this balance, if I may so call it, of white and black, you will make your relief appear the stronger; then go on . . . until you have accomplished your design; and this you may best judge by means of a looking glass. And indeed, I know not how it is, but anything painted has a particular beauty when seen in a looking glass, provided it be free from faults; and it is wonderful how every defect in a picture will therein show more considerable. What therefore you have copied after nature, amend with the help of a looking glass." (G. Leoni, translator, *The Architecture of Leon Battista Alberti*, New York and London, 1963, p. 262.)

tivity in judging the faults of the painting, but also as a guide to how objects may appear to be in relief though actually seen on a flat surface.[75] There is good reason to suppose that Velázquez was familiar with both Alberti's treatise and Leonardo's ideas, for, recorded in the inventory following his death, his extensive library included works on painting by Leonardo, Alberti, Baglioni, Vasari, and Pacheco, as well as various books on perspective and geometry. Leonardo da Vinci's *De la pintura*, which was listed, may, according to Sánchez Cantón, have been either the *Trattato della pittura*, published in Paris in 1651, or a Leonardo manuscript consulted by Pacheco.[76]

On the other hand, what the mirror shows us hints at its own unreality, in that it changes with altered light or with a shift in the point of view of the observer. It is above all ambiguous, uncertain, subject to interpretation. This blending of "reality" and "illusion" had a special appeal for seventeenth-century Spanish artists and writers. In the culture in which Velázquez lived, questions as to what is real and how we know it were pervasive. They were both implicit and explicit, for instance, in the works of those major poets and dramatists, Lope de Vega and Calderón, and of that avatar of seventeenth-century poetry, Góngora. Cervantes, above all, has brought these questions home to

75. "*How the Mirror is the Master of Painters.* When you want to see if your picture corresponds throughout with the objects you have drawn from nature, take a mirror and look in it at the reflection of the real things, and compare the reflected image with your picture and consider whether the subject of the two images duly corresponds in both, particularly studying the mirror. You should take the mirror for your guide—that is to say a flat mirror—because on its surface the objects appear in many respects as in a painting. Thus, you see, a painting done on a flat surface displays objects which appear in relief, and the mirror—on its flat surface—does the same. The picture has one plane surface and the same with the mirror. The picture is intangible insofar as that which appears round and prominent cannot be grasped in the hands; and it is the same with the mirror. And since you can see that the mirror, by means of outlines, shadows, and lights, makes objects appear in relief, you, who have in your colours far stronger lights and shades than those in the mirror, can certainly, if you understand how to put them together well, make also your picture look like a natural scene reflected in a large mirror." (Jean Paul Richter, ed., *The Literary Works of Leonardo da Vinci*, London, 1939, Vol. I, p. 320.) "*Of Judging your own Pictures.* . . . When you paint you should have a flat mirror and often look at your work as reflected in it, when you will see it reversed, and it will appear to you like some other painter's work, so that you will be better able to judge of its faults than in any other way." (Richter, p. 321.)

76. Sánchez Cantón, 1942, p. XVIII. It may be that Velázquez inherited these books from Pacheco, whose interest in art theory and technique they reflect. Though Velázquez left not a single word in writing to prove it, his paintings provide reason enough to believe that he too was concerned with such problems.

all the world.[77] Can we believe in the reality of that which our senses present to us? Or that which our wishes suggest to us? Or what is stated by authority to be true? Or "facts" based on practical considerations? Or can we believe only in the ineluctable ambiguity of reality? Cervantes's embodiment of these questions reaches our hearts and minds today; for the Spain in which his masterpiece was first read, it put into words ideas that were generally felt to be momentous.

Geography and history conspired to make Spain in the seventeenth century extraordinarily hospitable to notions which today seem untenable: the coexistence of marvels and everyday reality, of romantic fantasy and earthy realism, the intermingling of the divine and the human—all those confusions of truth, dream, faith, and reason which made life so complicated for the ingenious gentleman from La Mancha and those about him. To mention only one factor that emerged from, and in turn contributed to, the singular Spanish ambience: an incomparable array of mystical writers of the sixteenth century—most outstanding among whom were San Juan de la Cruz, Santa Teresa, and Saint Ignatius Loyola—intensified an emotional climate in which almost anything seemed possible and hardly anything seemed unlikely. Santa Teresa de Ávila, whose beatification in 1614 and canonization in 1622, along with two other Spanish saints, assured prolonged interest in her life and works, combined the appeal of artless directness with mastery of allegorical prose. She could write "Entre los pucheros anda el Señor" with the same ingenuous conviction as that with which Murillo, about a century later, could paint a picture of angels doing chores in the most earthly of kitchens.[78] The strictures of the Council of Trent, which assigned to art the task of fostering religious emotion and conviction, led up to the efforts of seventeenth-century artists to go beyond the mere imitation of nature. Given the task of turning men's minds to the realm of spiritual reality, artists were, paradoxically, directed to an intensified exploration of illusionistic representation.

Though Spain in many respects lagged behind the more advanced lands of Western Europe in the seventeenth century, intellectual and artistic circles in Madrid could not have been unaware of the experimentation in optics that involved science, literature, philosophy, and art. Descartes, Hooke, Huygens, and Newton, as well as the painters

77. *Don Quixote*, first published: Part I, 1605; Part II, 1615.
78. *The Miracle of San Diego de Alcalá*, Paris, Louvre.

Hoogstraten, Fabritius, and Vermeer, were all in their various ways concerned with optical experiments. Similar interests may have played a part in Velázquez's endeavors to produce in paint a total visual experience.[79] In his efforts to solve the problems inherent in the representation on a flat surface of such visual experience, he cast mirrors in important roles in two of his most interesting paintings, *Venus at Her Mirror* and *Las Meninas*.

Velázquez's were not, of course, the first instances of mirrors as significant factors in paintings. He was probably acquainted from his earliest days at Court with a great early-fifteenth-century Flemish example that was then in the royal collection in the Madrid Alcázar: Jan van Eyck's *Arnolfini Wedding Portrait* (Fig. 81), in which a small convex mirror serves the purpose, among others, of representing the fourth wall of the room depicted, thereby completing the "box" of the picture space. For Velázquez as well, the mirror provided the possibility of complex manipulations of space. In the painting of Venus, the mirror presents an additional view of the subject, thereby confirming its three-dimensionality. In *Las Meninas*, on the other hand, the mirror directs the observer's attention to "an event" going on outside the picture (the presence of the royal couple), which in turn brings the observer within the picture area. This intermingling of the reality within the picture and the reality outside, this essentially Baroque breaking of the bounds of the picture space, is the magic of the mirror in Velázquez's art. Velázquez could have learned both of these uses of a mirror depicted in a painting from that astounding innovator, Jan van Eyck. Two centuries before Velázquez's time, in the *Arnolfini Wedding Portrait*, he had combined in a single mirror image both a second view of the subject of the painting and reflections of an area beyond the picture space; the mirror on the far wall reflects both the backs of the couple portrayed and the front view of two witnesses conceived as facing them from outside the space depicted, thus sharing our location as we look at the picture.

In the room in the Prado in which *Las Meninas* now hangs in solitary splendor, the observer is invited to see the painting reflected in a mirror, which is supposed to lend added verisimilitude. This brings to mind the manipulations of levels of reality that Cervantes plays with in *Don Quixote:* the published book about some of the

79. Ann Laprair Livermore discussed studies of optical effects with which Velázquez may have been familiar.

Fig. 81. Jan van Eyck, *Arnolfini Wedding Portrait*

characters in *this* book, which some other characters have read and talk about; the "writer," Cide Hamete Benengali, not to mention the "false writer"; the "translator"; the references made by Sancho Panza and Don Quixote themselves to this book about them—all of which somehow makes the reader believe in the fictional characters even as it, in a sense, removes him step by step farther from them. Similarly, the paradoxes, the ambiguities, the artful tensions set up with the aid of the mirror in *Las Meninas* endow it with a special impact of reality —a mirror image of an actual event.

8. Challenging the Gods

Velázquez's proclamation of his own power and status as a creator, in *Las Meninas*, might quite naturally have been accompanied by some misgivings. His temerity in thrusting himself forward in a role akin to God's might well have given rise to anxiety. The two pictures on the rear wall appear to give vent to these feelings.

"In the Middle Ages it had been customary to compare God with the artist in order to explain the nature of divine creation; later the artist was compared with God in order to heroize artistic activity," as Erwin Panofsky put it.[80] Renaissance artists were very much aware of this parallel. Dürer wrote: "The great art of painting was held in great esteem by powerful kings many centuries ago, for they made the outstanding artists rich and honored them, considering such talent to be a creative thing like unto God."[81] Vincencio Carducho noted that the painter, like God, creates from nothing.[82] Pacheco named God as the first painter, as well as the first sculptor.[83]

Art theory had gone even farther, declaring that the artist improves on nature by conceiving things not as they are but as they ought to be.[84] To excel God's handiwork, as a painter must inevitably attempt to do as he creates a composition, may seem to a devout Chris-

80. Panofsky, *Idea: A Concept in Art Theory*, Columbia, S.C. 1968, p. 125. See also E. Kris and O. Kurz, *Die Legende vom Künstler*, Vienna, 1934, pp. 47–65: "Deus Artifex—Divino Artista."

81. Panofsky, p. 123.

82. Carducho, F°. 119, 164, and 179.

83. Pacheco, Vol. I, pp. 26 and 29. See also Kubler, 1967, p. 380 and n. 9.

84. See Rensselaer W. Lee, *Ut Pictura Poesis: The Humanistic Theory of Painting*, New York, 1967, especially Chap. I: "Imitation," pp. 9–16.

tian to smack of excessive pride, if not impiety.[85] The dangers inherent in competing with divinity had indeed been recognized long before the Christian era and embodied in undying myths. It is two of these myths that provided the subject matter that Velázquez chose for the two pictures within his painting that have legible content. They were based on oil sketches by Rubens. The one on the left represents *Minerva Punishing Arachne* (Fig. 82), the one on the right, *Apollo's Victory over Marsyas* (Fig. 83).[86] Both of these legends deal with mortals who dared to challenge gods, and the dreadful punishment that resulted.[87] Is there perhaps some significance in the fact that the picture closer to the Queen's image in the mirror depicts females, while that on the King's side has to do with contention between males? [88]

Minerva, goddess of wisdom, was the patron of the arts. Both fine and applied arts, as we would distinguish them, were in her charge. From the seventeenth-century point of view, this would be understood as encompassing the crafts, or mechanical arts, and the liberal arts, with which the painters sought to identify themselves. She had a special devotion to the art of weaving. Arachne was a young woman of humble birth whose skill in weaving and needlework aroused the admiration of the women of Lydia. Even the nymphs left their usual haunts to come and enjoy not only what she produced, but also her grace in doing it. It seemed that she must have been taught by Minerva

85. Perhaps a sense of the sinfulness of his creative activity had something to do with Michelangelo's depiction of himself as punished by being flayed in his *Last Judgment* in the Sistine Chapel. See also Kris and Kurz, pp. 87 ff.

86. Sánchez Cantón, 1943, p. 14. The paintings in the room that was presumably the scene of *Les Meninas* were by Mazo and were based on Rubens's sketches. Mazo's immediate model for *Apollo's Victory over Marsyas* seems to have been Jacob Jordaens's painting (Prado) after the sketch by Rubens.

87. Tolnay (p. 36) stated: "Both are myths which symbolize the victory of divine art over human craftsmanship, or the victory of true art over unskillfulness. Both exemplify that the talent of the artistic creation is an expression of divine principle. Both paintings in *Las Meninas* are commentaries which explain the inspired attitude in the self-portrait of Velázquez." To Soria (p. 269), both of the paintings on the wall signify "the Gods chastising man's presumption, and at the same time the triumph of true, divine artists over mediocrity, that is the divine origin of the arts." Emmens (pp. 56 f.) believed that the problem dealt with was the Use and Abuse of the arts, as discussed in the *Philosophia Secreta* of Juan Pérez de Moya. "Selon Moya, le jugement de Midas nous apprend, que le jugement corrompu préfère la terre au ciel, tandis que la punition d'Arachné nous avertit que nous ne pouvons pas nous comparer à Dieu. Les deux mythes sont des allégories où la sagesse triomphe l'orgueil."

88. Emmens (p. 57) explained that "le fait que ces deux représentations se trouvent en face des deux personnages royaux semble signifier que tout en étant comparable en sagesse à Apollon et à Minerve, ils sont conscients des limites des facultés humaines."

Fig. 82. Peter Paul Rubens, *Minerva Punishing Arachne*, oil sketch

Fig. 83. Peter Paul Rubens, *Apollo's Victory Over Marsyas*, oil sketch

herself. (This subject is often referred to as "Pallas and Arachne." As we know the story only as told by the Latin poet Ovid, it seems appropriate to call the goddess Minerva. It is possible that there was a Renaissance or seventeenth-century version of the legend in which the Greek appellation Pallas was used.) Arachne refused to share the credit, even with a goddess, and challenged Minerva to a contest. When Minerva, disguised as an old woman, remonstrated with the upstart, the arrogant girl rejected her advice and repeated the challenge. Throwing off her disguise, the goddess revealed herself, and the two contestants arranged their looms and set to work. Minerva wove a tapestry representing her contest with Neptune, in the company of ten other of the Olympian gods. In the corners she provided a warning to her rival, in the form of four episodes in which the gods punished mortals who had defied them. Arachne chose subjects that called attention to the misbehavior of the gods, especially the amorous adventures of Jupiter. Her work was admirable, but Minerva could not tolerate the insult to the gods. With her shuttle she tore the fabric and then struck Arachne's head.[89] Stung by the humiliation, Arachne hanged herself. Only then was Minerva touched by pity. She transformed the girl into a spider, nature's weaver.

The story of Marsyas also involves Minerva. The art that is the focus of the tragedy in this case is music. Having invented the flute, Minerva enjoyed its music. But when Cupid laughed at the puff-cheeked face she made while playing, she threw away the instrument. The satyr Marsyas found it, and he was so delighted with the sounds he could make that he challenged Apollo to a contest. Apollo, playing the lyre, was the victor, and Marsyas was flayed. The superiority of stringed instruments to wind instruments is of course one of the implications of this story. Its major import, however, is the catastrophic effect of competing with a god.

Art-historical research has by now amassed a considerable body of evidence that pictures that hang on the walls represented in seventeenth-century paintings commonly have some bearing on the meaning of the whole. This suggests that the two Ovidian fables should be taken into account in any interpretation of *Las Meninas*. Besides, judg-

89. Rubens's sketch, on which the painting on the wall in *Las Meninas* was based, shows Minerva attacking Arachne with her shuttle. Arachne's tapestry representing the Rape of Europa is visible at the right, and a scene of the two contestants weaving is in the background. The tapestry differs essentially from Titian's *Rape of Europa*, which Velázquez used in his painting of the fable of Arachne, *Las Hilanderas* (Fig. 96).

ing from internal evidence alone, it is hardly to be supposed that in so deliberately calculated a composition these subjects were admitted by chance. The other paintings on the walls are blurred into unrecognizability. These two alone, though they are far from sharply delineated, attract our attention to their content. Consciously or unconsciously, the artist brought into his conception of his dignity as an artist these two images of punishment for temerity toward divine powers. These two subjects also serve the purpose of equating painting (which is associated with tapestry design) with music, which had a secure place among the fine arts.[90]

Velázquez's whole life attests to his faithful devotion to the ruling house of Spain and to the Church of which Spain was the inflexible defender. He undoubtedly accepted without question the doctrine that the King ruled by divine right, as a surrogate of God. In advancing his claim to fellowship with members of the royal household, including the King's daughter and, rather more gingerly, the sovereign himself, the Court painter would probably have experienced some twinges of doubt and fear. To this there was possibly added the compunction he might have felt about asserting his status as a creator "like unto God." It would not be surprising if some echo of remorse, and perhaps even of anxiety as to possible punishment, had found its way into the composition that summed up his most profound personal commitments.

The two pictures on the wall can thus be understood as a commentary on the main subject, a commentary that stemmed from guilty feelings that the artist might have been unable to acknowledge, even to himself. They appear here in a muted way, easy to overlook, but recognizable as the other side of the coin of the artist's boldly assertive stance.

9. Las Meninas *in the History of Painting*

Few themes have received so much attention from artists as the subject of the artist at work. This is not surprising—once one thinks about it—for it is to be expected that painters and sculptors, like poets and novelists, will deal more or less explicitly with their own life situations and their problems as artistic creators. In the visual arts, a long series of images in many media have given information about the art-

90. Kubler, 1966, p. 213.

ist's working conditions and his place in his society, and also clues to aspects of his inner life. Velázquez's conception of *The Art of Painting* had interesting antecedents and successors.

In medieval miniatures it was usual to show the writer or painter kneeling to present his work to his noble patron, rather than creating the work. This tends to give the patron a major share of the credit for the production. At the beginning of the fifteenth century representations of artists at work began to appear. Three female painters were the subjects of illustrations in manuscripts of Boccaccio's book of famous and noble women. The earliest of such miniatures were by a Franco-Flemish illuminator working in Paris in 1402.[91] The stories came from Pliny, who described no fewer than six female painters in antiquity.[92] Marcia (Fig. 84), who painted "a portrait of herself, executed with the help of a mirror," was called Iaia by Pliny. Such was the merit of her pictures, he reported, that they sold for higher prices than those of successful painters of her day. Thamar (Fig. 85) was known to Pliny as Timarete, daughter of Mikon, who painted a picture of Artemis at Ephesos. In the miniature of 1402 she is Christianized into a painter of the Madonna, while an assistant grinds colors for her. A third woman artist, Irene (Eirene according to Pliny), is depicted applying colors to a sculptured Virgin and Child. The artists' equipment and workshops recorded in these miniatures are of great interest. They were altered in accordance with the changing times in miniatures painted for later Boccaccio manuscripts.

In the fifteenth and sixteenth centuries, especially in the Netherlands and Germany, the usual representative of painters was Saint Luke painting the Virgin; in some cases the image of the saint was a self-portrait of the artist. The identification with Saint Luke may imply a claim to divine inspiration similar to his. Roger van der Weyden's painting of about 1435 (Fig. 86) is the outstanding Early Netherlandish example of the theme that has come down to us. It is, to be exact, not a painting, but a silverpoint drawing that is being made by Saint Luke in this case. The patron saint of artists looks as sensitive and distinguished as any artist might hope to be; it has been assumed that this is an idealized self-portrait. The source of his inspiration is not a heavenly apparition but a solidly realistic Mother and Child who exist

91. Paris, Bibl. Nat. ms. fr. 12420.
92. Two representations of women painters in Pompeian wall paintings are known. See W. Helbig, *Wandgemälde der vom Vesuv verschütteten Städte Campaniens*, Leipzig, 1868, 1443 and 1444.

Fig. 84. Master of 1402, *Marcia Painting a Self-Portrait*

nues comme bien parees hommes comme nobles comme puissantes et a plusieurs grans
dommages et plusieurs grãs
prouffitz de ceq si sont venus
et ensuis. ¶ Car pour certai
ne maudiront lorgueil qui de
ce qi est ensiu. se par les femmes ou leurs pueres la franchise rommaine ne demourast. ¶ Mais la liberalite
du senat trop grande et trop
excessiue et la demeure par
tant de siecles moult domageuse ne puis loer. ¶ Car
contemptes de mondr dons
eussent este. ¶ Et bien pó
vray sembloit tresgrant cho
se du temple fonde et en richi
a femme fortune ¶ Comque puer ce estre le monde est
feminin et les hommes sont
femmins. ¶ Car pour cer
tain ce qui a este contraire
aux hommes et les choses nõ
proffitables que le grant a
age si a destruittes napeu del
tiure ne a prisier le droit aur
femmes que garde ne la sent
tresfort et vertueusement.
¶ Les femmes adoncques
a saturne rendirent loenges
et honnourent son nom
et sa merite toutes les fois
que leurs cheueux quelles

ont moult chiers de pourpre et
don sont atournez et que les
hommes quant elles pissent
se lieuent contre elles et que
a elles opleules grans substã
ces seulent venir de ceulx qui
meurent

Es cest cy de thamar de la
tresnoble peintresse fil
le de micon. la diiij. rubriche.

Thamar en sõ
temps et en sõ
auge fut tres
noble peintre
uesse et seul est
ainsi que le
grant temps nous ait oste
moult grandement de la sou
uenance de sa vertu et de son
bien. ¶ Toutesuoies son
noble nom par la cause de sõ
artifice encore oster ne nous

Fig. 85. Master of 1402, *Thamar in Her Studio*

Fig. 86. Roger van der Weyden, *Saint Luke Depicting the Virgin*

on the same level as the artist. The setting, however, has nothing to do with an actual painter's studio; rather it relates to the grandeur of the subject. In the adjoining room at the right can be seen the open Bible and the ox, symbol of the Evangelist Saint Luke. Among the symbolic elements that enrich the meaning are the small sculptured scene of the Fall of Man on the arm of the Madonna's throne and the enclosed garden outside the room in which the artist gravely contemplates his sacred subject. A series of painters based works on Roger's conception

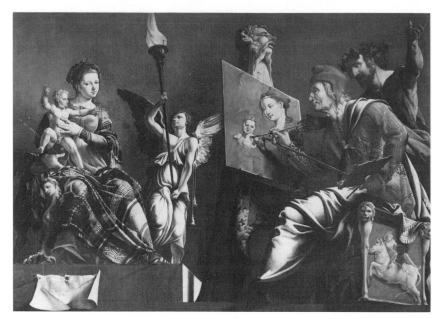

Fig. 87. Maerten van Heemskerck, *Saint Luke Painting the Virgin*

of this theme. Dirk Bouts's version of 1455 followed it rather closely (Penrhyn Castle, Lord Penrhyn Collection). By the time of Jan Gossaert's *Saint Luke Painting the Virgin*, around 1520 (Vienna, Kunsthistorisches Museum), the angel guides the hand of the artist-saint. (There was no angel in a version Gossaert painted about five years earlier, now in Prague, and a relatively naturalistic Mother and Child were Saint Luke's models, instead of the vision he sees in the Vienna painting.) Supernatural assistance to Saint Luke also is made visible in Maerten van Heemskerck's imaginative Mannerist version of 1532 (Fig. 87), which, like the Gossaerts, incorporates references to classical art in this quintessentially Christian theme. Indeed, all these examples have grand and elaborate settings in keeping with the elevated nature of the subject.

Depictions of a painter at work, undisguised by the cloak of the religious theme, were still unusual in the sixteenth century. The woodcut made by Hans Burgkmair in about 1515 for the *Weisskunig* (Fig. 76) has a more realistic setting and, like the 1402 miniature of Thamar, also includes the down-to-earth detail of an apprentice or assistant grinding colors. The woodcut has in addition the interesting aspect of presenting a self-portrait, identifiable on the basis of comparison

Fig. 88. Rembrandt, *An Artist in His Studio*

with a profile self-portrait drawing.[93] The implication of honor to the Emperor and also to the painter whom he visits in his workshop and in whose work he condescends to take so lively an interest pertains as well to the seventeenth-century paintings incorporating similar subject matter, including *Las Meninas*. A well-known drawing called "The Artist and the Connoisseur," by Pieter Bruegel the Elder (Vienna, Albertina), may also represent a self-portrait. No setting is indicated in this satiric drawing, in which the "connoisseur" looks over the shoulder of the artist and appears to ponder whether the work he sees on the easel warrants his taking money from his close-held purse. The worried artist, dependent for his living on the judgment of the vulgar, is a far cry from the exalted identification of the artist with Saint Luke or the Court painter favored by his noble patron.

The painter at work in his studio was frequently the subject of Dutch and Flemish paintings in the seventeenth century. Many of them are in a realistic vein and provide information as to studio practices of the period. A small picture Rembrandt painted around 1628, of *An Artist in the Studio* (Fig. 88), has been thought by some scholars to be a self-portrait, while others suggest that it is a portrait of

93. Hamburg, Kunsthalle. Inscribed: "1517/H. Burgkmair/Maler. 44. iar alt."

Fig. 89. Michiel Sweerts, *A Painter's Studio*

Gerard Dou, who became an apprentice in Rembrandt's studio in Leiden in 1628.[94] The painter is in my opinion not identifiable. What is clear—and this gives the painting a particular affinity with *Las Meninas*—is that what really matters in the studio is the artist's respect for the canvas on the easel. *A Painter's Studio* of about 1650 by the Brussels-born Michiel Sweerts (Fig. 89) shows pupils making studies after casts of fragments of ancient sculpture, while the master works from the nude model. This is probably a reasonably factual representation of the teaching of painting in the studio of a successful painter in the middle of the seventeenth century. The Haarlem painter Adriaen van Ostade depicted a painter working in his studio in the 1660s (Fig. 90). (There is a slightly different version dated 1663 in Dresden, Gemäldegalerie Alte Meister.) The studio is cluttered with equipment

94. On the identification of the artist depicted, see A. Bredius, revised by H. Gerson, *Rembrandt*, London and New York, 1969, No. 419.

Fig. 90. Adriaen van Ostade, *A Painter's Studio*

and props; in a back room, apprentices grind colors. Similar paintings by other artists support the likelihood that this humble setting gives an accurate idea of the workshops in which numerous Dutch painters produced the flood of works for the art market that was one of the amazing features of the United Provinces in the seventeenth century.

It was at a time when the great achievements of Dutch painting lay mainly in the past and a general decline in quality was not far in the future—fifteen years or so after Velázquez painted *Las Meninas*—that Jan Vermeer of Delft created another landmark in the history of depictions of the painter in his studio. Vermeer's *Art of Painting* (Fig. 91) is similar in many of its details to other paintings of the period.[95]

95. See Lawrence Gowing, *Vermeer*, New York, 1953, pp. 139 ff.

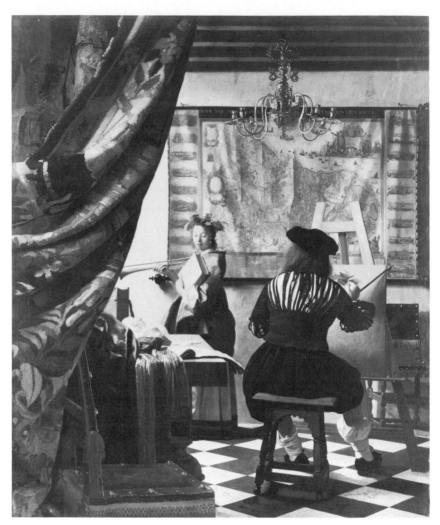

Fig. 91. Jan Vermeer, *The Art of Painting*

But, as in the case of *Las Meninas*, the artist so successfully adapted his borrowings to his own purposes and his personal style that a unique masterpiece resulted. Vermeer's tribute to the art he practiced is in a way the converse of Velázquez's. The Dutch painter made his artist anonymous but showed us precisely what he is painting. His subject is Clio, Muse of History, holding the trumpet of Fame. Symbols of the other Muses indicate his intention of placing painting on a par with the fine arts in their classical definition. He makes this point through explicit allegorical content, while in *Las Meninas* it is implied. Veláz-

Fig. 92. Jean-Honoré Fragonard, *The Lover Crowned*

quez, however, was no less interested in fame, and history, and the status of the art of painting than Vermeer, in his very different way, showed himself to be.

Antwerp painters in the seventeenth century often transformed the studio into a gallery where paintings were exhibited, as we have seen. Painters were in fact often art dealers as well during this period,

and pictures on the walls may have represented their stock in some cases. Sometimes they introduced allegory or legend into such subjects, to add luster to the art of painting. Thus they shed a different kind of light on the situation of the artist than did the more prosaic approaches to the subject. In painting *Las Meninas*, Velázquez took his place in this tradition.

Eighteenth-century artists found quite different uses than their predecessors had for their conceptions of artists at work. Fragonard fit the role of the painter into his romantic scheme of life, recorded in *The Progress of Love*, the delightful decorative ensemble that he painted between 1771 and 1773 for Mme. du Barry (who rejected it). In the last of the four paintings in this series, *The Lover Crowned* (Fig. 92), an artist seated in the right foreground is drawing the happy couple as they pose for him in a lush garden. The girl holds a crown of flowers over the head of her lover, who sits on the ground at her feet. Art is inspired by love.[96] The Arcadian tradition to which this conception belongs had a long history, going back to medieval scenes of courtly life, in which music was associated with lovers in gardens, as it is here. Bringing the visual arts into the garden of delights added a fresh note to the old convention.

In contrast with the romanticism and symbolism in Fragonard's vision of the artist, the artist's studio was essentially a genre subject for most French painters who dealt with the theme in the late eighteenth and early nineteenth centuries. At the Salons, however, many paintings were shown that purported to depict the studios of old masters, "excellent pretexts to show the dignity of painting, occasions to glorify the masters [of the past] and the author himself." [97] Some of these dealt with the relations of Kings with artists, such as the legend of Charles V picking up Titian's fallen brush.

In 1800 Goya painted *The Family of Charles IV* (Fig. 93). In what must have been a deliberate bow to Velázquez, he took his place with the royal family. True, he half hid himself in the darkness in the left background, but he had hardly any better option in this rather for-

96. Donald Posner ("The True Path of Fragonard's 'Progress of Love,'" *Burlington Magazine*, 114, 1972, p. 534) interprets this scene as meaning that "love makes best progress when it is cultivated and nourished by the civilizing influence of the arts." The converse seems somewhat more relevant to Fragonard's narrative, that is: Love inspires art.

97. René Huyghe, Germain Bazin, and Hélène Adhémar, *Courbet: L'Atelier du Peintre, allégorie réelle, 1855*, Paris [1944] (Monographie des Peintures du Musée du Louvre, III), p. 21.

Fig. 93. Francisco Goya, *The Family of Charles IV*

mal line-up. To rationalize his presence there in terms of his being
actually at work would be even more futile than the attempts to ex-
plain what Velázquez is painting in *Las Meninas*.[98] Goya's indebted-
ness to Velázquez is documented in the numerous etchings he made
after works by his seventeenth-century predecessor as Court painter,
among them *Las Meninas*.

 The outstanding nineteenth-century excursion into this field was
Gustave Courbet's *The Painter's Studio: A Real Allegory* (Fig. 94).
Extraordinary in subject matter, vast, and extremely forceful, this can-
vas was rejected by the jury for the *Exposition Universelle* of 1855,

 98. Xavier de Salas (*Goya, La Familia de Carlos IV* [Obras maestras del
arte español, III], pp. 26 ff.) compares Goya's painting with *Las Meninas*.
 Priscilla E. Muller ("Goya's *The Family of Charles IV*: An Interpretation,"
Apollo, 91, 1970, pp. 132–137) offers the hypothesis that the picture on the wall
behind the painter represents Lot and his Daughters. Erwin Walter Palm ("Ein
Grazien-Gleichnis. Goyas Familie Karls IV," *Pantheon*, 34, 1976, pp. 38–40) argues
that this picture within the painting represents the Three Graces. In the absence
of a known prototype, the subject of the picture, which is not clearly depicted,
cannot, I think, be proved.

Fig. 94. Gustave Courbet, *The Painter's Studio*

perhaps as much out of shock at the juxtaposition of the nude female and the motley company as because of its problematic social commentary. According to the catalogue of his private exhibition in which he displayed the picture, it describes a phase of seven years in his artistic life. In a letter addressed to his friend Champfleury (whose portrait in the picture ruptured the friendship), Courbet explained that his intention was

to show that I am not dead, nor is realism. It is the moral and physical history of my studio. . . . The picture is in two parts. I am in the middle, painting amidst the participants, that is to say, the friends, workers, art lovers. At the left, the other world of trivial life, the people, misery, poverty, riches, exploited, exploiters.

Far though this is from a clear summary of a political or philosophical position, it does show that Courbet intended the picture to be a statement of his attitude toward the world he lived in and the place of his work in that world. Systematic exposition was not his strong suit. Yet even the paradoxical subtitle he gave the picture, "a real allegory," sheds some light on his intentions. He used realist means, to which he was committed, for an allegorical end. Combining the portraits of specific individuals—including himself as a painter at work—with other, equally individualized figures that represented generalizations or abstractions, he attempted to create a visual argument in support

of certain social, political, and economic aims. That is to say, in terms of his own times and problems, Courbet repeated essentially the same experiment as that which had occupied Velázquez two centuries earlier.

Courbet's contemporaries recognized the parallels between *L'Atelier du Peintre* and *Las Meninas*.[99] Alongside the similarities, there are, of course, striking differences between the two paintings. Whereas Velázquez made the Infanta the central figure and the focus of the light, Courbet gave himself the center of the stage and the spotlight. This distinction reveals the fundamental differences in the roles of the two artists as they themselves perceived them. Velázquez deferred to royalty even while he was pressing his suit for greater social status for himself and his art. Courbet pushed himself to the fore, even in the act of taking a stand against social injustice. Cultural differences certainly played a part in the shift of the artist from side to center stage between the seventeenth- and the nineteenth-century compositions, and possibly psychological differences in the two artists did as well.

The appreciation of French painters for Spanish art followed on the heels of the Peninsular campaigns of Napoleon, which for the first time brought quantities of Spanish paintings into France. Spanish painting had until that time been relatively little known outside the country of its origin. The paintings of Velázquez, most of which were sequestered in the royal palaces, were hidden from the eyes even of the travelers who managed to see the art in churches and other institutions open to the public. It was not until 1819, when the greater part of the royal collections was placed in the National Museum in Madrid, that his works began to make their full impact. Delacroix was among the first of the French artists to express enthusiasm for the Spanish painters and especially for Velázquez, in the 1820s.[100] By the

99. Benedict Nicolson (*Courbet: The Studio of the Painter* [Art in Context], London, 1973, p. 69) denies the "often-invoked relationship" between *Las Meninas* and Courbet's painting, on the grounds that "the evanescence of *Las Meninas* has nothing in common with the aggressive physical presence of *The Studio*." The works that he advances as Courbet's sources of inspiration, Rembrandt's "*Hundred Guilder Print*" and "*Night Watch*," seem to me to be unrelated to Courbet's *Atelier*.

100. *Journal*, especially 19 March and 11 April, 1824. It should be noted, however, that Delacroix's enthusiasm extended to paintings that are no longer ascribed to Velázquez. It is important to recognize, too, that the general public was not so quick to appreciate Velázquez. As late as 1906 Stevenson (p. 2) published this statement: "As yet few but painters enjoy Velásquez or rightly estimate his true position in the history of art."

1830s a number of writers had reported on the works of the Spanish master, which were generally described as realistic reproductions of nature.[101] The opening of Louis Philippe's *Musée Espagnol* in Paris in January 1838 responded to and further stimulated curiosity about everything Spanish. Courbet could thus have learned about Velázquez's style without ever going to Spain.[102] And he, like many others, could have considered it to be in perfect accord with the realism that they professed. At the same time, romantic writers were able to interpret this art as supporting the keystone of *their* faith: the acceptance of all of nature.

Edouard Manet, the seminal figure in the next in the series of modern renewals of French art, was no less inspired by Velázquez than Courbet had been, though his artistic intentions were totally different. In 1865, after the exhibition of his *Olympia* at the Salon had made him the object of public scorn, Manet decided to get away from it all by visiting Madrid, which he had long wished to do. While in Madrid, by chance he made the acquaintance of Theodore Duret, who wrote that together they "spent a considerable time every day before the paintings of Velázquez in the Prado. . . . Everything Manet saw in Spain, which had haunted his dreams for so long, fulfilled his utmost expectations." [103] His etchings after Velázquez's portraits of Philip IV and the Infanta Margarita are among the proofs he left of his close study of the Spanish master he so greatly admired.

No artist has shown a more intense interest in the relation of the artist to his work than Pablo Picasso. On August 17, 1957, one hundred and two years after Courbet adapted *Las Meninas* to his own purposes, Picasso made the first of a series of forty-five studies based on Velázquez's picture. This painting analyzed the entire composition, with striking emphasis on the figure of the painter (Fig. 95). Picasso then spent almost four months on paintings of various details; nineteen of the studies feature the Infanta. Picasso gave these pictures to his friend Juan Sabartès, who afterward presented them to the Picasso Museum he established in Barcelona. In the book in which the paintings were published in 1959, Sabartès wrote: "What Velázquez was trying to do could scarcely be appreciated in his own age. He at-

101. For instance, Henri Cornille, *Souvenirs d'Espagne*, quoted by Ilse Hempel Lipschutz, *Spanish Painting and the French Romantics*, Cambridge, Mass., 1972, p. 92.
102. See Huyghe, Bazin, and Adhémar, p. 20, n. 1.
103. Theodore Duret, *Manet*, New York, 1937, p. 37.

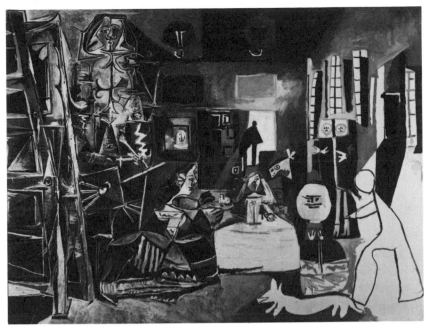

Fig. 95. Pablo Picasso, *Variation on Las Meninas, I*

tempted to capture the moment of suspended action, to record a gesture made in a fraction of a second." Thus it is clear that the "snapshot interpretation" of *Las Meninas* that was advanced by the nineteenth-century French critics, and by Justi and Beruete and other art historians, not to mention their twentieth-century followers, has never died. Yet Sabartès also recorded the insight that the painting was composed as it was "so as to bring the particular individuals portrayed together"—a view that we can endorse.

And would it be excessive to suppose that Picasso was not to be the last great artist to reincarnate the brilliantly original yet profoundly traditional painting in which Velázquez embodied his pride in the art of painting and his hope for the honor that would establish his status for all time? [104]

104. Among the contemporary artists who have based works on *Las Meninas* are the Spanish painter Salvador Dali and the Chilean Juan Downey. Downey used a copy of *Las Meninas* as the central theme of an "installation and performance piece" that was the principal work in his exhibition in New York in March 1975. The French filmmaker Jean-Luc Godard had Velázquez and possibly *Las Meninas* in mind in making *Pierrot le Fou* in 1965.

It is only just that *Las Meninas,* Velázquez's brief in support of the claim to honor due to the art of painting and to the creative artist, should nourish that art perpetually. Representing *The Art of Painting,* the picture is in itself a demonstration of the combination of intellectual subtlety and artistic sensibility that the best of its practitioners bring to their art. A mere craft? A "mechanical art"? Surely not. Velázquez gave timeless form to his proof that the appreciation of art ranks among the higher human functions, that it is a self-rewarding activity in the Aristotelian sense, enriching and ennobling those who devote themselves to it. In creating the picture, however, he himself was responding to the demands of life as well as art, and he sought a more concrete reward: the status of nobility.

IV.

Life Ends, but Art Endures

In 1656, the year in which he painted *Las Meninas*, Velázquez also had other tasks in hand. According to Palomino, in that year His Majesty ordered Don Diego Velázquez to take to San Lorenzo el Real (El Escorial) forty-one original paintings.[1] Some of them had come from the auction of Charles I of England, some Velázquez had brought back from Italy, and some had been given to the King by his former Viceroy at Naples, Don García de Avellaneda y Haro, Conde de Castrillo. About each of these pictures Velázquez wrote "a description and report on the quality, history, author, and location in which it should be placed, in which he elegantly and suitably gave proof of his erudition and great knowledge of art." Doubtless he had been called on not infrequently for services such as this, services that required not only knowledge and judgment, but the expenditure of precious time. To arrange and hang an "exhibition" of this size and write a catalogue for it is a demanding assignment.

Palomino goes on to say that in 1657 Velázquez wished to return to Italy, but the King did not give permission because of his procrastination the last time and because he was needed to supervise the painting of walls and ceilings of some rooms in the palace. Colonna and Mitelli, with whom Velázquez had negotiated in Bologna, arrived in 1658 to paint these frescoes. For the room known as the *Salón de los Espejos* (Hall of Mirrors) Velázquez laid out the plans for the ceiling frescoes illustrating the fable of Pandora. The Spanish painters Carreño and Rizi collaborated with the Bolognese artists in painting the frescoes in 1659. Velázquez's overall responsibility for the decoration

1. Palomino, p. 922. A report on the paintings and their placement in El Escorial, ostensibly written by Juan de Alfaro and published in Rome in 1658, is reprinted in *Varia velazqueña*, Vol. II, pp. 294–299. The authenticity of this document was questioned by Cruzada (p. 206) and Justi (Vol. II, pp. 244 ff.). Sánchez Cantón ("Los libros españoles que poseía Velázquez," *Varia velazqueña*, Vol. I, p. 647, note 23) points out that the fact that it was not in Velázquez's library at the time of his death argues that the report is not authentic.

must have required his presence at least now and then. He himself created four mythological paintings for this room. One pair of them dealt with murderous gods: *Mercury and Argus* and *Apollo Flaying Marsyas*. Suffering lovers were the subjects of the other two companion pieces: *Venus and Adonis* and *Cupid and Psyche*, the latter of which was the only one of the four tales represented that had a happy ending. Only the *Mercury and Argus*, now in the Prado, survived the fire of 1734, and it is in questionable condition.

The ambitious, large, multifigured composition known as *Las Hilanderas* (The Spinners), or *The Fable of Arachne* (Fig. 96), was probably painted after 1657. Very likely it is the picture that was listed in 1664 under the title *"la fabula de Aragne"* in the inventory of the Madrid collection of the courtier Don Pedro de Arce.[2] This title was not included in the inventory of his collection made in 1657, which suggests that the painting was finished after that date. Its condition makes it particularly difficult to date on the basis of style, but it is most closely related to works of the second half of the 1650s. There is no record that the picture was in the royal collection before the eighteenth century.

Velázquez's composition was distorted by later enlargement of the canvas on all four sides, most broadly at the top, where the added strip accounts for everything above the level of the top of the ladder. The vault and oculus that appear on the painting today, as well as the picture on the wall above the doorway at the right, are thus painted on the later addition and are not to be considered as included in Velázquez's conception. The additional strips are clearly visible to the naked eye, both because the lines where they were joined are evident and because the painting on them does not match that of the central portion of the picture in color, brushstroke, and craquelure. The size given in the 1664 inventory is almost exactly that of the central piece of canvas, without the four added strips, which establishes with a fair degree of reliability the probability that the central part alone represents Velázquez's original composition (Fig. 97). This is also confirmed by the

2. Caturla, 1948, pp. 302 ff. A few weeks before Caturla published her finding of this title in the archive, Angulo Iñiguez (1948) had published his interpretation of *Las Hilanderas* in relation to the fable of Pallas and Arachne. Enriqueta Harris (*The Prado*, London [1940], p. 85) had been the first to propose this interpretation. Caturla felt that Angulo explained everything except the musical instrument convincingly. The measurements Caturla found in the inventory conform with the size of the picture in the Prado without the later additions.

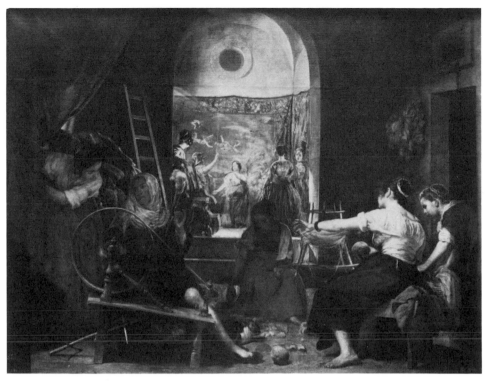

Fig. 96. Velázquez, *The Fable of Arachne (Las Hilanderas)*

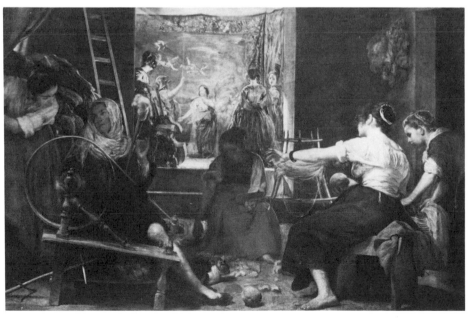

Fig. 97. Velázquez, *The Fable of Arachne (Las Hilanderas)*, approximately as Velázquez composed it

radiographic evidence that the central piece of canvas has been stretched and painted as such.[3]

What is going on in the principal scene appears to be obvious: five women are working, making yarn. Two of them are in the immediate foreground, and both the major spaces allotted to them and the clear depictions of their occupations mark them as the chief characters in the incident. The one on the left, dressed in black, and with a white shawl firmly wrapped about her head, is spinning yarn. Her skirt is pulled up above her left knee, so that an unusual expanse of bare leg is visible.[4] She appears to be older than her companions, but as no details are very clear, the relative ages of the women are mainly conjectural. Her head is turned toward a woman who stands beside her and leans down, apparently in conversation with her. Counterbalancing the woman sitting at the spinning wheel is a seated woman winding yarn at the right. She wears a dark blue-green skirt and a white blouse, and her bare lower left leg and foot are visible. Her head is turned away from us so that we see little more than her cheek line. This concealment of her face brings to mind the pose of the head in *Venus at Her Mirror* (Fig. 49). At the far right another woman sets a basket down on the floor beside her. Centered between these two groups, and set somewhat farther back in space than they, is a fifth woman whose reddish skirt blends with the warm colors of the costumes of the workers at the extreme right and left. The central figure is composed of flat patches of color, and her features are even more blurred than those of the other women; this may be in part at least because this area is badly defaced. But Velázquez used "neutral," flatly painted figures, similarly silhouetted, in other paintings; such figures play effective parts in the compositions of *Joseph's Bloody Coat* (Fig. 24) and *Las Meninas* (Fig. 62). A cat on the floor in front of the woman in the center is playing with tufts of wool that have fallen there, presumably as the woman worked at her task of carding the wool.

Though the composition was carefully designed by the artist, the impression given is that of a naturalistic rendition of a scene from everyday life. Indeed, the view prevailed for many years that this pic-

3. Menéndez Pidal and Angulo Iñiguez.
4. Angulo Iñiguez (1947, p. 19) believed that the two main figures and the most important elements of the setting were based on Michelangelo's Sistine Ceiling.

ture represented a scene in the royal tapestry workshops.[5] To con-
form to this view, the brightly lighted, stage-like alcove in the back-
ground was interpreted as a showroom, to which visitors had come
to inspect some tapestries. This interpretation could not be sustained,
however, once it was recognized that the central figure in the alcove—
and also by implication the helmeted figure with whom she seems to
be involved—is not a part of the tapestry, as had been thought, but
stands in front of it.[6]

The contrast between the gloomy workshop with its ill-clad labor-
ing women and the brilliantly illuminated alcove with its elegant
figures had, in fact, long since aroused curiosity as to the meaning of
the picture. As long ago as 1825 it was suggested that the subject is a
mythological one, that of the Fates.[7] This interpretation would do
nothing to dispel the mystery of the scene in the alcove, however. The
most noticeable object in the alcove is a tapestry represented as hang-
ing on the rear wall. The content of this tapestry was based on Titian's
painting *The Rape of Europa*,[8] which was in the Spanish royal collec-
tion from 1562, and the identification of this subject provides a clue.
The Rape of Europa was one of the subjects relating the amorous
escapades of Zeus that Arachne wove into the tapestry she produced in
her contest with Minerva. This suggests that the title listed in the
inventory of 1664, *The Fable of Arachne*, may indeed be the subject
of the painting. In line with this interpretation, the figure wearing
armor and helmet in the alcove scene has been identified as Minerva,
and her upraised arm has been construed as a threatening gesture
toward Arachne, who would be the central figure in that group, the

5. Justi, Vol. II, pp. 326 ff. To Justi, however, "the real subject" was
Light. Bartolomé Mestre Fiol ("'El cuadro en el cuadro' en la pintura de
Velázquez: 'Las Hilanderas,'" *Revista Traza y Baza*, 4, 1974, pp. 77–101) argued
that the entire background scene, including the vault, was a round-topped tapestry
that was hanging in the royal tapestry workshop in order to be repaired. Besides
ignoring the fact that the rounded top was added later, he implausibly claimed
that though it hangs on a dark wall, the so-called tapestry provides its own
brilliant illumination.

6. Trapier, pp. 349 f.

7. Cean Bermúdez, *Historia de Arte de le Pintura*, quoted in *Velázquez:
Homenaje*, p. 141. In 1943 José Ortega y Gasset expressed a similar conviction.
In 1954 Ortega y Gasset related the subject matter of the Fates to Catullus's poem
on the Wedding of Peleus and Thetis. The verses he cited, however, bear little
relationship to the painting. (*Velázquez*, p. 219.)

8. C. S. Ricketts, *The Prado and Its Masterpieces*, Edinburgh, 1903, p. 86.

one facing out toward us.[9] The three other women in the alcove would perhaps be the Lydian women who came to admire Arachne's handiwork.

The foreground has likewise been related to Ovid's story of the presumptuous Arachne, with the woman winding yarn representing Arachne and the woman at the spinning wheel representing Minerva in her disguise as an old woman, before she revealed her true identity and took up the challenge of Arachne.[10] But neither the activities in which these two women are engaged nor their companions in the foreground scene are consistent with the story of the competition in weaving described by Ovid. The prominent ladder, too, remains unexplained, except that its use in hanging tapestries could account for it on a naturalistic basis. Details of the scene on the higher level in the background are also difficult to explain. It hardly seems convincing to identify as the lowly Arachne a woman who appears to be wearing a diadem above her brow and whose blue sash from her right shoulder to her waist at the left also probably denotes aristocracy. The helmeted figure is not identifiable as female, and the upraised arm of this personage might indicate a greeting rather than a threat. The other three splendidly dressed women similarly fail to fit the story. The musical instrument, which could hardly have been inserted capriciously, cannot be ignored.[11] It appears, in short, that some literary source other than Ovid must have played a part in the definition of this subject matter.

The two scenes seem to bear the kind of relationship to one another that linked the foreground genre scene and the small religious scene in the adjoining room in Velázquez's early *Kitchen Scene with Christ in the House of Martha and Mary* (Fig. 2). That is to say, a rather freely interpreted episode from a literary text is composed in

9. Angulo Iñiguez (1952, pp. 83 f.) altered his 1948 view as to the moment depicted in the background, now interpreting it as the beginning of the metamorphosis of Arachne.

10. In 1948 Angulo Iñiguez had identified the two chief figures as Minerva and Arachne, but in 1952 he revised his opinion and called them "Arachne's workers."

11. Angulo Iñiguez (1948, pp. 9 ff) suggested that the viola da gamba is included because music is a legendary antidote for the poison of a spider's bite, and Arachne is to be transformed into a spider. Tolnay (p. 26) stated objections to this solution. Caturla (1962) suggested that it was not a musical instrument at all, but a group of three *devanaderas* (reels for yarn), two of which are mostly hidden behind the foremost one. This is hardly convincing, especially as no reels of the form she describes seem to be extant, nor is there any visual record of them.

small format within the context of a genre scene on a much larger scale. The activities in the two scenes are apparently related only in a general way, rather than jointly illustrating a specific episode from a narrative. The naturalistic approach to the foreground scene of everyday activities tends to be out of key with the secondary scene, which places the picture explicitly in the approved category of "history painting" rather than genre.

Pieter Aertsen's genre scene with Christ at Emmaus, which Velázquez may have known in his early days in Seville through a print by Jacob Matham,[12] contains in the background a similarly brightly lighted raised alcove, in which a separate figural scene is depicted as if on a stage. It seems that late in his career Velázquez reverted to this pattern that had interested him so long before. In the composition by Aertsen (as in the whole series of genre scenes with inserted biblical subjects to which it belongs, which were engraved by Matham) the individuals represented in the foreground appear to be unaware of the event represented in the background scene. This curious disjunction also characterizes *Las Hilanderas*.

Not one of Velázquez's humble workers is paying any attention to the dazzling scene that they might all have been expected to find irresistibly attractive—if a realistic report had been intended. Of the figures on the stage, only one, the woman on the extreme right, looks out in the direction of the workshop, and her gaze does not seem to be directed toward anything that is going on there. In a naturalistic sense, the two areas retain their isolation from each other. Compositionally, however, Velázquez provided a striking interrelationship: each of the two main foreground figures lifts a hand that overlaps a corner of the background scene, thus calling attention to it. The central foreground figure is also integrated with the background scene. Similarly to the way in which the main characters in *Las Meninas* are composed to provide a semicircular setting for the mirror, in *Las Hilanderas* the graceful arc of the foreground group as a whole is like a garland, a frame for the jewel-like radiance of the area that fills the upper central part of the canvas in the original composition. It is necessary to block out the added sections on all four sides of the canvas to appreciate fully the ingenuity and beauty of the composition. At this time of his consummate artistic mastery, Velázquez succeeded in creating effective relationships of form, light, and color that transform the ambiguous spatial organization into a moment of visual enchantment.

12. Bartsch 165, Hollstein 320. See our Chapter II, p. 21–22 and note 12.

Now capable of making pictorial space do his bidding, Veláz-
quez used space here to emphasize a counterpoint between the de-
mands of life and the gratifications of art. Illumination is his metaphor
for the experience of art. The shaft of light that draws our eyes to the
upper zone of his picture brings us into the higher realm, in which
Titian is the glorious representative of the art of painting, music takes
a prominent place, and perhaps the entire scene represents drama, as
the agent of poetry, which thus joins its sister arts. The realm of art
transcends labor and craftsmanship, but it is supported by them.[13] The
ladder may be understood as symbolizing the ascent from the material
concerns of life to the heights of art.

The eloquence of the space that separates the figures in *Las
Hilanderas* is the fruition of Velázquez's long years of grappling with
the basic problems of space representation in painting. In the earliest
of his *bodegones* he was not yet able to deal persuasively with the
space between the figures, but he made visible progress in this regard

13. According to Tolnay, the myth of Arachne was merely an addendum,
and the fundamental theme of the composition was "the representation of Pallas
as goddess of the major Arts and the minor Arts." He argued that by means
of composition and lighting Velázquez distinguished between fine arts (the
background scene) and craftsmanship (the workshop in the foreground), in
accord with Neo-Platonic Italian art theory of the late sixteenth and early
seventeenth centuries. He considered this distinction parallel "to the social
separation between artist and artisan in the XVI Century." Velázquez, he
believed, expressed in this composition his art theory: "idea and craftsmanship
together form the realm of art" (p. 32). Tolnay's interpretation is well founded
theoretically, but his identification of the figures in the background as personi-
fications of specific arts is strained.

Similarly stressing the contrast between the cluttered, earth-floored, ill-
lighted workroom and the "display room" with its richly clad figures, Gustaf
Cavallius interpreted the picture as "a depiction of social discrepancy, between
the luxury and leisure of an upper class and the poverty and labours of a lower"
(p. 155). Cavallius went even farther with his socio-economic argument, asserting
that the position of the workers, closer to us, makes them more accessible to our
identification and sympathy, and implies "a positive incitement . . . on behalf of
the working and exploited class" (p. 177). It is inconceivable that such an idea
would have been entertained by anyone in the seventeenth century, much less by
one of Velázquez's class and with his ambitions. Cavallius's interpretation pre-
supposes Karl Marx's theory of the class struggle. Among other associations that
Cavallius includes in his elaborate analysis of the picture, in addition to the
"antithetic relationship" of the two scenes, he speaks of "general ambiguity" as a
dominant theme of *Las Hilanderas*. The degree to which this general ambiguity is
veiled, he suggests, may be "the result of a confrontation between a strong, inno-
vating mind and a rigid, self-preserving society" (p. 177).

Azcárate interpreted the painting as an allegory of Obedience, Contrition, and
Concord, related to political and military events of 1656–1658, particularly peace
negotiations with France and suppression of the Catalán revolt. His theory
accounts for only a few of the figures and is incompatible with many of the
details of the painting.

before he left Seville. A few years after taking up his work at the
Court, while still in his twenties, with the portrait of Philip IV (Fig.
15) and that of *The Buffoon Pablo de Valladolid* (Fig. 16), he was
remarkably successful in creating a sense of atmosphere around a
single figure. The three-figure group in *Christ After the Flagella-
tion* (Fig. 21) presented a more complex situation, besides which the
supernatural nature of the subject conflicted with his naturalistic bent,
and Velázquez was not entirely successful in dealing with it. In *Hom-
age to Bacchus* (Fig. 23) too the spatial relations are unresolved. His
first trip to Italy seems to have stimulated new solutions, as we see in
the arrangements of the figures in space in *Joseph's Bloody Coat
Shown to Jacob* (Fig. 24) and *Apollo at the Forge of Vulcan* (Fig.
25).[14] Both of these pictures embody subtle and difficult problems
in spatial relations, and in both compositions the space itself acts as a
participant in the narrative in a decidedly original and successful way.
Thereafter in his few multifigure compositions Velázquez continued
to explore the possibilities of pictorial space. Even in the relatively
simple format of *Venus at Her Mirror* (Fig. 49) his inventiveness in
establishing a meaningful role for space is apparent. In *Las Meninas* or
The Art of Painting (Fig. 62) the space separating the figures is almost
palpable, and the intervals in themselves constitute an expressive ele-
ment in the picture. *Las Hilanderas* too has eloquent voids between the
individual figures and the groups, and it goes even farther in present-
ing areas of space located in such a way that they actively partici-
pate in the meaning of the painting. There is a higher realm and a
lower one, with all that this implies. The sphere of art is the higher
one.

If we look upon *Las Hilanderas* not as expository prose but as
poetry, the picture transmits a message with brilliant clarity: art exists
to remind us that there is something beyond our earth-bound daily
labors. While it occupies physically but a small part of the world, art is
more vivid, more colorful, more exciting—thus, in a sense, larger than
life. Art is sublimation. It heightens sensibility, expands conscious-
ness. And though life ends, art endures.

Las Hilanderas was in effect a summing up and a testament. But—
unless it was painted in 1659, which is not impossible—presumably it
was not Velázquez's last painting. Palomino reports that in 1659 Veláz-
quez executed two portraits for the King to send to the Emperor
Leopold I in Vienna. Both are still in Vienna, now in the Kunsthis-

14. Veronese's mastery in this regard may have inspired Velázquez's progress.

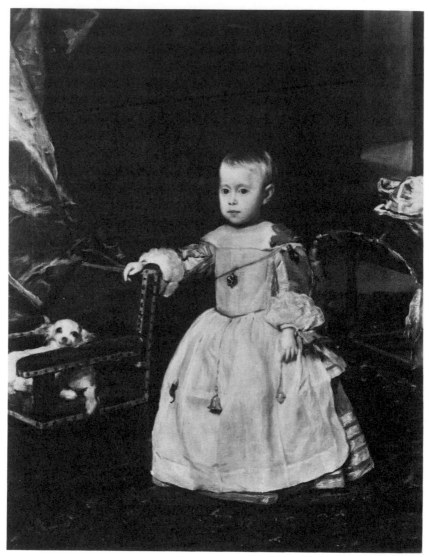

Fig. 98. Velázquez, *Prince Felipe Prospero*

torisches Museum. One was of the Infanta Margarita, who was to be-
come the Emperor's bride in 1666. The other portrait depicted the
new heir to the throne, *Prince Felipe Prospero* (Fig. 98), who was
born on November 28, 1657. The little Prince wears a translucent
white pinafore over his rose-colored dress lavishly ornamented with
silver braid. He wears a number of amulets, which should have assured
his good fortune, but he was to live only until November 1, 1661. His
right hand rests on the back of a chair on which a small white dog
lies, looking out at us alertly. The background and the features of the
child have been altered by restoration, but other parts of the picture
display the subtlety of Velázquez's handling and his marvelous sense
of space.

What else do we know about Velázquez's activity in 1659? In
February and March, as part of his continuing effort to be received
into the Order of Santiago, he signed statements addressed to the King
in which he explained his lack of opportunity to perform any acts of
distinction because his early years were spent in his father's house in
Seville and after that he had been in the service of the King. Docu-
ments also record that he fulfilled his palace duties and repeatedly had
to request money to meet expenses for which he was responsible as
Aposentador. We know nothing of how he may have rejoiced when, on
November 28, 1659, he became a Knight of Santiago and an *hidalgo*.

The year 1659, in which Velázquez painted his last portraits of the
royal children, brought new troubles to Spain. In the Peace of the
Pyrenees the Spanish crown lost its position of dominance in Europe
and contracted a dynastic marriage with France which laid the ground-
work for later disasters in the War of the Spanish Succession. Veláz-
quez's last months were devoted to arrangements for the ceremony
that was to take place on the Isle of Pheasants, uniting the Infanta
María Teresa with Louis XIV of France. Their marriage was to seal
the peace between the two countries. Velázquez left Madrid on April
8, 1660, in advance of the King, to arrange for the royal party's hous-
ing en route to Fuenterrabia, the town near the northern border of
Spain closest to the island that was to be the site of the ceremony. He
spent twenty-four days on the way. On June 7, dressed in his finest,
he was present at the festivities. Besides the red insignia of the Order
on his cloak, he wore suspended from a thick gold chain around his
neck a scallop shell Order of Santiago, adorned with many diamonds
and an enameled emblem. On the following day he left with the King

on the return trip to Madrid, where they arrived at dawn on June 26. According to a letter he wrote on July 3, he was then "weary of traveling by night and working by day, but in good health." [15] He seems to have taken up at once his duties at Court, for on July 3, 5, and 17 he signed papers dealing with payments due in connection with the trip. On July 31, after working at the palace all morning at the service of the King, he felt tired and feverish and went home. His family doctor and two of the King's doctors attended him and reported that he was in critical condition. On August 6, 1660, Velázquez died.

He left behind no artistic "school." The magic of his brush was not easy to imitate, and the mental conception behind it was far ahead of its time. It might be said that his first true follower was Goya, and after him the innovative painters of the nineteenth century, from Courbet with his "realism" to the Impressionists with their preoccupation with observing the fall of light on objects. Among his associates, Mazo is the only one known to us who followed Velázquez's example with some success, and he was a far less gifted painter. Still, their hands have sometimes been confused.

Up to the end Velázquez conformed to the requirements of his position in life. So far as the scanty records reveal his story, he was perfectly adapted to the social order in which he lived. He worked hard at his profession and improved his prospects by marrying the equivalent of the boss's daughter. He further advanced his career by getting along well with persons who had influence at Court. And he appears to have lived for thirty-seven years on equitable terms with the dissolute and melancholy Philip IV, carrying out satisfactorily his many prosaic duties. Even in the time allowed him for painting, royal orders for portraits took precedence, regardless of his own inclinations, and he carried out the commissions with verve. After years of what must have been the most irksome frustration, at long last he received the elevation in status to which he aspired; he became a member of the nobility in a society in which this distinction justified all the time and effort it had cost him.

Alongside this life story, there is the amazing record of his paintings. This conformist in life was a risk-taker in art. Though he was hugely successful as a portraitist from a very early point in his career, he was not satisfied to limit himself to portraiture and the certainty of

15. The letter is published in full in *Varia velazqueña*, Vol. II, pp. 382 f. On Velázquez's last weeks, illness, and death see Pedro Lain Entralgo, "La Muerte de Velázquez," *Archivo Español de Arte*, 33, 1960, pp. 101–107.

admiration accompanying it. Instead, he grasped every opportunity to face a new challenge. He undertook compositions of the most varied kinds of subjects, in many cases working out a notably original solution to the pictorial problem he set himself. The *bodegones* of his youthful days in Seville demonstrate his fearless disdain for prevailing fashions even so early in his experience as an independent artist. In company with the other gifted young painters who, along with him, created the Golden Age of Spanish painting, he chose the modern style of naturalism. Later he proved his mastery in mythological, biblical, and historical subjects and independent landscape. In each instance the strength of his artistic individuality made its mark. Throughout his working life, he used colors and values in uniquely expressive ways. One has only to recall his compositions in *Las Meninas* and *Las Hilanderas* to recognize the energy and inventiveness that propelled him until the end. His very brushstroke bespeaks a free spirit.

Lovers of Velázquez's art may be tempted to wonder, however, where such great gifts might have led in a different time or a different setting. Certainly to be regretted is the fact that, as Palomino wrote, his time-consuming duties at Court deprived posterity of many more proofs of his genius. Velázquez apparently did not contend against those aspects of his life that he could not change. He lived in harmony with the world as he found it. Though the prescribed asceticism and the actual sensual indulgence that prevailed in his environment were both probably foreign to his nature, he seems to have succeeded in steering a safe course, avoiding the cliffs and whirlpools of Court life. Perhaps his *flema*, his calm, was what saved him.

Remaining emotionally uninvolved in events, Velázquez spent his inner force solely in his work. And even in the face of his creative activity, he retained a certain aloofness and control that from our side of the picture looks like objectivity. His temperament led him naturally to a stance favorable to art, maintaining a distance that sets art apart from experienced reality. Mystery, ambiguity, reservoirs of meaning and feeling endowed his works with values that speak the common language of humanity. All this lies beneath and supports the visible brilliance and beauty of his paintings. So his work retains its vitality after more than three hundred years, inspiring new art and enlarging the experience of new generations.

List of Illustrations

All works reproduced are paintings by Velázquez except where otherwise stated. Dimensions are given in meters, height before width.

1. *The Meal*, Leningrad, Hermitage. (1.079 × 1.016) Photo, courtesy of M. Knoedler & Co.
2. *Kitchen Scene with Christ in the House of Martha and Mary*. London, National Gallery. (.600 × 1.035)
3. Jacob Matham, *Kitchen Scene with the Rich Man and the Poor Lazarus*, engraving after a painting by Pieter Aertsen. Amsterdam, Rijksmuseum.
4. *Old Woman Frying Eggs*. Edinburgh, National Gallery of Scotland. (.99 × 1.169)
5. *The Waterseller of Seville*. London, Wellington Museum. (1.065 × .82)
6. *The Waterseller of Seville*, detail.
7. *The Waterseller of Seville*, detail.
8. *The Adoration of the Magi*. Madrid, Prado. (2.03 × 1.25)
9. *Portrait of a Man Wearing a Ruff*. Madrid, Prado. (.40 × .36)
10. *The Immaculate Conception*. London, National Gallery. (1.346 × 1.016)
11. *Saint John the Evangelist on the Island of Patmos*. London, National Gallery. (1.355 × 1.022)
12. *Two Young Men at a Humble Table*. London, Wellington Museum. (.645 × 1.04)
13. *Don Luís de Góngora*. Boston, Museum of Fine Arts. (.51 × .41)
14. *Philip IV in Armor*. Madrid, Prado. (.57 × .44)
15. *Philip IV*, standing. Madrid, Prado. (2.01 × 1.02)
16. *The Buffoon Pablo de Valladolid*. Madrid, Prado. (2.09 × 1.23)
17. *The Buffoon Pablo de Valladolid*, detail.
18. Antonio Moro, *The Buffoon Pejeron*. Madrid, Prado. (1.81 × .92)
19. *The Count-Duke of Olivares*. New York, The Hispanic Society of America. (2.16 × 1.295)
20. *The Infante Don Carlos*. Madrid, Prado. (2.09 × 1.25)
21. *Christ After the Flagellation Contemplated by the Christian Soul*. London, National Gallery. (1.65 × 2.06)
22. *The Crucified Christ*. Madrid, Prado. (2.48 × 1.69)

23. *Homage to Bacchus* (*Los Borrachos*). Madrid, Prado. (1.65 × 2.25)
24. *Joseph's Bloody Coat Shown to Jacob.* El Escorial, Monasterio. (2.23 × 2.5)
25. *Apollo at the Forge of Vulcan.* Madrid, Prado. (2.23 × 2.90)
26. *The Gardens of the Villa Medici: Landscape with Wall.* Madrid, Prado. (.48 × .42)
27. *The Gardens of the Villa Medici: The Loggia.* Madrid, Prado. (.44 × .38)
28. *The Infanta María.* Madrid, Prado. (.58 × .44)
29. *Prince Baltasar Carlos with a Dwarf.* Boston, Museum of Fine Arts. (1.36 × 1.04)
30. *Philip IV in Brown and Silver.* London, National Gallery. (1.95 × 1.10)
31. *The Surrender of Breda* (*Las Lanzas*). Madrid, Prado. (3.07 × 3.67)
32. *The Surrender of Breda,* detail.
33. *The Surrender of Breda,* detail.
34. *Equestrian Portrait of Prince Baltasar Carlos.* Madrid, Prado. (2.09 × 1.73)
35. *Equestrian Portrait of Philip IV.* Madrid, Prado. (3.01 × 3.14)
36. *Equestrian Portrait of Olivares.* Madrid, Prado. (3.13 × 2.39)
37. *Philip IV as a Hunter.* Madrid, Prado. (1.91 × 1.26)
38. *The Infante Fernando as a Hunter.* Madrid, Prado. (1.91 × 1.07)
39. *Prince Baltasar Carlos as a Hunter.* Madrid, Prado. (1.91 × 1.03)
40. *Menippus.* Madrid, Prado. (1.79 × .94)
41. *Aesop.* Madrid, Prado. (1.79 × .94)
42. *Mars.* Madrid, Prado. (1.79 × .95)
43. *The Sculptor Juan Martínez Montañés.* Madrid, Prado. (1.09 × 1.07)
44. *Portrait of a Bearded Man.* London, Wellington Museum. (.76 × .648)
45. *Portrait of a Lady with a Fan.* London, Wallace Collection. (.95 × .70)
46. *Portrait of a Little Girl.* New York, Hispanic Society of America. (.5.5 × .41)
47. *The Dwarf Sebastián de Morra.* Madrid, Prado. (1.06 × .81)
48. *The Coronation of the Virgin.* Madrid, Prado. (1.76 × 1.24)
49. *Venus at Her Mirror* (*The Rokeby Venus*). London, National Gallery. (1.225 × 1.77, approx; edges uneven)
50. *Philip IV, the Fraga Portrait.* New York, Frick Collection. (1.335 × .985)
51. *The Dwarf Don Diego de Acedo.* Madrid, Prado. (1.07 × .82)
52. *Juan de Pareja.* New York, Metropolitan Museum of Art. (.82 × .698)
53. *Pope Innocent X.* Rome, Galleria Doria-Pamphili. (.78 × .68)
54. El Greco, *Cardinal Fernando Niño de Guevara.* New York, Metropolitan Museum of Art.
55. *Camillo Astalli, Cardinal Pamphili.* New York, Hispanic Society of America. (.61 × .485)
56. *The Infanta María Teresa.* Vienna, Kunsthistorisches Museum. (1.27 × .99)
57. *Queen Mariana.* Madrid, Prado. (2.31 × 1.31)
58. *The Infanta Margarita.* Vienna, Kunsthistorisches Museum. (1.05 × .88)

87. Maerten van Heemskerck, *Saint Luke Painting the Virgin*. Haarlem, Frans Hals Museum.
88. Rembrandt, *An Artist in His Studio*. Boston, Museum of Fine Arts.
89. Michiel Sweerts, *A Painter's Studio*. Amsterdam, Rijksmuseum.
90. Adriaen van Ostade, *A Painter's Studio*. Amsterdam, Rijksmuseum.
91. Jan Vermeer, *The Art of Painting*. Vienna, Kunsthistorisches Museum.
92. Jean-Honoré Fragonard, *The Lover Crowned*. New York, Frick Collection.
93. Francisco Goya, *The Family of Charles IV*. Madrid, Prado.
94. Gustave Courbet, *The Painter's Studio*. Paris, Louvre.
95. Pablo Picasso, *Variation of Las Meninas, I*. Aug. 17, 1957. Barcelona, Picasso Museum.
96. *The Fable of Arachne (Las Hilanderas)*. Madrid, Prado. (2.20 × 2.89)
97. *The Fable of Arachne (Las Hilanderas)*, approximately as Velázquez composed it.
98. *Prince Felipe Prospero*. Vienna, Kunsthistorisches Museum. (1.29 × .995)

Bibliographic Note

(with special reference to further reading in English)

Pacheco and Palomino are our chief sources; all the later studies of Velázquez's life and works draw on them. Only some parts of Pacheco's book have been published in English translation. As for Palomino, Richard Cumberland's abridged English version of his biography of Velázquez, published in London in 1787, was reprinted in *Varia velazqueña*, Vol. I, pp. 144-153. Later incomplete versions in English were published in Elizabeth Holt, *A Documentary History of Art*, Vol. II, New York, 1958, and in R. Enggass and J. Brown, *Italy and Spain 1600-1750* (Sources and Documents in the History of Art), Englewood Cliffs, N.J., 1970, along with extracts from Pacheco.

Stirling-Maxwell and Curtis wrote pioneering books in English. Justi, whose great work was published in Spanish and Italian editions as well as in the original German and in a somewhat abridged English version, is fundamental to modern Velázquez scholarship. Beruete also made significant contributions. Trapier took into account the research that had been done since the time of Justi and made interesting observations of her own. López-Rey's catalogue raisonné of 1963 was based on Mayer's catalogue of 1936, but included numerous changes in attributions and dates, most of them judicious, though he accepts some paintings that I consider to be wholly or in part by other hands than Velázquez's. I also differ with him about some dates. His introductory study in this book, which was reprinted with some corrections and revisions in his 1968 book, gives rise to serious reservations. Velázquez's paintings seem to me to give no grounds for López-Rey's views about "the polarity of the divine and the human that gives meaning to his naturalism and is at the core of his art" (1968, p. 16).

A number of important publications (not encompassed by López-Rey) commemorated the three-hundredth anniversary of Velázquez's death in 1960. *Varia velazqueña*, published by the Department of Fine Arts of the Ministry of Education of Spain, includes in Volume I essays on many aspects of the artist and his works, and in Volume II reprints poetic tributes, critical commentaries, and documents. Both volumes are mainly in Spanish, but

there are some sections in other languages, including a few in English. The Instituto Diego Velázquez published on that occasion *Velázquez: Homenaje en el tercer centenario de su muerte,* which comprises seventeenth- and eighteenth-century biographies and commentaries on Velázquez and contemporary letters and documents concerning him, with many facsimiles. The exhibition *Velázquez y lo velazqueño,* held in Madrid in 1960, stimulated many fresh thoughts about attribution and dating. The Spanish journal *Goya,* numbers 37/38, Madrid, 1960, was devoted to lavishly illustrated articles by Velázquez scholars. *Archivo Español de Arte* was also particularly rich in Velázquez studies in its 1960 volume.

The major contributions since that time are included in the following list of literature that was consulted for this book.

List of Cited Literature on Velázquez

Allende-Salazar, Juan, *Velázquez, des Meisters Gemälde* (Klassiker der Kunst), Berlin and Leipzig [1925].

Alpers, Svetlana, *The Decoration of the Torre de la Parada* (Corpus Rubenianum Ludwig Burchard, IX), London and New York, 1971.

Angulo Iñiguez, Diego, *Velázquez: Como compuso sus principales cuadros,* Seville, 1947.

———, "Las Hilanderas," *Archivo Español de Arte,* 21, 1948, pp. 1–19.

———, "Las Hilanderas," *Archivo Español de Arte,* 25, 1952, pp. 67–84.

———, "La Fabula de Vulcano, Venus y Marte y 'La Fragua' de Velázquez," *Archivo Español de Arte,* 33, 1960, pp. 149–181.

Azcárate, José María de, "La alegoría en 'Las Hilanderas'," in *Varia velazqueña,* Vol. I, pp. 344–351.

Bergström, Ingvar, *Maestros españoles de Bodegones y Floreros del siglo XVII,* Madrid, 1970.

Beruete, Aureliano de, *Velázquez,* Paris, 1898. Revised English edition, London, 1906.

Birkmeyer, Karl M., "Realism and Realities in the Paintings of Velásquez," *Gazette des Beaux-Arts,* 6th Series, Vol. 52, 1958, pp. 63–80.

Bonet Correa, Antonio, "Velázquez, arquitecto y decorador," *Archivo Español de Arte,* 33, 1960, pp. 215–249.

Braham, Allan, "A Second Dated Bodegón by Velázquez," *Burlington Magazine,* 107, 1965, pp. 362–365.

———, *Velázquez* (Themes and Painters in the National Gallery, 3), London, 1972.

Camón Aznar, José, *Velázquez,* Madrid, 1964.

Caravaggio y el naturalismo español, Exhibition Catalogue, Seville, 1973, with introduction by Alfonso E. Pérez Sánchez.

Carducho, Vincencio, *Diálogos de la Pintura, su defensa, origen, essencia, definición, modos y diferencias,* Madrid, 1633.

Caturla, María Luisa, "El coleccionista madrileño Don Pedro de Arce, que poseyó 'Las Hilanderas' de Velázquez," *Archivo Español de Arte*, 21, 1948, pp. 292–304.

————, "Cartas de pago de los doce cuadros de batallas para el salón de Reinos del Buen Retiro," *Archivo Español de Arte*, 33, 1960, pp. 333–355.

————, "Devanaderas," *Arte Español*, 24, 1962, pp. 73–76.

Cavallius, Gustaf, *Velázquez' Las Hilanderas*, Uppsala, 1972.

Ceán Bermúdez, Juan Agustín, *Diccionario histórico de los mas ilustres profesores de las bellas artes en España*, Madrid, 1800.

————, *Diálogo sobre el arte de la pintura*, Seville, 1819.

Chueca Goitia, Fernando, "El espacio en la pintura de Velázquez," in *Varia velazqueña*, Vol. I, pp. 147–162.

Cruzada Villaamil, Gregorio, *Anales de la vida y de las obras de Diego de Silva Velázquez*, Madrid, 1885.

Curtis, Charles B., *Velázquez and Murillo*, London and New York, 1883.

Emmens, J. A., "Les Ménines de Velázquez: Miroir des Princes pour Philippe IV," *Nederlands Kunsthistorisch Jaarboek*, 12, 1961, pp. 51–79.

Gaya Nuño, J. A., "Picaresco y tremendismo en Velázquez," *Goya*, 37/38, 1960, pp. 92–100.

————, *Bibliografía crítica y antológica de Velázquez*, Madrid, 1963.

Gerstenberg, Kurt, *Diego Velázquez* [Munich] [1957].

Harris, Enriqueta, "Velázquez en Roma," *Archivo Español de Arte*, 31, 1958, pp. 185–192.

————, "La misión de Velázquez en Italia," *Archivo Español de Arte*, 33, 1960, pp. 109–136.

————, "Cassiano dal Pozzo on Diego Velázquez," *Burlington Magazine*, 112, 1970, pp. 364–373.

————, "The Cleaning of Velázquez's Lady with a Fan," *Burlington Magazine*, 112, 1975, pp. 316–319.

———— and John Elliott, "Velázquez and the Queen of Hungary," *Burlington Magazine*, 118, 1976, pp. 24–26.

Hume, Martin, *The Court of Philip IV*, New York and London, 1907.

Justi, Carl, *Diego Velázquez und sein Jahrhundert*, 2 vols., Bonn, 1888.

————, *Diego Velázquez and His Times*, London, 1889 (abridged English edition).

Kehrer, Hugo, *Die Meninas des Velázquez*, Munich, 1966.

Kubler, George, "Vicente Carducho's Allegories of Painting," *Art Bulletin*, 47, 1965, pp. 439–445.

————, "Three Remarks on the *Meninas*," *Art Bulletin*, 48, 1966, pp. 212–214.

———— ed., *"The Antiquity of the Art of Painting" by Felix da Costa*, New Haven and London, 1967.

Künstler, Gustav, "Über 'Las Meninas' und Velázquez," in *Festschrift Karl M. Swoboda zum 28 Januar 1959*, Vienna and Wiesbaden, 1959, pp. 141–158.

Lafuente, Enrique, *Velázquez: Complete Edition*, London, 1943.

Livermore, Ann Laprair, "Francisco Sánchez: a Possible Influence on Some Aesthetic Ideas of Diego de Silva y Velázquez," in *Varia velazqueña*, pp. 217–232.

López-Rey, José, *Velázquez: A Catalogue Raisonné of his Oeuvre*, London, 1963.

——, *Velázquez' Work and World*, London, 1968.

Maclaren, Neil, *National Gallery Catalogues: The Spanish School*, 2nd ed., revised by Allen Braham, London, 1970.

Mayer, August L., *Velázquez: A Catalogue Raisonné of the Pictures and Drawings*, London, 1936.

Menéndez Pidal, Gonzalo, and Diego Angulo Iñiguez, " 'Las Hilanderas' de Velázquez: Radiografías y fotografías en infrarrojo," *Archivo Español de Arte*, 38, 1965, pp. 1–12.

Ortega y Gasset, José, *Velázquez*, Madrid, 1968.

Pacheco, Francisco, *Arte de la Pintura*, Madrid, 1956. (First edition, 1649.)

Palomino Velasco, Antonio, *El Museo Pictórico y Escala Óptica*, Madrid, 1947. (First edition, Book I, 1715; Books II and III, 1724.)

Pantorba, Bernardino de, *La Vida y la Obra de Velázquez*, Madrid, 1955.

Pita Andrade, J. M., "Los cuadros de Velázquez y Mazo que poseyó el séptimo Marqués del Carpio," *Archivo Español de Arte*, 25, 1952, pp. 223–236.

Prado, Museo del, *Catálogo de las Pinturas*, Madrid, 1972.

Ricketts, C. S., *The Prado and Its Masterpieces*, Edinburgh, 1903.

Rodríguez Villa, Antonio, *La corte y monarquía de España en los años de 1636 y 37*, Madrid, 1886.

Salas, Xavier de, *Velázquez*, London, 1962.

Sánchez Cantón, F. J., *Como vivía Velázquez*, Madrid, 1942.

——, *Velázquez: Las Meninas y sus personajes*, Barcelona, 1943.

——, "La Venus del Espejo," *Archivo Español de Arte*, 33, 1960, pp. 137–148.

Saxl, Fritz, "Velásquez and Philip IV" (1942), *Lectures*, London, 1957, pp. 311–324.

Soehner, Halldor, "Die Herkunft der Bodegones de Velázquez," in *Varia velazqueña*, Vol. I, pp. 233–244.

Soria, Martin, in George Kubler and Martin Soria, *Art and Architecture in Spain and Portugal and their American Dominions 1500 to 1800*, Harmondsworth, 1959.

Stevenson, R. A. M., *Velázquez*, London, 1906.

Stirling-Maxwell, William, *Velázquez and his Works*, London, 1855.

Tolnay, Charles de, "Velázquez' *Las Hilanderas* and *Las Meninas*," *Gazette des Beaux-Arts*, 35, 1949, pp. 21–38.

Trapier, Elizabeth du Gué, *Velázquez*, New York, 1948.

———, *The Hispanic Society of America: Velázquez, Portraits in the Collection*, New York, 1952.

Válgoma y Díaz-Varela, D. de la, "Una injusticia con Velázquez: sus probanzas de ingreso en la Orden de Santiago," *Archivo Español de Arte*, 33, 1960, pp. 191–214.

———, "Por que el Santiaguista Velázquez no residió en Galeras," in *Varia velazqueña*, pp. 683–687.

Varia velazqueña, 2 vols., Madrid, 1960.

Velázquez: Homenaje en el tercer centenario de su muerte, Madrid, 1960.

Velázquez y lo velazqueño, Exhibition Catalogue, Madrid, 1960.

Zarco del Valle, M. R., *Documentos inéditos para la historia de los Bellas Artes en España*, Madrid, 1870.

Index

Page numbers for illustrations are italicized. Those illustrations for which no artist's name is given are by Velázquez.

WESTMAR COLLEGE LIBRARY